Changing the Signs

CHANGING

University of Nebraska Press: Lincoln and London

Albert Spaulding Cook

THE SIGNS

The Fifteenth-Century Breakthrough

The paper in this book meets
the guidelines for
permanence and durability
of the Committee on
Production Guidelines for
Book Longevity of the
Council on Library Resources

Portions of the chapter
on Carpaccio have previously
been published in slightly
different form, as "Carpaccio's
Animals," in *The Centennial
Review*, 27 (Fall 1983): 224-43;
and of the chapter on Bosch
as "Change of Signification in
Bosch's *Garden of Earthly
Delights*," *Oud Holland*, 98 (1984):
76-97; and of the chapter on
Botticelli as "The Presence of
Botticelli's *Primavera*," *Stanford
Italian Review*, 4 (1984),
reprinted by courtesy of ANMA
Libri, Saratoga, California.

Library of Congress Cataloging
in Publication Data

Cook, Albert Spaulding.
Changing the signs.

Bibliography: p.
Includes index.
1. Painting Renaissance. 2. Visual
perception. 3. Composition (Art)
4. Narrative painting – Themes,
motives. I. Title
ND170.C66 1985 759.03
84-17280
ISBN 0-8032-1425-1 (alk. paper)

To my students and colleagues

at Brown University

and to the memory of

Abigail Camp Dimon

Contents

Illustrations

PLATES

Following page 114

Acknowledgments

I am grateful to Martin Pops and Ray Waddington, who read part or all of the manuscript and commented on it. My wife, Carol, also provided valuable stylistic and substantive suggestions in addition to bibliographic help. Edward Snow, in particular, helped to give the book its present shape by suggesting the order I have adopted for the chapters, and also by providing many acute stylistic comments.

I owe thanks to the libraries of Brown University, Cambridge University, and I Tatti; to Clare Hall, which gave me the fellowship on which I was able to evolve the thesis of the book; and to the *Centennial Review, Oud Holland,* and the *Stanford Italian Review* for publishing some of the material in it. My research assistant, Angelika Webb, efficiently produced early drafts of the manuscript; and her successor, Blossom S. Kirschenbaum, saw it with admirable resourcefulness to its conclusion, offering useful stylistic advice in the process and also preparing the index.

The dedication indicates my gratitude to the ambience of intelligent discourse in which I have been able to conceive and execute this book. My reference to colleagues very much includes the late Reinhart Kuhn, who was crucially responsible both for creating this ambience and for inviting me into it.

In fact the dedication frames my career, since I first heard extended discussion about Italian Renaissance painting while a high school student in a lecture series at the Munson-Williams-Proctor Institute in Utica, New York, under the sponsorship of Abigail Camp Dimon. My friends and I remain indebted to her for much cultural enhancement besides.

For permission to reproduce works of art, I am grateful to the following: Musei Civici di Padova, Padua, for Giotto's *The Kiss of Judas.* Sacro

Convento, Assisi, for Giotto's *Saint Francis Preaching to the Birds*. David Lees and the Galleria degli Uffizi, Florence, for Botticelli's *Primavera*. Museo Correr, Venice, for Carpaccio's *Two Venetian Women*. Accademia, Venice, for Giorgione's *The Tempesta*. Archivi Alinari and the Galleria degli Uffizi, Florence, for Leonardo's *Adoration of the Magi;* Botticelli's *The Adoration of the Magi* and *The Birth of Venus*. The Louvre, Paris, for Giorgione's *The Concert Champêtre* and Bosch's *The Ship of Fools*. Prado Museum, Madrid, for Bosch's *Garden of Earthly Delights*. Staatliche Museen Preussischer Kulturbesitz, Berlin, for Bosch's *The Hearing Forest and the Seeing Field*. Staatsgalerie, Stuttgart, West Germany, for Memling's *Bathsheba*. Museum Boymans-van Beuningen, Rotterdam, for *The Prodigal Son* and *The Wedding at Cana*. The Hermitage, Leningrad, for Giorgione's *Judith*. Thyssen-Bornemisza Collection, Lugano, Switzerland, for Carpaccio's *Young Knight in a Landscape*. The National Gallery, London, for Botticelli's *The Mystic Nativity* and *Venus and Mars,* Crivelli's *Virgin,* Pisanello's *The Vision of Saint Eustace,* and Piero di Cosimo's *A Mythological Subject*. Reproduced by courtesy of the Trustees. The Metropolitan Museum of Art, New York, for Carpaccio's *Meditation on the Passion of Christ*. All rights reserved. Isabella Stewart Gardner Museum, Boston, for Botticelli's *The Madonna of the Eucharist*. Fogg Art Museum, Harvard University, Cambridge, Massachusetts, for Botticelli's *The Mystic Crucifixion*. Gift of Friends of the Fogg. Scala/Art Resource, Inc., New York, for Bosch's *The Hay Wain, The Seven Deadly Sins, The Cure of Folly,* Prado Museum, Madrid; *The Hearing Forest and the Seeing Field,* Staatliche Museen Preussischer Kulturbesitz, Berlin. Alinari/Art Resource, Inc., New York, for Botticelli's *Pallas and the Centaur,* Galleria degli Uffizi, Florence; Giorgione's *Portrait of Laura* and *The Three Philosophers,* and Bosch's *Christ Carrying the Cross* and *Reverse of Christ Carrying the Cross,* Kunsthistorisches Museum, Vienna; Giorgione's *The Madonna of Castelfranco,* Chiesa Parrocchiale, Castelfranco Veneta; Carpaccio's, *A Miracle of the Relic of the True Cross,* Accademia, Venice, and *Saint George Fighting the Dragon, Saint Jerome Leading the Tame Lion into the Monastery,* and *Saint Augustine in His Study,* Scuola di S. Giorgio e Trifone, Venice; Anonymous, *The Farnese Bull,* Soprintendenza Archeologica delle Provinci di Napoli e Caserta, Naples; Piero della Francesca's *The Brera Virgin,* Laboratorio fotografico della Soprintendenza per i Beni Artistici e Storici, Milan.

Changing the Signs

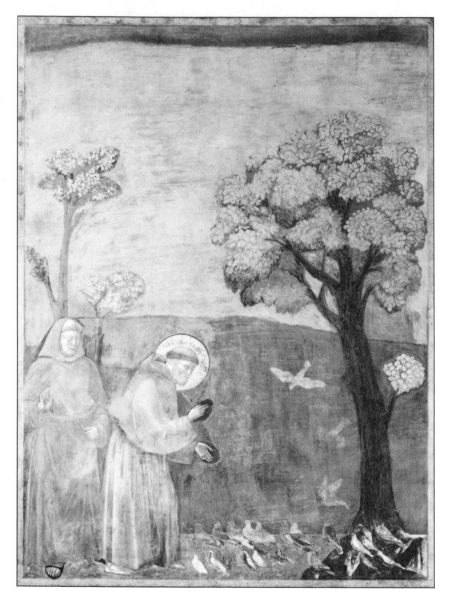

Figure 1. *Saint Francis Preaching to the Birds,* by Giotto.
Courtesy of Sacro Convento, Assisi.

Introduction

Word and the visual image, as well as the related pair of the visual image and its signification, interact so subtly, and with such a vast range of complexity, that no pair of terms can focus all the dimensions of their interaction. Image itself as a term nests so many complexities that some theorists have taken to avoiding it. Any pair of terms, then, will somewhat force the hand of the theorist. In this domain especially he may be tempted to succumb to the particular *ignava ratio* of Jacques Derrida and make a postulate of his awareness that the inevitably schematizing terms do some violence to the fluid situation he would discuss.[1] Another, related pair is the *signifier* and *signified* of modern semiology. For verbal language the signifiers are phonetic constructs framing, say, the word *tree*, which connects to a signified, the mental conception of a tree.[2] The relationship between *signifier* and *signified,* as writers since Saussure have come to see, admits of considerable dialectical expansion, and it also offers the instrumentality by which the intricate suggestions of signification that are encoded into paintings or sculptures may be submitted to a properly calibrated sequence of interpretive extrapolations.[3] To raise the question of how the pair of signifier and signified draws upon and bears upon the "real" elm or palm in the experiential world is to shift emphasis to still another pair, *representation* and *object*. Since *mimesis*— a variant of *representation*—very deeply engages literary and pictorial art in our culture, as in others, this pair has been much examined, and it has been found to center on what turn out to be considerable, arresting sets of logical puzzles.[4] The "forbidden tree" of Milton as against the "chestnut-tree, great-rooted blossomer" of Yeats, or the Umbrian trees surrounding Giotto's Saint Francis[5] (figure 1), as against the orange trees backing the painted personages of Botticelli's *Primavera* (plate 2), offer

groups of likeness and difference that would engage, variously but of course overlappingly, every one of these terms.

The pair *discourse* and *figure* has been adopted and forcefully employed by Jean-François Lyotard and Norman Bryson.[6] This pair has the merit of taking each term at an advanced, constructed stage. *Discourse,* as it applies initially to verbal utterances, comprises whole utterances and not just their semantic and syntactic constituents. *Figure* brings together a visual or verbal representation and its signification. And the terms go easily together, in ways that these writers show will aid a focusing discussion of art works. Not only is the figure of the tree in Milton, and again in Yeats, dependent on the discourse into which it is built but also, mutatis mutandis, the figure of the trees in Giotto and in Botticelli, whatever their differences, are alike in being engaged with the personages in the painting in a significative connection that may loosely be called discourse.

Giotto's trees are figures for "nature" and even for "background of solitude." There is a syntax that connects them to the birds and to Saint Francis. The birds themselves are figures for "God's creatures" as well as also for "nature," and the particular role of Saint Francis, a relatively recent saint in Giotto's lifetime, comprises many figural functions as they surface in possible interpretations of this particular famous episode from a preexisting text, the *Fioretti* XVI. All this richness of discourse, as it brings together varying richnesses of figure (including other features like the blossoms on the trees and the gold sky), would not necessitate Erwin Panofsky's elaborate iconographic machinery with its discrimination of themes and motifs.[7] (*Theme* and *motif* constitute still another pair of applicable terms.) The motif of this saint feeding the birds leads easily to more generalized themes like "caring for the lowly" or "being attentive to the life in Creation." Giotto's painting offers no puzzles of identification and no difficulty at locating an external verbal text, though of course the visual properties of the painting as we experience it in what Bernard Berenson calls its tactile values and in its compositional strategies of deploying line and color offer a universe of subtle presentations that themselves imply signification.

So, too, the three different personages at the right of the *Primavera* are formed into a discourse by a syntactical connection to the trees behind them, to the flowers below them, to the six other personages in the picture and to their groupings. These personages—the group of three and the others individually and in groups—constitute very rich figures in themselves. Even if these personages can really be taken to refer explicitly to some single preexisting story—and this is an iconographic reading I

shall be questioning at length in what follows—still each of the three re-
lates to the others, and their group connects both to the other groups and
to the persons in them for a developed and intertwining syntax.

They connect with far greater boldness and intricacy than Saint Francis
relates to his birds and his trees. And the late Giotto's *Kiss of Judas* (figure
2), too, presents the figures of Crowd and Judas and Kiss and Torches and
background Treetops and surprisingly blue Sky in a discourse much more
like *Saint Francis Preaching to the Birds* than like whatever discourse is
enunciated in the *Primavera*.

There is, furthermore, in the signifier of the Word a whole prior set of
phonetic, phonemic, and linguistic rules that are internalized as "compe-
tence" before the "performance" of a verbal utterance. And for the visual

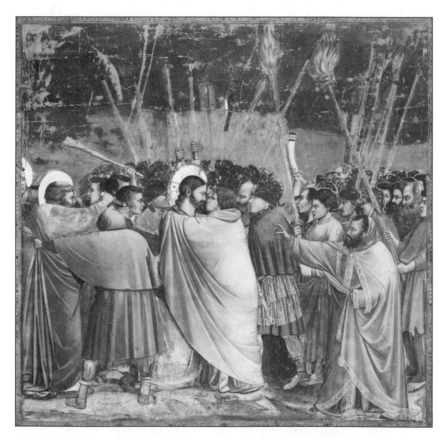

Figure 2. *The Kiss of Judas,* by Giotto. Courtesy
of Musei Civici di Padova, Padua.

Image, visual artifacts seem more immediate than words are. They are more immediate in that they produce the illusion of being taken in at one sweep spatially, as well as in their wordless silence and in their undisplaced resemblance to the object of representation. For all the cultural conditioning and constructive perception involved, Giotto's trees, Botticelli's trees, and also the trees on Minoan and Mycenean gems—all resemble the real tree much more than does the transcribed series of phonetic symbols *t-r-e-e*. The pictured tree is an icon of a tree in Charles Sanders Peirce's sense too, the word *tree* is not. Such a situation has led Lyotard somewhat precipitously to speak of a convergence of "sense" and "reference" (Frege's set of terms) in the visual work to which a verbal discourse does not have access. However, as Gombrich has shown us, our perception of the visual work is (re-)constructed from sets of visual cues that to this degree function as phonemes do. Ongoing research in human perception of constructed line and contrasted or blended color, as it combines with and fortifies specific aesthetic theory, has tended to amplify the amount of prior perceptual work involved in approaching a painting.[8]

While all of this construction, for Word or for visual Image, is prior, questions about it may fairly safely be bracketed as the works themselves are addressed. The relation between Word and Image itself may not be bracketed, however, because in the general *langue* of interacting human significations, as well as in the *parole* of a particular poem or painting, Word and Image do interact. And even the sort of moderately new separation, or redefinition, of the relationship between Word (or lexical signified) and visual Image that I shall be arguing for Botticelli and others still amounts to a kind of relationship—a separation that at the same time may well involve, resolutely, only a partial inclusion of lexical and syntactic significations into the work. Or, put more simply, a freedom from story obtains in the painting that could also be described as a relationship to story, one of distancing or reconstruction.

At an imaginable earliest, but very long-lived, phase of pictorializing—the paleolithic cave paintings as Lascaux—Word and Image may be conceived of as in a state of nearly total convergence.[9] Since all written language, so far as we know, originates in pictograms that become hieroglyphics, there is no arbitrary point where we may draw a line and refuse to the pictogram the status of a linguistic morpheme. In this sense the bull at Altamira writes down the word *bull* and the reindeer at Lascaux *reindeer*. Of course, the paleolithic bull and reindeer have long been characterized as startlingly realistic or mimetic in ways that forbid our setting up a simple historical evolution, whereby Word gets separated from Im-

age as Image moves from crude schema to more refined representation. Nor for the figural signification of the visual Image can a medieval-to-Renaissance development be generalized, "from emblem to expression,"[10] whereby painting becomes more secular, and less schematically figural, as its techniques of representation are refined. The paleolithic bull and reindeer, which are subtly representational, and which may have become increasingly so over millennia of technical development, must surely at the same time remain overpoweringly and schematically religious. Whatever they meant within their almost wholly lost cultural context, everything we know about hunting and gathering societies would argue that Bull and Reindeer must loom large in whatever cults and myths and holistic systems the society that produced them possessed.

Bryson persuasively employs the terms *discourse* and *figure* at once to delineate how these constituents interact in particular visual works and to account for individual separate details within a painting. Specifically, he expounds the existence of an increasingly charged area within Renaissance painting as an artist like Masaccio establishes "a new right to incorporate the non-pertinent-semantically 'innocent' detail." This new flexibility, he argues, operates through perspective as "the great guarantee of irrelevance," which "strengthens realism"—and hence a freedom from the schematic reference to a text—"by greatly expanding the area on the opposite side of the threshold to the side occupied by textual function."[11]

Again, within the middle and late quattrocento, as more generally, a binding rule cannot be enunciated of using visual perspective by itself to suggest the degree of freedom from a preexisting text, or even from staple motifs. Leonardo is much more realistic than his near-contemporary Botticelli, and he is far more adept also, as he is always perceived, at perspectival manipulation. Yet while on the one hand his work is far more abundant in irrelevant detail, it is Botticelli on the other hand who in his more characteristic work is far freer of a given text. In a late work like the *Mystic Nativity* (plate 1), indeed, both situations obtain: the painting is all at once coded to schematic convergence, full of irrelevant detail, bound to a particular text, free in its handling of iconographic staples not usually combined with it—and strangely free, further, to inscribe a discourse in words added to the discourse in paint, an apocalyptic text in a sort of Byzantine biblical Greek. As Botticelli and certain of his contemporaries help to remind us, even a comprehensive account of discourse and figure will not be simple.

It is not so, indeed, even in the Middle Ages, where the themes and motifs of stained glass, for example, remind the viewer-worshiper of a

known motif inserted into a series of other stories from Bible and saints' legends into the encyclopedia of the medieval cathedral.

All figures in stained glass are more schematized than those in any quattrocentro painter. Yet the examples at Canterbury that Bryson discusses, or those in King's College Chapel at Cambridge, are harder to read—the viewer is slower in passing through their threshold to a reminder of the story—than the ones in Chartres or Bourges, where the visual personages are far more easily distinguished. Yet, as though to insist on the dynamic of visual access to the transparency of perception, it is the hard English ones that have a far larger proportion of translucent, relatively colorless glass, while the easy French ones are noteworthy for spelling out their personages in robust nuggets of strong and boldly juxtaposed color. Even the colors in the English glass are paler. Also, the lead separations from panel to panel are much less pronounced in the English glass and the figures are larger. All of this allows a viewer to take in a whole window much more readily, both to dim and to generalize his view, and to bring it into a more direct connection with the metaphysics of light much discussed in medieval theology in the centuries before the glass was employed. All these attributes of English and of French glass could be interpreted along lines of the interaction of discourse and figure, as could the differences between the prevailingly blue figures of Chartres and the prevailingly red figures of Bourges, and their perhaps correspondingly different management of the relation between curved and rectilinear lines both inside a single panel of glass and over a whole many-paneled window.

Moreover, in the large overall progress from Chartres to Leonardo, it is not only the media employed and their implied context for the images or figures that undergo vast and multifarious refinements. The technique as well, in ways that the ongoing discourse of art historians has shown us, has run through intricate phases of development. Yet through all this development, the initial reference of the "words" or discourse on which the works are built remains fairly inert. As Meyer Schapiro says, "A great part of the visual art in Europe from late antiquity to the 18th century represents subjects from a written text."[12] Painting in the Middle Ages and the Renaissance is for the most part anchored firmly to a story, which draws upon and in turn manipulates associated icons from a large and rich repertoire. The figures make up a Nativity, a Crucifixion, or something from the staple events of Scripture, legend, and the lives of saints. The particular convergences of painterly constituents in the vision of the viewer anchor themselves in such a story.

The significative strategies even of humanistic paintings like the allegories of Andrea Mantegna (1431–1506) and others do not depart from this sort of relation between discourse and figure. The allegory coordinates its themes and motifs as signifiers that refer to an abstract signified, say, the Virtues and Vices. While Mantegna did not follow a written text, his allegories show a system that refers to a lexicon outside the painting. A substitute text, so to speak, is provided by the *Hieroglyphics* of Horapollo, and later the *Iconology* of Cesare Ripa, an index of pictorial motifs that may be codified into a painting so as to signify certain abstract themes. This procedure often remains even for Mantegna's venturesome later contemporaries like Piero di Cosimo (1462?–1521?), whose stories and allegories alike, though deliberately remote, are usually decodable, as Panofsky has demonstrated.[13] Only rarely, indeed, does Botticelli himself not follow a text or build on such allegories as those in *The Calumny of Apelles* (with an important modification, as Panofsky was the first to notice)[14] or the Villa Lemmi frescoes (where, however, one can be identified as presenting the Seven Liberal Arts, while the other, a woman with scarf or veil who is approached by four others, cannot be identified).

Most of Botticelli's great contemporaries took the textual situation pretty much as they found it and concentrated their supreme attention upon the modifications, refinements, and revelations that painterly or sculptural means could bring a text to yield. Leonardo (1452–1519), like Piero della Francesca and others before him, wrote systematically on the technical resources of the painter. Along the lines of such traditional emphasis, Leonardo was able early in his career to block out an *Adoration* (figure 3) in which a suggested shadowy universe of beings, built on the known text (Matthew 2:1–12), assembles round the Holy Family. In the strenuous spatial involutions of this work, the Holy Family is crowded round, leaned toward, and stared at by an intense assortment of beholders, ringed off by a vague earth ridge in an unbroken arc running nearly the length of the picture, while a contrasting pair at either side, Old Man and Youth, seems somewhat oblivious of the others. Up behind them all, still others are carrying on mysterious activities. They are backed by a scaffolded structure, pointed more to the future as a half-completed building than to the past as a ruin, but also eliding into dream through the unfinished staircase that dominates its right side and the center of the painting, beginning almost at a tree that rises centrally from a point far from but slightly above the Virgin's head. The syntax of this tree,[15] for all the complications, must be taken to belong to "Adoration,"

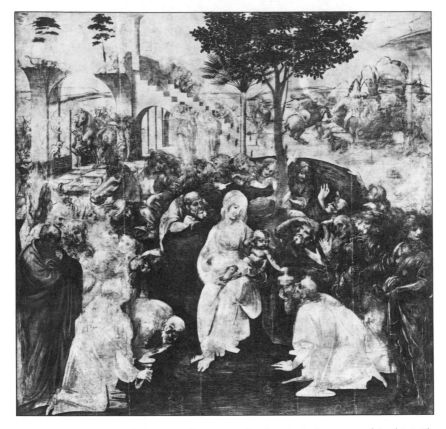

Figure 3. *Adoration of the Magi,* by Leonardo da Vinci. Courtesy of Archivi Alinari and the Galleria degli Uffizi, Florence.

as must even the powerful horses rearing at a distance and straining at an angle away to a point beyond the frame.

So, too, the Raphael (1483–1520) even of the *Stanze,* and the Dürer (1471–1528) even of the *Melancholia.* Michelangelo (1475–1564) invented vast projects that concatenated what were still iconographic staples, and even the fuller evolution that produced the strong iconographic modifications of the Morning, Evening, Day, and Night of the Medici Chapel followed the received tradition of relating the allegorical Word to the visual Image. Running a Creation across the whole Sistine ceiling so that the viewer must stretch strenuously to take in this primal heaven, and making classical and Christian permute intricately with one another[16]—still the extended symphony of these effects returns to the illumination of Genesis.[17]

This standard relationship between Word and Image was being modified, and indeed deeply changed by certain contemporaries of Leonardo, Raphael, Dürer, and Michelangelo. Botticelli (1445–1510), Giorgione (1476?–1510), Carpaccio (1460?–1523?), and Bosch (1450?–1516) redefined the significance of images so powerfully that their chief works have remained enigmas before the persistent and informed inquiry of a century of critical investigators. The change, to be sure, was being carried out in their work intermittently, hesitantly, and often only partially. These painters, like all the others, begin with the standard relationship of textual Word to Image and often stayed with it.

These painters, except possibly for the two Venetians, worked, of course, in full independence from one another, all in the period 1480–1510. Each achieved a breakthrough by incorporating signs in paintings in ways that this book will try to establish. For Botticelli, a cue both to the shift in his innovative attention and to its importance, is given by Leonardo, in an account that constitutes his sole mention of a contemporary painter by name:

come se non gli piace i paesi, esso stima quella esser cosa di breve e semplice investigazione, come disse il nostro Botticella, che tale studio era vano, perchè col sol gettare di una spugna piena di diversi colori in un muro, essa lascia in esse muro una macchia, dove si vede un bel paese, . . . E questo tal pittore fece tristissimi paesi.

As if a landscape does not please him, he reckons that to be a matter of brief and simple investigation, as our Botticelli remarked, that such study was vain, because just with throwing a sponge full of diverse colors against a wall, a spot is left on that wall where a beautiful landscape is seen . . . And that painter made the wretchedest landscapes.

The attribution, and the familiar "our Botticelli," in the light of Leonardo's scrupulosity, would lead us to see this as direct reportage. Botticelli makes a blunt attack that sorts ill with the graceful temper of his painting—so much so that we wonder if Leonardo is not registering his own profound disturbance rather than Botticelli's tone when his own very principles of "investigazione" and "studio" are being questioned. He is as much as saying "yes, and Botticelli's landscapes look careless enough to have had such a casual origin." Something of such a view must be suggested in "tristissimi," a strange superlative; Botticelli's landscapes, though far short of the perspectival *sfumato* of Leonardo, are neither that simple nor that bad. And so far as mood is concerned, in all his work, only the sky of *The Mystic Crucifixion* would qualify as "tristissimi."

It is revelatory, too, that the passage I have elided—one of Leonardo's famous statements of free-associating by looking at spots on a wall—occurs in this context associated with Botticelli. This association makes it a psychic Rorschach (the impetus to think of Botticelli) framing the enunciation of a physical one (the association of indeterminate spots with heads, seas, clouds, etc.):

Egli è ben vero che in tale macchia si vedono varie invenzioni di ciò che l'uomo vuole cercare in quella, cioè teste d'uomini, diverse animali, battaglie, scogli, mari, nuvoli e boschi ed altre simili cose; e fa come il suono delle campane, nelle quali si può intendere quelle dire quel che a te pare. Ma ancora ch'esse macchie ti dieno invenzione, esse non t'insegnano finire nessun particolare.

It is indeed true that in such a spot are seen varied discoveries of that which a man wishes to seek in it: that is, heads of men, diverse animals, battles, cliffs, seas, clouds, thickets, and other similar things; it acts like the sound of bells, in which you can hear said what appears to you. But while these spots give you discoveries, they teach you to finish nothing in particular.[18]

The shift here from third person to second person, and from a singular spot to plural spots, indicates Leonardo's absorption; and the desire to finish something particular for this famous hesitator must be some admonition to himself as well as a prescript to others. The list of possible *invenzioni* in the spots, both individually and as composites, itself suggests the staple figures in many of his paintings. All this comes up as he is gathering his force to qualify the work of Botticelli. One cannot get a finished particular work from such free association, Leonardo asserts—and it is only the painters after Romantic times who would try to do so. Botticelli himself, however—and here Leonardo implicitly may be said to miss the mark—is original enough to follow neither the practice in Leonardo's paintings of composing a work from a prior text nor the practice that Leonardo here abjures of painting directly from free association. His third, original mode is to combine and transcend these procedures.

This emphatic negative quotation gives us the clue to what Botticelli was up to. If he was not profoundly modifying the rendering of image, he was redefining the relation of his images to a coherent discourse outside the painting—and also consequently, I shall argue, within it.

Take the example of Botticelli's *Primavera*, which I shall examine at greater length in my first chapter. There have been many attempts to make elements in that painting refer firmly and without much modification to an external written text, as though Botticelli were still, if in a

somewhat more obscure way, following the old canons. Aby Warburg, with much less than full persuasiveness, finds the action of the three figures at the right of the *Primavera* (plate 2) to draw on the metamorphosis of Chloris in Ovid's *Fasti* (5.193–214).[19] The Wind figure who grasps the Nymph with the face turned up and back is supposedly Zephyrus. She is supposed to be Chloris, who will be—or is (a difficulty already presents itself)—metamorphosed into Flora, the nearly dancing, tall figure in flower-woven robe. The hands of the Nymph do overlap the dress of "Flora," though without touching her. Yet if these are to be the same person, the features of the two women are quite different; the Nymph has a distinctly upturned nose that the straight-featured Tuscan beauty of "Flora" wholly lacks. Allowing for the garments, the hands and arms of "Flora" are slenderer than those of the Nymph. And the Nymph's lower calves are a shade more robust than "Flora's" slender ones. But closer look-alikes for either of them can be found among the other four women in the painting.

Certainly the *Fasti* of Ovid is much less commonplace than Scripture, and it requires a fair amount of faith to assume that a painter of little education though great intelligence would have turned to such an out-of-the-way text. To be sure, Angelo Poliziano gave lectures on such subjects at the time, but can we be sure that a busy painter would have attended them? But allowing for Botticelli's relation to the circle of Ficino through Poliziano—itself largely conjectural—we may assume that he could have read the text, and still we would face a number of such difficulties. We would also have to assume that a metamorphosis takes place in just a part of the painting before our very eyes. Such a representation would be unique in all of Botticelli's work, except for his illustration of Inferno 24, where a metamorphosis is described in Dante's text. To posit two different time moments for "Chloris" and for "Flora" would entail positing a special time relationship for just this one segment of the painting. The paintings—usually of saints' lives by Botticelli and others— that do show a series of temporally discrete incidents in the same canvas do so evenly throughout the picture and without time-jumbling for a given segment.

Were we to accept this source in spite of all the difficulties, we would still be obliged to coordinate the Zephyr-Flora-Chloris story with the rest of the painting.

For the "spring" of his *Primavera*, Botticelli has in fact drawn on a large repertoire of multiple sources,[20] just as the poet Poliziano, with far less inventiveness, had done for his *Giostre* and his *Orfeo*. In addition to the questions raised above, the very fact that Warburg is able to find par-

allels in Niccolò da Correggio and Boccaccio as well as in Ovid and Poliziano should put us on our guard against singling out some specific source to provide a story for even part of the *Primavera*.

Visually, the nine persons form an easy, graceful, and varied chain across the middle of the painting, while what they signify divides into at least four realms that would require a fair amount of deduction to connect: there is the trio already discussed, then Venus along with Cupid—who aims at an unusual target, at the next group to the left, the Three Graces. And finally on the left side is Mercury, who stands fairly alone. These four areas form no "sentence" of simple discursive affirmation about the glories of spring, eternal blessedness, spiritual harmony, or the union of earthly and celestial Venus, though all these suggested themes do somehow bear on what the painting communicates. Each of the four areas taken separately is drawn from a complex and somewhat elusive iconographic tradition. Taken together, they echo no story or allegory anywhere. And of all these nine persons, only one is possibly a mortal, the Nymph. The connections among their groups is at least rare, since Venus is not normally shown along with the Graces, Mercury with either, and still less Zephyrus or any wind with all of them.

The trees also, taken as signifiers, diverge in their look and functions. The orange trees, Hesperidian in the typology of the time, spread across the garden, broken at the left by a laurel of Apollo that is not in bloom but withering, and Zephyr breaks forth from it. The myrtle, typologically linked to Venus, stands behind her more remotely and in less sharp focus than the orange trees that shade the Graces. Mercury holds his caduceus up to the orange trees in a way that engages him more with them than with the other personages. The trees, as befits a garden, verge in their greenness at the same time toward a greater homogeneity than can be constructed for the divergent personages. As Trees they hold places assigned them in a very full lexicon of paradigms. As a garden, the wall of trees suggests the *hortus conclusus*, the enclosed garden of medieval typology, shutting in the enraptured participants. Yet the 1982 cleaning reveals elements in it that also suggest the opposite, a *hortus apertus* or open garden. Behind Zephyrus, mountains and clouds are clearly visible through the boughs, and in the interstices behind Mercury there can now be seen mountains, fields, and a river beyond. In the light of these spatial cues, the garden would seem to be elevated, and even on a mountaintop, in line with such traditions as those governing the mountaintop Earthly Paradise of Dante's *Purgatorio* 28. And thus the syntagm of the internal connections within the *Primavera* modifies itself. Here, as typically in the

Mythologies of Botticelli, there are sometimes too many signifiers imposed upon a figure, and sometimes too few, but in any case the syntagmatic possibilities are energized, rather than simplified, by being disrupted. As the tone of the painting tells us, they are harmonized and disrupted all in one motion.

To continue with Bryson's terms, a still life would stand as a sort of opposite to this particular text-free painting. For if in still life the syntagm "reaches its climax," then still life also simplifies not only the paradigm but the items to be coordinated. Botticelli has already devised another way to allow the syntagm to reach its climax, without at all reducing his paradigmatic components, by freeing the painting from a specific external text. Botticelli is neither "discursively saturated" nor "discursively drained."[21] He plays off draining (the lack of a textual referent) against saturation (the multiplicity of iconographic sources for a single figure, the divergence of signifiers for the syntagmatic connections among them). Leonardo includes an almost Chardin-like still life in a detail of the table setting in *The Last Supper*. Botticelli, by analogous significative procedures, endows the *Primavera*, through the enveloping garden, with a still-life calm that grounds and aerates the energies of its figures.

Botticelli, then, uses prior signs to put together his own code, as do Giorgione, Carpaccio, and Bosch at their most emphatic moments. Even in their traditional works, indeed, the invention of a new code presses upon the painting, as it does in Botticelli's *Mystic Nativity,* Giorgione's *Judith,* Carpaccio's *Saint George Slaying the Dragon,* and Bosch's Lisbon *Temptation of Saint Anthony.*

Again, stories provide the reference for paintings in the mainstream of medieval and Renaissance practice. Leonardo and Alberti, among others, use the term *istoria* to designate the subject of a painting. But Botticelli's great originality lies in coordinating the multiple elements, the varied and rich icons, for the *Primavera* in such a way that no story can emerge. Botticelli has changed the signs.

The Presence of Botticelli

Apainting like Botticelli's *Primavera*, even if it told a single story or set forth a coordinate allegory, would still break the frames of expectation at its time.[1] Large pictures of such dimensions representing peacefully occupied figures had a religious orientation, while the *Primavera* celebrates secular intimations. It takes the expected religious orientations and refers them to the actualities of his secular figures, that in turn suggest enriching spiritual possibilities, by a similar process, though from a different starting point and in another medium, to the way Ficino, and later Pico della Mirandola, domesticated Plato to uses that were or could easily become Christian. Even if we accept the by now conventional, but still largely conjectural, connection between Ficino and Botticelli, that allegorizing philosopher's system does not provide a stable and coordinate set of signifieds for the signifying figures in the painting.

Even allowing that Botticelli and Ficino share a common spirit and may have known one another through a common patron, the philosopher's system is too elaborated, and at times too quirky, to have provided an explicit text for the painter here. The *Primavera* draws most patently on such classical motifs as the dancing Graces and on such themes as the Hesperides. The union of body and spirit that the *Primavera* celebrates, as distinct from the thrust of Ficino's system, implies a preexisting Christianity. On the other hand, it falls somewhat short of reconstituting a Christian reading of what may here be called a *hortus apertus*, an open rather than a closed garden. And the physical situation in the painting, a wall of trees with mountains beyond, is both open and closed. The modality that could bring the philosopher's system into harmony with the coordination of figures in the painting would have to be attenuated to the point of impoverishment. In the light of the "Botticellian" women

who figure as Virgin and Venus alike, the Neoplatonic elements are partial at best, and they are handled differently from group to group in the painting—which can confidently take the title *Spring* only if we accept the description of Giorgio Vasari.[2]

Botticelli does not simply refer outside his picture to some single system or story. Rather, he strikes a commanding balance between the complex but lightly indicated figurations in his imposing bodies and a repertoire of lexical and narrative cues. These cues do not thrust their disparities upon the viewer because he is drawn into the formal harmonies of the picture. He is kept moving evenly through the entwining figures because Botticelli has stayed frontally quite close to the picture plane and largely eschewed the perspectival resources of his time. The open blue sky revealed more strikingly by the recent cleaning (1982) modifies the painting's frontality, but without giving perspectival importance to the relatively little shown of the bare sky. In the *Tempesta,* Giorgione leads the viewer's eye off to the towers of a receding but not too distant town, up to dark clouds and a tiny flash of lightning, down off through the shrubbery-obscured trickle of a disappearing stream. Instead of availing himself of such mysteries, Botticelli sets his figures out forthrightly under the forthright flourishing trees, upon a variegated carpet of flowers. The homogeneities of the setting, and the dancelike order of the figures, set the profusion and the disparities of lexical possibility both at odds and at rest.

As Lyotard, Rudolf Arnheim, and E. H. Gombrich have variously shown us, the visual apprehension of a picture is itself a constructive act. This act interacts with the assignment of an iconological syntax to the picture. Botticelli arrests the second process in two ways. First, in the iconological domain, he recombines the cues of an individual figure: Venus, even if she be Venus Urania, is unusually austere. Then, still drawing on the vocabulary of given significations, he produces a "sentence" from signifiers not usually associated with one another. Cupid is not usually associated with Venus Urania, or at least not by shooting the flaming arrow at the Graces, who in turn are not usually thought of as marriageable[3] or of being targets for Cupid. Second, in the pictorial domain, he minimizes these lexical differences, and the viewer is brought, paradoxically, to a sense of refreshment and repose not wholly discordant with the overall similarities of the figures. All of them, whether half-clothed or festively clothed, accord with the temper of the springlike Hesperian grove. They stand in an even light, a friezelike planar presentation of processional bodies.

Instead of having the expressive qualities and pictorial elements in the

picture reinforce the iconological elements, Botticelli induces a sort of dialectic between the two. This dialectic may be said to enlist, but not to be resolved into, the viewer's necessary constructive acts. While miming those constructive acts, Botticelli's dialectic between the pictorial and the iconological arrests their mutual reinforcement. At the same time he produces a celebration of their continuing interaction and of their completion in the pictorial. The pictorial becomes paramount for making external iconological references less than final. The viewer is at once, so to speak, charmed into a dreamlike state by the self-sufficiency of the picture and enlivened into pleasurable wakefulness by the different registers of signification that the iconographic cues of the figures suggest. Faced with the easily graceful fusion of serenity and energy in the best-known Mythologies of Botticelli, in the *Primavera,* and in *The Birth of Venus* too, we are presented with a visual harmony that should not, then, be resolved back into some elusive iconographic code.

Yet at the same time it would be captious to impoverish Botticelli's paintings by wholly refusing the possibility of such carefully worked-out conjunctions. Referring the figures in these paintings to classical traditions, or to some version of Ficino's philosophizing, would have the effect of enriching their range of reference. So to relate them to other contexts of discourse would enrich the paintings so long as we were not, in effect, composing some equivalent for the later recipes of Ripa, that staple dictionary of allegorical constituents.[4] The spirit of Ripa would lock these paintings of Botticelli away from the hovering suggestibility that the veils, the enigmatic smiles, the splendidly dancing bodies seem richly to be producing. A Ripa-like reading would also have the effect of reducing the rich disparity of Botticelli's potential sources. And it would flatten out the dialectic implied in their innovative mode of signification.

The very newness of Botticelli's Mythologies in the iconography of Renaissance painting, the boldness of the integral scenes they present to us, should put us on our guard against reading their relation to various verbal sources as passively following the relation of word to picture in other paintings. Again, much of the painting in the Middle Ages and the Renaissance has the character of the elaboration, if not the bare illustration, of a prior text: it refers to Holy Scripture. But the Mythologies do not directly, simply, and unequivocally refer to a single such text. They may incorporate many texts, and they do so differently from a painter's rendering of such a subject as the Adoration of the Magi, whether Botticelli's or another's. In such a painting, traditions have been cumulatively built from a single text of maximum authority, in this case a passage from

Matthew (2:1–12). In Botticelli's Mythologies, dubiousness of connection, the miscellany of conflation, the forceful visual unity of the particular painting—all would qualify the presence of the verbal significations.

Those verbal presences would, by a seeming paradox, work energically in the Mythology of Botticelli, whereas the very certainty and authority of the scriptural source make its words comparatively inert for the painting of sacred subjects. We need not attend to them. "Madonna and Child" as a subject has a distant and blurred source in Scripture, "The Baptism of Christ" a proximate and specific source. But this difference of relation to the scriptural text hardly matters. We may confidently treat as more or less inert, and ignore except for details, the particular character of relation to Scripture, which remains fairly steady for the various Madonnas of Margaritone, Piero della Francesca, Raphael, Leonardo, and Rubens—for all their other differences. In their relation, the pictorial qualities and the iconographic integers simply—and so somewhat inertly—reinforce each other. That relation is not, interestingly enough, inert in quite the same way for the Madonnas of Botticelli, a question I shall return to.

If on Lee Baxendall's showing, the early Italian humanists, and even Leon Battista Alberti, tended to describe a painting as though it were a periodic sentence, that may tell us as much about the humanists as it does about the paintings.[5] The term *istoria* is used by both Alberti and Leonardo, among others, to refer to the subject of a painting: it is assumed that the painting incorporates a story. The *Primavera* and *The Birth of Venus* do offer a vague analogue to a paratactic series of sentences: the groups in both paintings are arranged horizontally across the picture, groups difficult to bring into relation logically one with another, which at the same time coexist easily in a sort of mobile unfolding of similarities one to another.[6] Suggesting the presence not just of one story but of at least two for each painting, this variety of stories implies also the supersession of the stories by the presentational homogeneity of the figures: they render possible stories dialectically subordinate with respect to themselves.

Gombrich, in his elaborate presentation of the bearing of Ficino on the Mythologies, adduces decorum as a governing principle[7] for Renaissance painting generally. Yet the very newness of the Mythologies must be taken as modifying the principle of decorum. And if, as Gombrich says, "Ficino and his friends rejected the [Ripa-like, we may say] potted versions of the medieval mythographer,"[8] it would be strange if Botticelli, in his own right, were to have turned Ficino into the potted versions he is said to reject. Gombrich admits that as much adjustment would be needed to apply Ficino to the Mythologies as to combine him with other

quattrocento sources.[9] As he well says, "The Graces in the 'Primavera' must have been surrounded by an aura of potential application and still-to-be discovered meaning which may be just as essential for their understanding as the significance they had for the initiated."[10] We may leave the initiated in the quattrocento and say that the aura of potential application *is* essential to the understanding of these paintings—potential application not only of the manifold potential verbal sources but of their dynamic interaction with the moderately contradictory simplicity of the visual presentation of the painting.[11]

There is no authentic vocabulary, Gombrich reminds us through Saint Thomas, for translating things into signs.[12] Things differ from words, but painted things would have the double character of removal from the object of representation—a removal much discussed by the Plato who was Ficino's master—and a closeness to the object that words cannot achieve. In the Nardi Altarpiece and in the *Mystic Nativity,* Botticelli innovatively incorporates words other than scriptural into the text. Thereby he engages the syntax of language to point, and at the same time to be overwhelmed by, his dexterities of pictorial and iconic combination. In his Mythologies he suggests the need for words, puts given texts to a rich possible use, and supersedes the need for words, all in one sweeping gesture of presentation. The act of presence is made imperiously to ride, finally, on itself, for its very embroilment in a multitude of other possible lexical indications.

The Mythologies, like all the paintings we have, exist in a context of prior paintings, including those of Botticelli. They also draw on a variety of iconographic staples for particular representations. Beyond this, the verbal context in classical literature is so rich in its parallels to what Botticelli has mounted—and successfully conflated—that a number of plausible passages from various authors has been adduced. In addition to specific Ovidian possibilities,[13] the *Primavera* in its graceful intertwinings, and in its playful profundity, possesses what may be called a general Ovidian temper, as opposed to a specific Ovidian reference. Since it is a country scene, the tradition of *carmen rusticum* can be adduced, and even spelled out, with reference not only to Vergil's *Georgics* but to Columella's *De Re Rustica.*[14] Lucretius' Venus has been brought to bear on this painting and on *The Birth of Venus.* Seneca on the Graces has also been adduced, as have Theocritus, Hesiod, and even Apuleius.[15]

Ficino declares in the *Commentarium in Convivium* (2.8) that the lover sculpts the figure of the beloved in his soul; he does so in such a way

that the spirit of the lover is made a mirror wherein the image of the be-loved shines back. ("Amans amati figuram suo sculptit in animo. Fit ita-que amantis animus speculum in quo amati relucet imago.") The defini-tion is redolent, indeed, with suggestion for helping a viewer find his way to the sort of atmosphere in which Botticelli's Mythologies are created.

Through Ficino, Plato can be made to hover over these paintings. And as for Ficino himself, we may choose specific mythological figures, the general principles of mythology, or the conjunction of mythological fig-ures in the reinterpreted legends or in astrology.[16] Once we are liberated from a univocal application of their work to Botticelli, the step from Ficino to Poliziano is an easy one in quattrocento Florence, and details of that poet's *La Giostra* do correspond, somewhat loosely in some cases but tightly in others, with details of the *Primavera*.[17] But Poliziano's focus is quite different from Botticelli's. He is recounting the circum-stances of celebratory games, with quite a direct series of compliments to Giuliano de' Medici. And the very fact that the details Botticelli may have got from him are drawn from a common heritage of such details would argue against the exclusiveness, even against the particular appositeness, of Poliziano.

Still another sort of source has been offered—the Ripa-like system of allegory codified before Ripa in The *Hieroglyphics* of Horapollo and al-ready even more elaborately exemplified in the *Divina Commedia*. Bot-ticelli did indeed illustrate the *Divina Commedia*, but there is no evidence that he subserviently governed his representational system by such ty-pologies of figuration. And the suggestibility, the aura, the almost tactile presence, of his painted personages would argue otherwise. It is implausi-ble that he would have proved himself sweepingly inventive at the peak of his career, and then stopped short; that he would have broken strikingly new ground for the whole conception of a painting and then constructed on that new ground a building strictly governed by old plans.

In representing the Graces—one of the main constituent groups of the *Primavera*—he may very well have drawn on Alberti, as scholars have argued. The Graces are traditional, and by this late in the quattrocento Alberti's treatise would have been well enough known for his recommen-dations on how to render the Graces to have had suggestive power.[18]

Equally influential, we may be confident, would be the intangible but strong spirit of the Medici circle and Ficino's ambience. There is a festive air about these paintings not wholly to be attributed to the secular spirit of the aristocrat at play in his country villa—or in his town house. The

inspiring beauty of such specific women as the legendary Simonetta, even
if she is not specifically represented in the paintings, might also have
played a role.[19] And in addition to specific philosophical ideas, the very
climate of philosophizing might have furthered the growth of new iconic
speculation about what would be proper for painting.

All these possibilities become absorbed inside the single consciousness
of the painter. They are at once transcended and embodied—*aufgehoben*
or sublated, and more than sublated—in the objectified act and splendid
presence of the paintings themselves.

For measuring the role of circumstances, traditions, and thought sys-
tems on Botticelli's iconographic presentation in the *Primavera,* an es-
pecially sharp case is offered by Edgar Wind's ingenious and forceful cor-
relation of its figures with a contemporary harmonic system:

If one takes the full system of Ficino's ["permutations"] into account . . . in the
case of the *Primavera,* the spectator was probably meant to sense that the group-
ing here so clearly dominated by Venus and guided by Mercury was capable of the
Apollonian translation (into a triad of these gods through astrological conjunc-
tion), of the kind proposed by Ficino; and of this there is an example in a contem-
porary musical source.

At the top of the frontispiece to the *Practica musice* of Gafurius, which pic-
tures the musical universe, Apollo is so placed that the Three Graces appear on
his right and a pot of flowers on his left. The latter attribute looks like a gra-
tuitous ornament, but when we remember from the *Primavera* how Venus was
placed between the Graces and Flora . . . we may suspect that Apollo was to be
endowed with a similar inclusiveness of powers. The correspondence becomes
more explicit in the system of musical intervals . . . explained in the book. Here
the note associated with Apollo or Sol is again placed 'in the centre' . . . but in
such a way that there are three notes below it and four notes above . . .

$$8765 \quad 4 \quad 321$$

The resulting division of the octave, with the fourth note treated as central and
the eighth as transcendent, and the remaining six forming symmetrical triads, cor-
responds very closely to the composition of the *Primavera.* It is possible therefore
that the painting was meant to carry a musical suggestion, the eight figures repre-
senting, as it were, an octave in the key of Venus. Transposed into the key of Apol-
lo, the highest note of the octave would belong to the muse Urania, who was fre-
quently represented turning away to gaze at the stars," etc.[20]

Now all this, taken just so, is almost equally apposite and far-fetched.
Under the spell of these identifications we need to remind ourselves that

Apollo does not appear at all in the *Primavera*, that there are eight figures in it only if an important ninth, Cupid, is discounted, and that Wind overreads in a very specific direction the roles of Mercury and Venus. Far from being in conjunction, they are at quite a distance from one another in the painting. Mercury's role, actually, is even more obscure than Venus'. Yet the notion of musicality seems apt for the painting not only because the Graces are dancing and because a harmony of sight so beautifully spreads over the picture. The very groupings of persons could be taken, if somewhat distantly, as analogous to the groupings of notes in sequence. The sense of connectedness, of something uniform running through the group of the *Primavera,* is pronounced for a series of persons so horizontally organized and disparately associated. And it is fascinating that just a step from Ficino a musical treatise can be found with both classical-astrological conjunctions and the octave numbers to be stretched over the figures of the painting. Yet the whole identification suggests an ambivalence that, finally, is foreign to the assuredness, the felicity, of these grouped figures. It is too univocal in implication, and so it slights Botticelli's important transposition of all such significations to what has to be secondary status. The visual insists on its predominance over such references.

What, then, are we to do with all these possibilities as they hover over the *Primavera?* Musicality rises in the *Primavera* like a bubble about to burst. Keying the musicality to a specific music, note by note, would burst the bubble or encase it in an intellectual plexiglass. It would return Botticelli to the simple significations of his predecessors.

The term *poesia* is used by Titian of mythological painting, and part of the newness of Botticelli's painting here is to move the work from *istoria* to *poesia,* to blur and cross the possible lines of reference to one mythological story in order to body forth a perceptible essence of a mythological repertoire generally, just as Titian and Giovanni Bellini did on occasion also. The visual is made to do duty as something that can enlist and recombine significances as well as refer to them. The groups themselves are not quite symmetrical, as Heinrich Wölfflin and others have noted, though overall they convey an air of symmetry. Venus, clothed in her less common tradition, stands a little to one side of center and a little above the line of others. Her body, too, is more slender and less weighty than any other, as though she stood simultaneously a little above them, some-

what out of their full-bodiedness. At the same time she would dreamily stand for what gives balance, poise, and a nascent ecstatic energy to their presence. All in all, the groups in the *Primavera* would seem, then, to violate and transcend Wölfflin's distinction between closed and open form, between a-tectonic painting that refers its dissymmetries to a world beyond itself and to the enclosures of tectonic painting that funds all the figures of the painting inside its own organized boundaries.[21]

The four groups all belong to different domains, and it requires a strenuousness of reconstruction to relate them one to another, a strenuousness at odds with the serenity of a painting that is not busy, that does not suggest the intricacies of, say, Leonardo's *Adoration*. We have, from right to left, the group of Zephyr, the Nymph ("Chloris"), and Flora—a group that adjusts quickly from the vigor of Zephyr to the serenity of Flora. From there on, the painting is predominantly serene, except for Cupid, who flies above, aiming the flaming arrow at one of the Graces. Next in order is the clothed, abstracted, vaguely gesturing, self-contained Venus, a group of one. And next come the Graces themselves, dancing self-absorbed in a pattern of harmony quite different from the transmutations of mood in the group on the right. They are most like the Nymph of that group. But the Nymph is more heavily erotic—her shaded pubis is large and prominent under her veiling. We can get logically from the Nymph to the Graces only, so to speak, through Venus, or rather the idea of a Venus not too removed from a Ceres, or from a Mother not only pandemic but positively devout. Such a mood would sort well with the implacability of this Venus. She has the severely sweet and impassive look common to Botticelli's women, maidens and Virgins alike.

A group of three, a group of one, a group of three, and another group of one formed by the Mercury figure, who stands self-confident, looking away, a little up to the clouds. If he is driving them away, as some say,[22] he is doing so indolently—so much so that he stands as a kind of antithesis to the blue, onrushing Zephyr at the other end of the painting, his blue brow deeply furrowed in pained concentration and effort. Mercury may conjoin with Venus, but not with Zephyr. Cupids don't shoot arrows at the Graces. The triangle of male figures (Zephyr, Cupid, Mercury) contains but does not triangulate the six women, who, in a sexual division, are grouped two-one-three, asymmetrically. The males somewhat restore the symmetry, creating a group of nine that, for all we know, could carry some distant hint of the *Enneads* of Plotinus—where does one stop in applying Ficino to Botticelli?[23]

The right-hand group of three is linked in a rapt conjunction that pulls

them away from the others. The Nymph does almost touch Flora's veiled left arm with her own nearly bare left hand. And there is continuity of flower broidery from the open leaves and small blossoms miraculously issuing from her parted lips onto the embroidered flowers of Flora's gauzy, flowing garment. The flowers continue into Flora's lap and her other hand; she is strewing roses. The flowers embroidered on her garment are "carnations, cornflowers, and a third flower too stylized for identification."[24] From the Nymph's lips are streaming white flowers, roses, and cornflowers. Flowers of magical production barely match the flowers of erotically heightening ornament. Flora herself seems unaware of the group in which she moves. She stares blithely, almost dreamily, ahead into space as she softly and richly strews her flowers. She is the only figure of all who offers a full frontal view. In size, in ornamentation, in her combination of isolation and conjunction, she is more prominent than Venus herself, and arguably the central figure for whom Venus is a centralized, more removed, more abstracted, and even more constricted doublet. Flora and Venus pose in ways more like each other than they are like any one else, so far as their isolation-in-the-midst is concerned. Mercury is totally isolated. Yet Flora's flowing drapery and air of poised nobility is shared most with the Three Graces.

The Nymph does not look at Flora either, and seems also unaware of her, as though she were a dream issuing from the spirit of the Nymph, just as Venus seems a dream issuing from the spirit of Flora. Instead, the Nymph looks back at Zephyr in a gaze that some have taken for terror or fear but may also be taken for yearning and acquiescence. The tilt of her face, indeed, can be found very soon, but little modified, in the enraptured women of Titian. Her posture is conventional in antique representations that Botticelli probably could not have seen on vases or elsewhere. It is a conventional posture for a nymph pursued by a satyr, and there is no reason for us not to take the flowers issuing from this Nymph's mouth as fortifying her air of sexual readiness, especially given the markedly prominent pubis revealed by the legs parting for what has perhaps begun as hesitant flight, legs parted so shallowly they could easily be slowed for consummation.

No one else in the painting presents the Nymph's strong sexuality—least of all Venus, the most fully draped and clothed person in the painting. Mercury accords with this somewhat, since all of his left side is naked to the waist and his thighs as well, a mingling of the draped and undraped of which Donatello offers still more extreme examples. His cloaked right shoulder and bared left shoulder repeat exactly the disposi-

tion of Zephyr, whose figure is so wind-blown that the cloak tucks up almost under his left armpit. Zephyr, too, is withdrawn from the color harmonies of the other figures; he is all blue-green: cloak, face, hair, and body. These two male extremes emphasize the division of the whole canvas into figures of pressured mobility on the right and of graceful immobility on the left. Zephyr and Nymph, in their struggle-approach, balance the three Graces in their rapt dance, whose slowness is indicated by a far lower velocity of wind moving their drapery.

Venus is a puzzle, gesturing with a hand that seems to refuse as much as to partake of motions that for all the others involve partially exposed bodies. The ideal of Venus Pandemos or Venus Urania will not fully account for the attributes presented here.[25] Nor can she easily divide; there are no iconographic cues leading in this direction, only the text of Ficino. It would be impossible to align Ficino's definition of the double aspect of Venus with the Venus of either the *Primavera* or *The Birth of Venus*. "Thus Venus is twofold," he says (*Commentarium in Convivium Platonis De Amore*, Oratio Secunda, 7.17v–18r). "One is clearly that intelligence which we have placed in the angelic mind. The other the force of generation attributed to the soul of the world." (Denique . . . duplex est Venus. Altera sane est intelligentia illa, quam in mente angelica posuimus. Altera, vis generandi anime mundi tributa.) The clothed Venus of the *Primavera* is no intelligence, and the term *angelic* is quite remote from the presence she offers, even if we accord her a predominantly spiritual force. Still less is the Venus of *The Birth of Venus* a *natura naturans*, a generative force in nature, even if attributed to the *anima mundi*.

If Botticelli imitates anything in Ficino, it is the energetic freedom of Ficino's combinatory play among the classical myths and the ideas of Plato. He in no way parallels, nor can he really be said to adapt, the arbitrariness, the particularity, and the far-fetched extravagance of Ficino's individual interpretations. These characteristics, indeed, make Ficino's commentary on Plato's *Symposium* read not so differently from the random allegorical effusions of the many medieval hermeneuts who help fill the *Patrologia Latina*. It is rather the process of Ficino's thought that Botticelli's practice resembles, and not the details of its results. There is nothing to tighten up the looseness of the analogy to Ficino. The profusion of conflicting areas on the canvas fortifies and enriches the looseness in other directions. No more can Mercury be made a Hermes Trismegistus and enlisted in the complexity of myth that finds no counterpart or echo in the other figures here.

The lateral organization of the picture recalls the much more complex lateral organization in the *Youth of Moses*. The painting in the Sistine

Chapel depicts seven scenes separated and coordinated on a time line. The group figures zigzag more sharply, whereas those in the *Primavera* gently undulate from the flower-strewn floor of this forest.

The orange trees render the picture plane to a nearly two-dimensional frontality, closing off those distances of cloud and sky.[26] They also offer a homogeneous background, at once a spring and an eternal Hesperides,[27] for the enigmatic and certainly somewhat heterogeneous activities proceeding in front of them. This is tapestrylike in some ways; enough so to point the painting in the direction of the explicit narrative often involved in tapestry. But the background, prominent as it is, does not dominate nearly as much as the background does in tapestry. The figures are too prominent; they rise from the design far more pronouncedly than figures in tapestry do. And their perspective differs from that in tapestry.[28] They flow as much as figures in mosaic do. Botticelli later worked in both mosaic and tapestry, but it would seem without great success. His whole vision operates beyond the single-mindedness of both those forms.

The Graces look like diminished and less flamboyantly gowned cousins of Flora. They also look much like one another. They turn inward harmoniously upon one another, unlike any other figure in the painting. For this very reason, and because of the attention to the classical sources that name them and declare them to be so draped, an effort [29] has been made to characterize and distinguish them by attending to secondary features. Edgar Wind reasons them to be, from left to right, Voluptas, Castitas, Pulchritudo (which leaves the question of why Pulchritudo, rather than Voluptas, would most pronouncedly repeat the Nymph's shaded belly and pubis). Gombrich cites Warburg's identification of them with the figures in a Tornabuoni medal, where they are labeled Castitas, Pulchritudo, and Amor. He also adduces Pico della Mirandola's medal, with the slight variation "Amor, Pulchritudo, Voluptas." Alberti, he points out, adapts from Seneca a version of the Graces as "liberality": "One of the sisters gives, the other receives, the other returns the benefit."[30] Still others have attempted to disentangle three stages of married life in the Graces, from Virgin to Bride. Gombrich offers still further identifications from Ficino.

Of all these interpretations we may say what Gombrich generally says: "Our difficulty is obviously, not that we do not know any meaning, but that we know too many." He goes on: "There are not dictionaries in this language because there are no fixed meanings." But then he proceeds to apply to the Graces Ficino's principle of Platonic "multiplication" for mythical figures, a principle formed on the familiar fourfold allegory of the Middle Ages.

There is nothing fourfold about the presence, at once rapt and relaxed,

of these beautiful personages, hovered over by Eros in meaning as Eros himself hovers over them in sight. The visual, pictorial sense of the figures does not admit of such hierarchies, while at the same time it engenders a profusion of possibilities—rather than the usual certainties—for iconic signification. The *Primavera*, in its planar suggestion of roundedness and in its sinuous horizontal procession, gives initially a univocal impression; it has none of the energy of Leonardo, or differently of that almost exact contemporary, Hieronymus Bosch—or for that matter, of Botticelli's later *Mystic Nativity*. It does not at first seem to be combinatory, and it insinuates a gradual complexity of meaning only when the mind tries to match Mercury with the Graces, Cupid with Graces, Venus with Flora, Zephyr and the Nymph with all. Asking for identifications, we get them—in a profusion that assuages our sense of the harmony of the picture without really fully allaying the desire for a complete concordance, a simple key, or a unified story. The *Primavera* intimates a realm on which Venus would have some bearing, but it intimates meanings that would partially escape her in an ultimate independence not unlike that of the figures who surround her here. In the nascent dialectic of their relation to Venus that Botticelli creates, they can be taken as ignoring her wholly, or worshiping her utterly, or going about the business of assimilating, accomodating, aiding, and enjoying her—in a manner not too different from that of an observer of the *Primavera*.

The association of Venus with the spring, and supremely with May, goes back through Lucretius to the most primitive seasonal rituals. The orderly personages of the *Primavera*, however, evoke not only mystery but civilization, allowing an easy extension of Venus' summary erotic power into the "moralized planet" that Gombrich wishes especially to emphasize: "Venus stands for *Humanitas* which, in turn, embraces Love and Charity, Dignity and Magnanimity, Liberality and Magnificence, Comeliness and Modesty, Charm and Splendour."[31] Fair enough for the richness of overtones in the *Primavera*, and yet the painting does not admit of the transposition of this figure's significance too directly into such human activities. There is arguably not a single human being in the painting with the possible exception of the Nymph: all are allegorized mythological deities. The forces of the gods suffuse actual men as well as the anthropomorphic deities, though, and a heavenly Venus who includes chastity in her austere drapery here perfuses the earthly Venus for whom so fertile a spring scene is a fitting environment.

The spring itself is also an eternal spring; oranges are associated with the *Hesperides*. *Hesperides* was the name given to this painting in the

seventeenth and eighteenth centuries. There is gold in the hair, dress, and ornaments of the *Primavera,* though Botticelli gilds even more in *The Birth of Venus,* where the roses have gold hearts and the foliage is edged in gold. But just as the myrtle tree behind Venus carries at once natural presence and allegorical suggestion, so the other plants, while idealized, can be precisely identified, down to the tiny flowers besprent on the ground.[32]

Other quattrocento paintings of large bodies strung out horizontally across the canvas broach an austere univocality, a flattening of meaning in the fullness of sense. This is true of large works of Mantegna, Uccello, Ghirlandaio, and Botticelli's associate Pollaiuolo. If the meaning is not univocal, the largeness of the bodies bulks to pose a mystery emphatically, as in Piero della Francesca's fresco of the Queen of Sheba. "Bodies are part of the *istoria,*" Alberti says, and "bodies ought to harmonize together in the *istoria* in both size and function." In the work of Andrea del Castagno, even the single large body seems tilted on the edge of a mystery that it puffs out its chest to incorporate.

Venus, I have said, is the smallest of these bodies, and in some ways the least conspicuous of all. So much so that Vasari may have made a mistake and identified her with Flora here because, in speaking of two large Venuses of Botticelli, he mentions "women who are fairly nude," *femmine ignude assai.* He means the *Primavera* and *The Birth of Venus,* as he effectually says, "l'uno Venere che nasce e cosi un altra Venere . . . dinotando la Primavera." The whole aura of mystery in this painting, in fact, derives from the significative openness of this Venus, both in herself and in her relation to the other figures.

For the other, *The Birth of Venus* (figure 4), there is only a hint of chastity in the pose of *Venus Pudica,* a hint belied in the glorious spread of the golden hair. This great fall of hair, pitched and tossed by the wind according to the prescripts of Alberti, is an erotic presence in itself, all the more because the body has been rounded to a sort of abstraction not departing wholly from Gothic norms.[33]

The Birth of Venus received that title only in the nineteenth century, and the title has been challenged. It is rather an alighting of Venus after her birth. Certainly if it includes many of the details of that mythological event in a way that Poliziano recounts out of the Homeric hymn to Aphrodite, it also omits many of the details that Poliziano offers. And the prominent shell is an iconographic commonplace, needing not Poliziano. In particular, Poliziano makes a point of the prior event in the myth, the castration of Uranus and Venus' birth from the foam his genitals left on the waters. On the waters of Botticelli's painting there is no distinct foam:

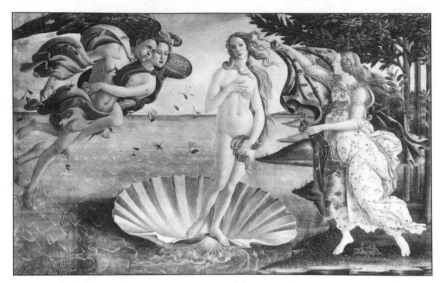

Figure 4. *The Birth of Venus,* by Botticelli. Courtesy
of Archivi Alinari and the Galleria degli Uffizi, Florence.

waves are far more pronounced, and the small white froths of possible
foam are no greater that those that waves would naturally produce. Ura-
nus, really, cannot intrude upon the splendid, self-absorbed moment of
this Venus. She is as emphatically central in this painting as the clothed
Venus is enigmatically marginal in the *Primavera*.

The interlaced blowing Zephyrs on the left ("lascivious" and "amo-
rous," if we were to apply Poliziano's words to them), who turn Venus
into the sail of the shell on which she rides, emphasize the momentary
focus of this painting. Here the dialectic of the spatial painting seems to
be set upon a temporal axis by focusing, originally and perhaps unprece-
dentedly, on a fleeting moment caught in an instant of time. The tran-
sitoriness of the moment works against the large, simple spatial assign-
ments of space to the broad areas of the picture, and also against the
reposeful, abiding, dreamlike bearing of its central figure. It is the mo-
ment just before landing, and the fine-tuned timing is also emphasized by
the Hour on the right, who stands ready with a cloak billowing out to
receive Venus, a cloak that must be precisely timed, to the second, for
unfurling so as to fall just right round Venus' shoulders as she skims into
land. The vectors of movement must precisely converge for the cloak not
to fall short or for Venus not to sail past too quickly to catch it.

The sides of the painting, then, embody a single moment. But as they converge to the center, they encounter the calm and grace of a Venus whose languid look and fixed pose show her capable of entering and maintaining a far slower rhythm than the one governing these attendants. The brunette Zephyr is so intense that his interlacing with the blonde one ravishes any amorous involvement, redirecting it as wind energy toward the Venus. She may be said to recycle the wind to its source, since she must inspire the act binding these two.[34] The Hour also is intense. Her flowing garment recalls the Flora of the *Primavera,* her dancelike step the Graces: she is all four women rolled into one, and aimed at the single action of sweeping the splendid, red, flowered cloak up over Venus. Venus looks frontally ahead, at neither of these intense groups. At her still center she transmutes the intensity from either side into a languishing softness imperiously framed and heightened by her luxuriant hair. This is so long, graceful, and docile that a thick strand of it curls heavily down to fit easily in her left hand. The lowest yellow strand trails off toward the sea, overlapping its service as an aid to the gesture of the *Venus Pudica.* The strand is so thick that its shape forbids a coy reading of display-through-hiding of pubic hair. In modest simplicity the pubic hair we do not see would have the same color; this is no fig leaf. But it would not have the same shape, texture, or thickness. The thickness of the hair sensualizes and de-eroticizes in a single painterly gesture.

The hair, taken all in all, emphasizes Venus' slowness. It is as though it were caught in a slower wind than the cloak held by the Hour or the heavily billowing capes of the Zephyrs, so lightly is it tossed to and fro. Its rendering may be traced to Alberti's recommendation for handling hair. Handled differently is the comparative and unrepresentational variety of winds from turbulence at the sides to near calm at the center. That, like the very conception of the painting itself, derives from Botticelli's pictorial, and significative, originality. This vision of a time deeply adaptive to serene presence and to an active but docile nature submerges all its sources in one gesture of peaceful celebration.

In the same chamber of Lorenzo di Pierfrancesco dei Medici's house in Florence, outside the bedroom, where above a settle the *Primavera* hung, there hung also above the doorway another mythological painting on a still more unprecedented subject, *Pallas and the Centaur* (figure 5). The fact that a *Virgin and Child* hung on the opposite wall

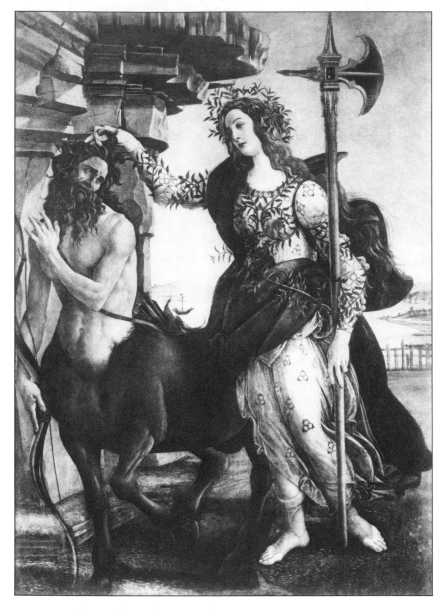

Figure 5. *Pallas and the Centaur,* by Botticelli. Courtesy of Alinari/Art Resource, Inc., New York, and Galleria degli Uffizi, Florence.

complicates the situational picture enough to turn our attention away from the social circumstances into which these three paintings were set.[35] The social situation that would permit such a mixture of types must have been relaxedly close to the aesthetic emphasis of the modern collector's home. Or, to put it differently, the aesthetic and philosophical aspirations were benign enough to be admitted as desirable expansions of a religious view confidently derived from some spirit other than the Savonarolan.[36]

Pallas carries a large halberd in this picture, not an offensive weapon like a lance or spear, the sort she might be carrying if encouraging an army. It is a weapon carried by guards,[37] and one of prominent bulk and height, being taller than either Pallas or the Centaur. But she does not use or wield the weapon. The halberd is not ported or brandished but gracefully and lightly carried, balanced rather, in the shallow crook of a nearly dangling left arm. It is virtually supported by its own weight. It is twined about by the ivy that continues its progress up over her breasts, around nearly all of her right arm in one direction, and around her head almost like a laurel crown in the other. Her large kirtled and billowing overcloak is much more prominent than the shield of nearly the same color just visible behind her back. Her posture, except that she leans forward to the right, much resembles the posture of Venus in *The Birth of Venus* or the rightmost of the three Graces in the *Primavera*.

Her most military gesture is the grasp by her right hand of a large clump—more than a lock—of the Centaur's hair. Were it not for the pained look on the Centaur's face and the fact that she is pulling, the gesture would have erotic overtones. The genitals of the Centaur are partially but prominently visible. Something like Reason overcoming Passion, or Civilization taming Savagery, dominates this painting, but its senses do not end there. Here, in still another dialectical twist, Botticelli offers a pair of figures who are firmly identifiable and patently allegorical, while leaving open what that allegorical combination might be. And he counterbalances the high initial clarity of this mythology by the restricted number of two figures so large that they almost recall the outsize personages of Andrea del Castagno. The Centaur holds his bow rather loosely; he is not close to shooting because the bow is slack and the quiver of arrows is slung behind his back almost out of reach and out of sight. Pallas has a strangely contemplative look; she is not intent on her action, she has gathered no forces for it. Nor does her grasp breathe the quick of a single moment, as does the Hour's spreading of a cloak for Venus in *The Birth of Venus*. The Centaur looks back and up, not quite at her, in sur-

prise as well as in pain at an action that seems almost more gratuitous than it is emphatic.

The Castagno-like scale of these large figures emphasizes their dominance of the scene. But in the irregular oval formed by the torso and back of the Centaur, the arm and side of Pallas, tiny but distinct in the virtual center of the painting, is a sailing ship with a bare mast and oars just visible. This ship rhymes with what frames it, the hair of the Centaur. The pale blue of the calm water on which it rides gives it still greater prominence. Beyond is a mountain, and on the shore at the extreme right a town. The Centaur stands at the edge of plain, nearly Doric pillars facing a rugged part of a building that seems to be won out of the living stone that tops it and scarps its side. The naturalness of the top is highlighted by the presence of a mosslike vegetation covering the top and dangling down over the pillars. Nature and Culture, Civilization and Savagery interfuse constantly in the objects of the picture, if the persons do broach the allegorical starkness that the very curiosity of their encounter helps to imply. Still, the pattern on Pallas' dress is a Medici design; in social context this would be a compliment. In signification it introduces, faintly but unmistakably, still another complication. Pallas, no doubt, is on the side of the Medici, but the masculine hunter she momentarily tames cannot be placed in antithesis to Lorenzo the Magnificent and his younger namesake who commissioned the painting.

Another such strange encounter, for figures on a still larger scale, is the *Venus and Mars* (figure 6); these figures recline in opposite directions almost without touching. Their initial designation, too, is boldly simple; their final signification mysterious. Mars is fast asleep in the unnatural

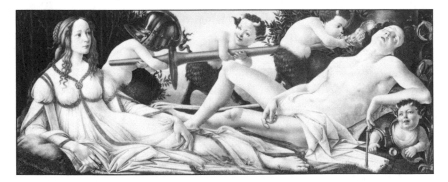

Figure 6. *Venus and Mars,* by Botticelli. Reproduced by courtesy of the Trustees, The National Gallery, London.

posture only a sleeper would maintain, and the touch of his right foot on the left, clothed thigh of the alertly wakeful Venus derives as much from pure accident or careless erotic aftermath as it does from the courtly caress. She looks at him imperiously and questioningly, with a more pronounced expression than that of the other two Venuses, or for that matter of any figure in the other Mythologies.

Yet she is clothed, abstract, and self-contained like the Venus of the *Primavera*. She looks toward the conch-blowing faunlet as though directing her attention to him. Her fully clothed body is entirely free of the languid, nearly nude Mars, though her right elbow leans on a gold-broidered and banded pillow of a rose reminiscent of the rose tinge to his cover, and her gold-banded hem spreads onto his cover to produce the illusion of a similar banded design there. The brush strokes at this lower border melt it into the rose-purple of his cover, strikingly for a painter so attentive to bounding outlines as is Botticelli.

In this "picture of classical personages painted without classical models,"[38] the casualness of the scene, its very informality, would reduce to mere background or preliminary coordinates all the lore, astrological and other, about the conjunction of Mars and Venus. They are not in conjunction, and neither do they war with one another. They lie together and apart, she awake and he asleep. By contrast with their immobility, wasps are swarming around the head of Mars and into and out of their nest in a huge knothole. Four baby satyrs or faunlets—their horns, pointed ears, and furry haunches carefully displayed—sport teasingly towards Mars, as though ignoring Venus entirely, though their horizontal-curving arrangement crosses two-thirds of the picture. The one who might be looking at Venus has his head totally covered with the helmet of Mars. He supports under his arm a lance so long and heavy that another baby satyr must balance its end. Emphasizing the importance of the lance for structurally organizing the painting is the appearance, underneath it, distinct but faintly visible, of an entire town, fronted by a mysterious line of boatlike shapes on the green field, the only figures in that far distance.

The marked position of this small, distant town with relation to attributes of the large central figures invites us to interpret their relations in a thematic as well as in a visual sense. Myth stands to the foreground, calm ordinary life in the background. Earlier, such distant landscapes are framed by a window, as in Domenico Ghirlandaio, or by structural features of the canvas, or by both, as in the fullest northern painting of a generation before, that of Jan Van Eyck and Roger Van der Weyden. Botticelli himself follows the conventional procedure for the two windows in

his smaller Venice Madonna—a ship seen through one window and distant mountains through both. Yet the whole practice had been introduced less than a century before, and so it may have been felt to be a technique new enough to undergo manipulation. So too the harbor framed not by architecture but by the bodies of Botticelli's *Pallas and the Centaur*. So, somewhat differently, the forty-eight scenes distributed as miniatures on the pillars of *The Calumny of Apelles*. Leonardo's distances fade off in a sort of bluish chiaroscuro: the mystery is in the far background, and there is much in Leonardo's *Notebooks* about the particular techniques appropriate for rendering distant mountains. The *Primavera* and *The Birth of Venus*, contrastingly, are saturated in presence: the complexities are so fully foregrounded that there is scarcely any need of background. Their relative two-dimensionality, in the context of the time, must be a deliberate choice, and again therefore with thematic as well as visual implications.

The tip of the lance in the *Venus and Mars* is not an arrowhead but, strangely, a conch shell that the other baby satyr puffs his cheeks to blow directly into the ear of the heedless Mars. A third baby satyr between them simply looks on in idle curiosity, while a fourth crawls up from under the purplish rose pallet of Mars directly below the sleeper's left arm. In their being they are allegorical, in their activity informal, and the ideological contrasts of this painting, too, melt into the easy complexities of its spatial harmonies.[39]

Botticelli complicates the allegory in his religious paintings too. In *The Madonna of the Eucharist* (figure 7), Saint John's arms are full of grapes and wheat, to be made into consecrated bread and wine as the Child who leans back against the Virgin will grow up to consecrate and be sacrificed. He raises his hand in blessing the grapes and wheat while Saint John and the Virgin have lowered their eyes to admire and contemplate them, the Virgin reaching out to palp a stalk of wheat. The room is starkly simple, which throws attention on the landscape and buildings beyond, its distance underscored by the heads of Saint John and the Virgin, intersecting the embrasure of the window. This is the world to which the Eucharist will be referred. In the *Madonna del Libro*, too, the time of the painting enters a figural time of past and future through the inclusion of iconographic pointers. The cherries of Paradise are present,

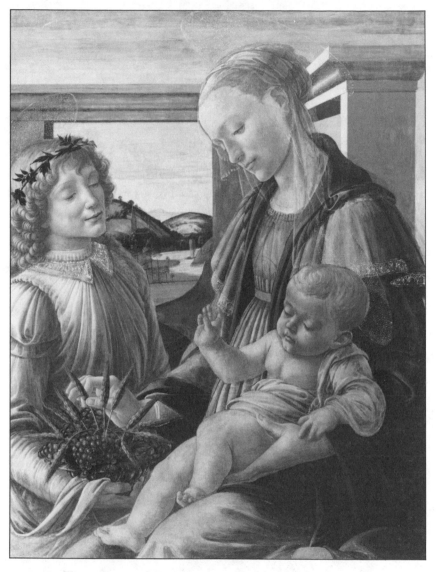

Figure 7. *The Madonna of the Eucharist,* by Botticelli.
Courtesy of the Isabella Stewart Gardner Museum, Boston.

and also the nails of the Passion, held by the Christ child whose wrist is braceleted by a small crown of thorns.

The Mystic Nativity gathers in one energetic scene elements of the birth story usually kept iconographically distinct. The painting is layered in planes of significance, vertically rather than in the horizontal manner of the secular mythologies. The elaborate vertical arrangement of *The Mystic Nativity* turns into intense quasi-allegorical suggestiveness the similar arrangements in such slightly earlier paintings as Cosimo Tura's *Madonna and Child Enthroned* or Carlo Crivelli's *Annunciation*.

Botticelli's own *Adoration of the Magi* (figure 8) adapts such complex verticals to the *tondo* form, where the round of the painting is utilized only at the bottom end, crowded with persons and horses, while the top is dominated by the angular skeleton of the building open behind the central Virgin. At the very bottom of the painting, below the prominent horses, large white building blocks point upwards and inwards at a shallow angle, revising toward the rectilinear the round form of the painting,

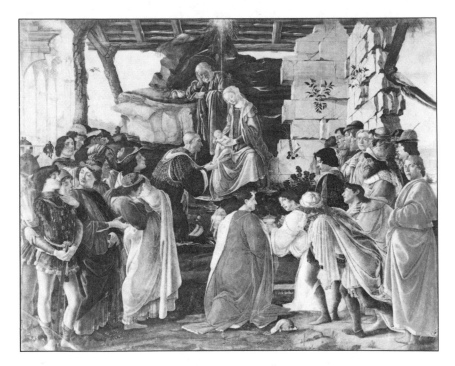

Figure 8. *The Adoration of the Magi,* by Botticelli. Courtesy of Archivi Alinari and Galleria degli Uffizi, Florence.

and imposing the verticals upon it. In such an arrangement the perched peacock—an icon found in Carlo Crivelli and Ghirlandaio—serves as an allegory, as do the monkey with a red waistband who leans against his master and the faint hinds escaping horizontally into the forest off to the right. The "clause" that combines horse, scaffolding, and crowds may be derived from Leonardo, but these horses, caught in the crowd, have none of the energy of those in Leonardo's *Adoration,* which move outward strenuously to the borders of the painting. These horses of Botticelli are held inward, their energy contained and pointed almost heraldically, as though in contrast to the obscured utility of the horses slowly and measuredly crossing a bridge away from the action off in the background toward a far town.

In *The Mystic Nativity* itself, the manger does not refer to such icon-types. It is both hut and cave. Outside its open tree-beam pillar to the left, an angel in red guides the three Magi, while to the right an angel in white guides the Shepherds. All these details contain allegorical suggestions but do not structure into allegory. The red of the left angel's garb, the pink of the right angel's wing, and the red of one kneeling shepherd, are picked up in the gown of the larger-than-life central Virgin, while the green of Saint Joseph's tunic and the gold of his robe are picked up, on this central level, by the robes of two Magi, the tunic of one Mage and one Shepherd, as well as by the spectrum of greens across the painting.

This is the center. There are unnatural variations in scale within this group; the Virgin is larger than the slightly more foregrounded Saint Joseph, and the Child is too large for a new-born baby. On the levels above and below are further changes of scale. At the bottom level, tiny devils scuttle into the zigzagging ravine-abyss along which three angels greet three men in a flying Kiss of Peace. Near them, at a lower level, are a couchant dragon, and hooked poles. The rainbowed wings of these angels pick up and intensify the range of colors in the painting. They simply repeat the left-right-center disposition of the middle scene, as does the trinity of gold-winged angels in white, red, and green respectively, playing music on the roof. Around them stand rounded trees, above them is a paling blue sky. But just a bit above, pointed by their large olive branches, a dancing circle of twelve olive-bearing angels floats between the blue sky and an immense oval of gold light, a Paradise or preternaturally enormous sun, rimmed itself by a rainbow range of color (a figure used, less prominently, in the *Madonna of the Pomegranate*). In Ficino, the sun is an orphic tabernacle of God.[40] Crowns woven of olive—three of them—drop in midair from these twelve toward the three on the roof. Other

crowns deck the olive branches. The twelve alternate brown, red, and white for their robes, simplifying the brown-gold straw of the roof two levels below and the range of brown, gold, and green on the ground and in the ravine.

These colors are simple enough to elide mimesis in the direction of schematization, but at the same time they lack the rich associations of liturgical colors. And they stand on a scale of easy assimilation, many of them, in one range of the palette—green to brown to red to gold. Green suggests budding nature, red fulfilled nature, brown dead nature, and gold a celestial supernature, amplified by blue and white.

The topmost layer qualifies, aims, orients—but does not define—the painting by a long, iconographically anomolous signature—and the inscription, which is rendered into three lines of flourishing Byzantine Greek, light-brown on a lighter gold, as though to draw the painting back through the language of Scripture and of Plato to the time of icon and mosaic, back finally to the very time of the events it depicts. The inscription reads: "This picture (*graphen*) Alessandro painted, in the half time after the time at the end of the year 1500, the troubles of Italy at the time of the fulfillment of the 11th of St. John in the second woe of the Apocalypse, in the loosing of the devil for three and a half years. Then shall he be chained according to the 12th and we shall see . . . as in this picture."[41] This text deliberately rerenders any contemporary reference to Charles VIII and/or Savonarola into a spiritual significance linking those events, as past, to a future whose presence, triumph, and resolution the painting celebrates, as the last lines of the inscription say. These lines refer us for significance to the painting itself, while at the same time participating in the painting as a segment of it. The picture is so general in its application to a future that Ronald Lightbown can even plausibly say of it: "He has represented the events related in the Apocalypse as a repetition of the first Nativity, adding the defeated devils disappearing into hell and all the inhabitants of heaven rejoicing."[42]

The tension between the lines and the representations in the painting repeats and figures the tension between the world and apocalyptic fulfillment. But there is a further complication. The men in the Kiss of Peace, like the dancers far above, trail streamer banners, and two of these carry Latin inscriptions. The man to the far right has a banner on which is visible something like "pluribus bona voluntate"; another man toward the center has one with only a word legible, reading something like "sanibus." These inscriptions set the Latin of the Vulgate and the Church against the Greek that is the language of the New Testament, a juxtaposi-

tion that does not permit an easy contrast between temporal and spiritual, especially since the prominent Greek inscription melds the personal note of the painter with an apocalyptic but extrascriptural and extra-liturgical message.[43]

Floating, flying, dancing—the bodies in *The Mystic Nativity* all slowly swirl in a sort of rapture that conflates all these motions, rendering them as versions one of another. The main figure in *Judith* submerges horror in the dancelike balance of her swift movement. In floating, in flying, and in dancing, the body illustrates its presence and its grace by calling its equilibrated forces into play, at the same time exhibiting its trust in water, wind, and the rhythm of music. The angle at which Saint Joseph bends from the waist rhymes with the angle at which two of the angels bend in the lower tier, assimilating his immobile kneeling to their near-flight. The Magi and the Shepherds are bent at the angle of the angelic musicians on the roof, while the long-waisted Virgin gently leans in a reversal of the shallow angle held by some of the arched, dancing angels in the great circle of golden light at the top of the painting. In the San Martino *Annunciation,* too, the Virgin bends from the right at an angle close to that of Gabriel, bending from the left in a flight that brings her gesture into coordination with his. In the *Primavera* too, in the Villa Lemmi Frescoes, in the *Mars and Venus,* near resemblances of posture, and even slight differences, bring forward poses that portend a hieroglyphic of the relation between body and spirit, the more so that the iconographic elements in these paintings are not taken straight but are strenuously recombined. One theme qualifies another, one motif qualifies another, and the result throws us back for cues on the visual presence of the painting. The dance of thought is matched by the dance of bodies.

In *Pallas and the Centaur,* the slight s-curve of Pallas' torso rhymes with the Centaur's, a similarity emphasized by the tuck of the green cloak high on her waist to the right, and by the triangle his dangling right arm makes with his sharply tucked-in right side. Her tug on his head bends it to a reversal of the same angle as her head. His forelegs, the left knee exaggeratedly bent, repeat the posture of her legs. Only the large, uplifted haunches of his hind quarters bulk backward, finding no correspondence for their energetic, arrested horizontality, though its flow is somewhat continued in the flow of her green drapery.

In *The Birth of Venus,* Venus herself is in contraposto. It may be said

that her proleptic domination of the Zephyrs and the Hour, and also her regal freedom from them, are figured in the difference of her poised frontality from their varied, strenuous bearing. As for faces, the Botticelli look of sad dreaminess can be read under the intentness of the Hour's profile. The presence of this look is direct and simple in the nearly full face of Venus; it is emergent, or else it would be full face. Her head dips slightly to the right, too, like that of *Abundance,* or of Pallas in *Pallas and the Centaur,* and of many another woman in Botticelli's work. Only in the tilt and presentation of her head does the Venus of *The Birth of Venus* resemble the Venus of the *Primavera.* None of the angels has this look in *The Mystic Nativity.* The Virgin's profile there is nearly horizontal as she bends over in prayer to the upturned profile of the Child, whose own absorbed infancy is shown in his playing with his lips.

This type of Filippo Lippi face is not submerged, as with Filippo Lippi, in a repertoire of idealized representations and full, derived complements of images.[44] Instead, it is isolated in space—an open space surrounding each of the figures, even in the fairly crowded *Mystic Nativity.* Without any of the tragic individuality in Masaccio or Leonardo, the singularity of each personage is given room to breathe, to offer the implications of his presence boldly to the viewer. This presentation is notable in Botticelli's portraits, with their backgrounds that are simple by comparison with those of Leonardo or Ghirlandaio. Both the late frontal Saint Augustine in the Uffizi and the earlier profile Saint Augustine in Ognissanti stand out against the background of a relatively austere and simple, if architecturally proportioned, study. The later study is still barer than the earlier, and even that one is far less busy than the *studiolo* of the *St. Jerome* by Ghirlandaio, commissioned to face it in the church.[45]

In the several *Miracles of St. Zenobius,* clusters of small-scale bodies in robes of whole, simple colors are distributed in the wide space of a simple architectural setting.[46] Indeed in one of them, *Three Miracles of St. Zenobius,* a Chirico-like empty square looms large under a dark, simple arch, structured of one light house and a darker, both with red roofs. By contrast, the squares in the foreground where the miracles take place, in their time compression, are quite crowded. The four scenes of the *Magdalene* predella significantly vary their spaces. In the first panel, *Christ Teaching,* there are no windows at all inside the temple. The second panel, *A Feast in the Home of Simon,* shows the door just open, a long vertical cracks upon a gold sky and cypresses. In the third, *Noli Me Tangere,* through the larger space of the door on the left is seen a landscape, and above the walls a sky of natural color. The fourth panel divides into two

scenes: the one on the left wholly outdoors with mountains and a ship in the distance, the one on the right again wholly indoors, closing the circle.

It is as though Botticelli were heeding the precept of Alberti that the most dignified *istoria* should have a few figures and then went the precept one better by tempering the space around the figures in subordination to them. This is the positive side of Leonardo's slur that Botticelli painted landscapes that were "tristissimi." His figures, in their bodily presence strike a mean between the matt, nearly two-dimensional figures of Mantegna and the distinct, heavily detailed personages of Pisanello and Ghirlandaio. In Wölfflin's terms, he is linear with respect to his personages but often somewhat painterly with respect to their settings. Yet even in such buildings as those of the Saint Zenobius paintings, Botticelli has not wholly abandoned the expressive flatness of Adrian Stokes' quattrocento. He models it into a kind of equivalent of low relief. The dancing figures with drapery, the Graces of the *Primavera,* and the Hour of *The Birth of Venus* resemble reliefs in bronze or alabaster more than they do the figures in other paintings. He is closer to Lorenzo Ghiberti or Agostino di Duccio than to Andrea del Verrocchio.

Botticelli's bright, often simple palette, only a shade softer than that of the dazzling Fra Angelico, keeps the compositional units of his paintings positively oriented to their signification person by person, segment by segment. His planar dispersion, I am insisting, thrusts its significance upon us. Its visual rightness cannot be divorced from its iconographic redefinitions. His handling of myth by playing fast and loose with its integers recalls Ovid, rather than the solemn Ficino, and yet the finality of the simple bodying-forth in Botticelli's paintings also attains a certain solemnity that is foreign to Ovid, and even more foreign to the constantly ornamenting Poliziano.

Even the multiple, firmly winged angels of the *Mystic Nativity* merge delight with solemnity as they show human vivacity and variety of gesture while running to their Kiss of Peace. Even the Magdalene clasping the foot of the cross in the depressive *Mystic Crucifixion* (figure 9) shows in her posture, her rapt expression, and the flow of her red robe something of the spirit of the white angel who bends slightly to approach and bless her on the other side of the cross. Thus, as throughout much of Botticelli's most distinctively individual work, the visual harmonies qualify and blend the particular, often discordant, iconographic constituents of the painting. Painterly presentation and received signification enter into an original combination that constitutes a larger, and a newly conceived, overall signification. Botticelli justifies, right through his career, the per-

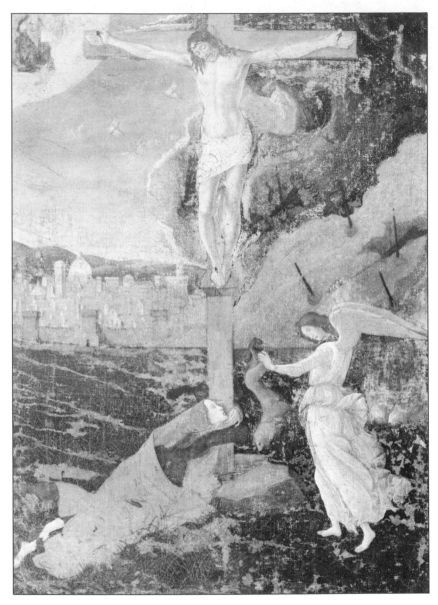

Figure 9. *The Mystic Crucifixion,* by Botticelli. Gift of Friends
of the Fogg Art Museum, Harvard University, Cambridge, Mass.

spicuous praise of Henry James: "What it comes to is that [Botticelli] is the most interesting of a great band—the only Florentine save Leonardo and Michael in whom the impulse was original and the invention rare. His imagination is of things strange, subtle and complicated—things it at first strikes us that we moderns have reason to know, and that it has taken all the ages to learn; so that we permit ourselves to wonder how a 'primitive' could come by them."[47]

The Integers of Giorgione

Giorgione, popular in his own time and mysterious in ours, early began to modify his iconographic inheritance away from univocal signification. At the peak of his powers he produced works of rich and measured suggestiveness that would remain unsolvable only for those who insist on a story outside the painting on which to hang its referential cues.

This painter, even when adopting traditional subject matter that referred to a preexisting story, would modify it in the direction of virtual and self-subsistent figures. He early introduced mysterious figures into *The Mystic Marriage of Saint Catherine,* the *Madonna of Castelfranco,* and *The Altar of Saint John Chrysostom.*[1] He did confine himself to the referential framework of standard allegorical combinations in the Liberal Arts fresco friezes at Castelfranco Veneto. But his allegorical portrait of an old woman, *La Vecchia,* or *Col Tempo,* already goes beyond the stock associations of time's effect on the body. The old woman is no withered crone ravaged by time. To begin with, she points at herself, and presumably applies to herself the phrase *col tempo* on the small scroll that touches her right side. The phrase itself is simply proverbial; her own act is more complex.[2] She is also somewhat robust and full-bodied, her person still carrying some contradiction to stereotypes of age. Vasari's linking of Giorgione and Leonardo as "autori della maniera moderna" will carry only as far as the use of color, which Vasari himself specifies.[3] Otherwise the "fantasia"[4] of Giorgione soon departs from Leonardo's received iconography. Even Vasari notes the enigma in Giorgione, seeing in one of his works an angel in Cupid's guise.[5]

The very subjects of *Paris Exposed, The Assault,* and *The Testing of Moses,* while not mysterious, carry with them an initial strangeness. In

the *Portrait of Laura* (figure 10), the one bared breast of the somewhat bovine woman, and its marked nipple, stand in puzzling contrast to the very prominent laurel bouquet crowning her. It is actually not quite a crown, and it trails down outside her breast. A veil, from possibly a third domain of convention, circles the neck and curls round the breast to hold it, almost demarcating the nipple.[6]

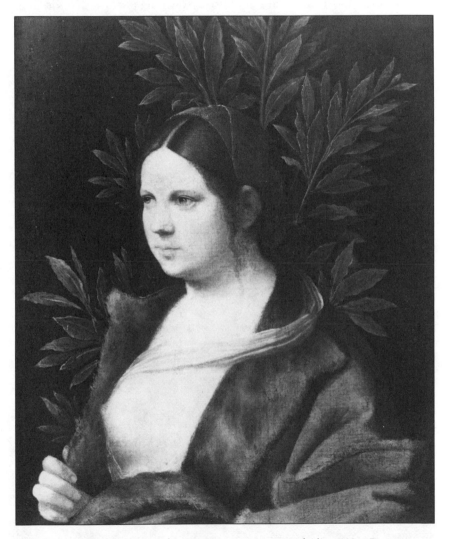

Figure 10. *Portrait of Laura,* by Giorgione. Courtesy of Alinari/Art Resource, Inc., New York, and Kunsthistorisches Museum, Vienna.

To take Giorgione's most imposing work first, the imperturbability of *The Tempesta* (figure 11) does not yield to simple allegorizing or traditional iconography. Edgar Wind's reading of the work, for example, as *Strength and Charity*, raises more problems than it solves, nor does conjoining "Fortune" from an allegorical dictionary entry as "tempest" a century later throw much further light on its final significations.[7] Wind's many iconographic analogues do not explain the near-nudity of the woman, her nursing, her slouched but almost crouching posture. Nor do they explain the strange, compound dress of the man, well characterized by Adrian Stokes as "a gypsy, a soldier, a peasant, a hero of Greek myth."[8]

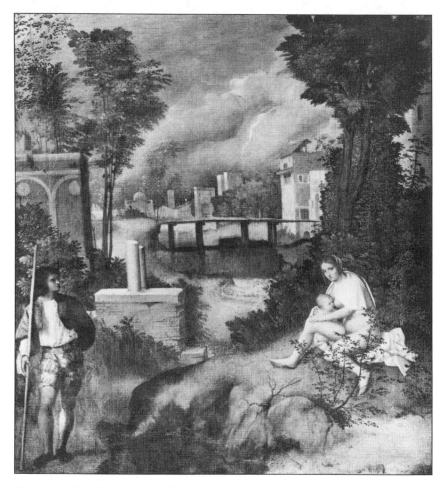

Figure 11. *The Tempesta*, by Giorgione. Courtesy of Accademia, Venice.

Still less would such an allegory explain the distance between the fig-
ures, the complex ravine and stream between them in the foreground,
and the complex, silent town, shut in and away behind them—to say
nothing of the single streak of lightning through blue sky that gives a title
to the painting. Indeed, though, another enigma lies in the relative
placidity of this tempest, at just the time when Leonardo is expounding
the interest for the painter of deep turbulences in nature, of cataclysmic
meteorological disturbances quite alien to the mild perturbation Gior-
gione shows us here.

On another tack, John Erwin [9] sees the work as a failed Annunciation,
and this is a tempting reading, given the mothering nurture of the woman
(which would make it an Annunciation post-facto), the heraldic bearing
of the man, and his posture on the traditional left separated by a distance,
just as the angel usually is, from Mary on the traditional right. Even the
flash of lightning could be taken as a conflation of the Dove and the beam
of light. Still, we are outdoors here, and well outside the city, as though
the Flight to Egypt had been conflated with the Annunciation—even with
the Massacre of the Innocents, since the man might be seen as a soldier
approaching a defenseless woman and child. Giorgione has certainly
adapted some of the set of Annunciation, while leaving the closed and
exclusive reference high and dry, open in many directions so as to feed
Annunciation back into the act of appeased wondering that the painting
offers. Wind's allegorical possibilities, too, may be subsumed into the
painting without pointing its references. These would not so much be
combined with Annunciation (super-Fortezza as angelic, super-Carità as
suggesting the Virgin). Rather, these possibilities would reverberate over
figures who are more complex, more collected, and more disjoined, than
either Annunciation or Strength and Charity. And the painting is more
literal too, though its literalness is immediately, as it were, caught up in
the *possibility* of signification, a possibility that is pointedly not actual-
ized.

The arresting juxtaposition of the two figures—the perceiving dark-
faced man with his lance, the absorbed open-but-blurred-faced woman
with her nursling—was, we know, a later thought of Giorgione's. The
pentimento under the man shows that a second woman would have been
there instead, lowering herself into the stream to bathe.[10] (This would
provide a further difficulty for Wind and others, who would have to ar-
gue that Giorgione changed the whole subject of his painting in mid-
stream.) The painting's final seesaw of sexual alternation is resolved in
the very intricacy of the landscape and in the very differently assured pos-

ture, balance, and bearing of the two figures—clothed man and all-but-nude woman.

Beyond them are balcony, tower, dome, more towers, bridge, chimneys, and what seems a garden between two buildings. Behind the man is a kind of geometric balcony or parapet. This harmonious cultural-architectural disorder is framed by a natural growth of trees, by ground plants that hide a barely visible serpent, and by the narrow stream. Further front, atop a rectangular brick rampart perhaps three feet high, with a foot-high step, a sort of small abstract edifice of two open columns interposes, or almost interposes, between the man on the same side of the stream and the woman on the other side. This edifice also has the air of a disappointed bridge, and it aligns itself easily with two similar ones, the only structures outside the city—the mysterious "parapet" and the simple bridge. Whatever it may be, it is no ruin, and Wind nods when he says that these rudimentary columns are broken. They are smooth as glass, all around and on top. As Stokes well says, the composite edifice shows "the cylinder and the cube, the bare bones of the new Venice."[11] They stand like an epitome of all the architecture behind them, qualified by the man nearby and the woman across, as those more achieved buildings are qualified by barely perceptible animals, a huge red-painted dragon barely visible on the wall of one building and a "real" white, storklike bird on its roof, and possibly a tiny serpent in the foreground.

There is something almost Chirico-like in these smooth columns. They revise Mantegna's ruins in the direction of white-faced completion—and also in the direction of isolation. They do not huddle against equally ruined buildings, as ruined columns conventionally do. Rather, they stand by themselves, serene and abstract, an intermediate step between the expanses of the sociable but empty city beyond and the human isolation of the man and the woman, both of whom have the air of wanderers detached from the city that they are either nearing or leaving—she humbly but serenely caring for her almost sated infant even so, he like an itinerant condottiere, showing *sprezzatura* by his bearing even if there may be a hint of vulnerability in his look. Even the infant, in a seated posture unusual for a nursling, is somewhat detached.

For a title it is hard to improve on Michiel's, written down a little more than a decade after the painting itself. He calls it a "paesetta in tela cun la tempesta, la cingana et soldato," a small landscape on a canvas with a storm, a gypsy, and a soldier. The work is small, as Michiel says, a surprise to the viewer who expects a large scale for so rich a work. And Giorgione, notably in the frescoes for the Fondaco dei Tedeschi, did often

work on a much larger scale. Here he elides his significances into an open space that triumphs over its own reduced dimensions, the "shrinking" of the painting's size a kind of spatial analogue to the reinvestment of iconographic significance back into the painting instead of outward to some system or story.[12] This painting will neither resist nor endorse such readings as Ferriguto's 'air, earth, water, and fire.'[13] It absorbs such a census of Aristotelian elements as it absorbs the threshold between city and country, building and vegetation, unseen society and visible wanderers on the earth, soldier and mother, man and woman, tree and stream.

In a poetic construct one can begin to disengage the themes and motifs from separable verbal cues. The "genius of the shore" in Milton's *Lycidas* operates in a narrative context where a Christian guardian angel may be called into play. At the same time the history of the Latin word *genius* enlists a pagan notion of the animistic spirits in Nature—a notion that other cues in the poem, the nymphs and so on, reinforce. Other cues indicate that Milton ironizes the pagan icons while he uses them.

In a painting, irony can enter not through such contrasts but only by a version of caricature, by the distortion of single figures as in Goya and Henry Fuseli, and not by the interplay among them. Once the capital gesture has been made by Giorgione, and by certain of his contemporaries, of removing an external story as a point of reference for individual figures, the convergence can become complete of its senses taken together; interqualifications have no cues to set at odds.

So it will not do to say that the soldier and the gypsy in *The Tempesta* or the figures in the *Concert Champêtre* (figure 12) inhabit different orders of being. They stand emphatically for a single order of being, presented to us by *The Tempesta* or the *Concert Champêtre*. We cannot begin to disengage, or even to conflate, say, the Charity and the Virgin elements in the gypsy, the Fortezza and the angelic elements in the soldier, as we can classical and Christian elements in Milton, or for that matter in painters and sculptors like Michelangelo, who follow the usual practice of offering us a story. In *The Tempesta* the possibility of prior iconographic constituents, including encyclopedic ones ("all nature," "the Aristotelian elements," etc.), have been wholly subsumed and redirected into the order of the painting's world, which asserts the primacy of that order against the alternations and antitheses of such reductive and overspecific readings.

Giorgione, in fact, approaches his harmonies in what—by contrast with the busyness of Botticelli and Carpaccio or with some of his own predecessors—can be called a monodic bias. This man, whose fame for

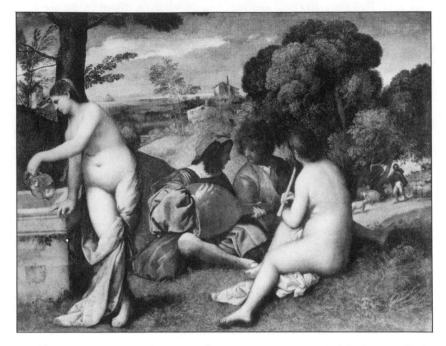

Figure 12. *The Concert Champêtre,* by Giorgione. Courtesy of the Louvre, Paris.

playing the lute Vasari reports, allows large spaces from element to element of his canvases. In *The Tempesta* there are a few trees on either side of a small dark stream, a single flash of lightning, a group of far buildings, a bridge, a parapet, and then the man with a staff on one bank and the nursing gypsy on the other.

Similarly, as Richter points out,[14] the organization of the Castelfranco altarpiece is extremely simple. The large segmentation of the figures is repeated in the segmentation of the floor pattern. The spacing of the figures in the Madrid *Altarpiece* is unusually wide, and hues of green spread across it in broad segments, linking the gowns of saint and Virgin to the broad green cloth of the backdrop and to the green of the surrounding vegetation.

Simple, too, is the organization of *The Three Philosophers* (figure 13) and *The Finding of Paris.* As Ludwig Baldass says of the latter, "The idyllic landscape is quietly and symmetrically arranged."[15] The asymmetry of *The Adoration of the Shepherds* is modified by the amplitude of spaces around the figures in the right foreground and the simple landscape extending distantly beyond and behind them in the left background. Disproportion, too, emphasizes by occasional contrast the self-subsistence of

the painting's own symmetry, as in *The Madonna of Castelfranco,* where the simple furled flag is painted larger than the timbered buildings and the tower behind it (extending and amplifying a practice of Piero della Francesca's). The horizontality of these paintings austerely refrains from presenting too many figures, with the exception of *The Testing of Moses.* We take them one by one, slowly, refreshed in the plenitude of the new alphabet their simplicity offers.

Giorgione's Judith (figure 14) stands simply, frontally before us, filling out almost the whole of the painting. It is as though he were revising the story behind the painting back into portraiture and its mysterious evasion-in-presentation. Judith's flesh picks up the pinks of her dress, and only her jewels concentrate the color into a dark garnet blaze. One foot rests on the greenish head that she demurely glances at with downcast eyes. The vegetation picks up, contradicts, and naturalizes that green. The action is all over. The common iconography associated with the story—of tent and maid and busy nocturnal haste—has all been left out and

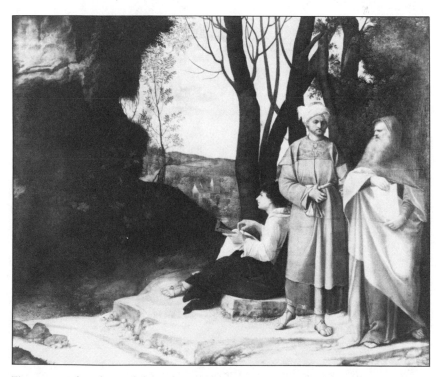

Figure 13. *The Three Philosophers,* by Giorgione. Courtesy of Alinari/Art Resource, Inc., New York, and Kunsthistorisches Museum, Vienna.

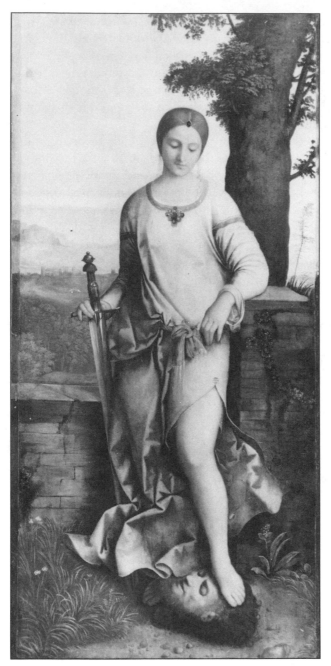

Figure 14. *Judith,* by Giorgione. Courtesy
of The Hermitage, Leningrad.

superseded. Against a sky streaked with the yellow of dawn the single figure balances the large sword she seems too frail to have wielded. She enters a fullness of contemplation with a smile that offers a fainter version of the Gioconda's smile. Here, to be sure, a story is offered, but it has been digested and redistributed in the form of a few simple, if horrifying elements. Demureness takes over from exerted force and modesty from boldness. Not *Judith* but *The Recollection of Judith* might be the title. As in *The Tempest,* the brick pillar of a wall yields to a dark tree, and the distance is simple and reposeful, empty of any city.

Many of Giorgione's paintings are either portraits or single figures like *Judith* and *The Sleeping Venus.* One can say of all these pictures what Terisio Pignati says of the *Madonna of Castelfranco:* "He feels the necessity of continuing the dualism of a vision that threatens to break the unity of his language."[16]

In such a smoothness of presentation the strangeness of individual figures is the more imposing, as is the case even of the strange, small gold-armored pair, center right, in *The Madonna of Castelfranco* (figure 15). The standing one, red-capped, seems to be handing something to the one who sits with a lance across his knees. The simplicity of Giorgione's spacing gives the disparateness of his elements room to breathe. And if *The Three Philosophers* crowds its three disparate figures together somewhat asymmetrically in the right half of the painting, they are at once counterbalanced by the landscape that takes up all the left half.[17] Following the impulse the paintings themselves evoke to bring them into a unity, Michiel thought in fact that all three philosophers are contemplating the sun's rays in the landscape. Certainly the astronomical appurtenances of two of them would reinforce this interpretation, though it would connect them to a different moment of the sky from the one visible in the picture.

Perhaps, as Baldass reports,[18] some suggestion of the Magi hovers over these figures. But that icon would be heavily qualified by the absence of usual typologies, as well as by the absence of a Manger. (We do, to be sure, have a dark, empty cave on the other side of the picture.) The visual evidence is too scant, and at the same time too varied, to align these three men with three schools of philosophy. They are too close to one another, and each of them at the same time is too self-absorbed for dialogue. They are as dreamily oblivious of one another in their close proximity as the soldier and the gypsy are in their distance, or still more strikingly, the women and men in the *Concert Champêtre.* Their costumes indicate different walks of life, different personal dispositions towards dress from austere to gay, different national origins, and most predominantly, differ-

Figure 15. *The Madonna of Castelfranco*, by Giorgione. Courtesy of Alinari/Art Resource, Inc., New York, and Chiesa Parrocchiale, Castelfranco Veneta.

ent ages. Reading from left to right, they comprise simply Youth, Middle Age, and Old Age: the Three Ages of Man.[19] Their postures lend them to semiallegorization: the seated youth gazing off to the heavens, the mature man posed squarely and frontally, the old man, in near profile, walking deliberately in a direction that will pass him soon before the others toward the mysterious cave he alone, vaguely, faces. Stages of contemplation, too, suggest themselves: the youth is busy with his astronomical or surveying instrument, the assured middle-aged man holds nothing. The old man is pulling from the folds of his garment a sheet filled with already finished astronomical calculations. (Future, Present, Past?) As for their absorption in intellect, Ferriguto notes the unreality of the garb of all three.[20]

In the *Concert Champêtre*[21] the self-absorbed figures are harmonized by relaxing in close proximity to one another, but at the same time they are sharply differentiated from each other. The two clothed male lutanists separate the two nude women, she at the left pouring out a pitcher in a gesture the more purely beautiful for having no utility. The other, her back toward us, handles a recorder that she may be preparing to play. Beyond these two pairs, over a crest, driving a flock at what appears to be a decent if dilatory pace, a bagpipe-playing shepherd moves across the background, unseen and unseeing. The "grammar" of the picture then offers four single figures, but two men and two women in one order. In another order there is a group of four and a single man with a flock. In still another order there are two close solitary men and one distant flock-accompanied man against two serenely occupied women. Company and solitude cross their inflections here, since everyone is solitary, and the only person separated from others is deeply absorbed in a quintessential human-social activity, tending the flocks that accompany him. Yet the most prominent figure, the foreground nude pouring water from her pitcher, is the only one of the five not engaged in making music. The sheep refer to a sort of homely enterprise not otherwise exemplified in the painting, unless the nudes be taken, as they sometimes are, to subsume "pastoral figures." Some interpreters would want to call them "nymphs" or even "goddesses,"[22] but there is nothing in the painting to seal them exclusively into those functions. Nor can they be floated off into another level of being when they stand so close to the men, who are no more self-absorbed and oblivious of all others than the women are. The shading toward pastoral is suffused by the painting's other shadings. A pastoral note would include the laurel, ivy, and myrtle that are faintly, if at all really, perceptible in the vegetation.[23] As in other cases, Giorgione, when he

overpainted the work, changed not his mimetic slant, the way other painters do, but primarily the significative attributes of the woman with the pitcher. This woman strikes the viewer whose eye takes the culturally determined path of starting from the left. Her graceful body slightly inclines, repeating on a larger, warmer scale the curves of the pitcher. The two preoccupied men, however, sit almost dead center, resembling each other more than any of the remaining three do them or any other.

The viewer, induced by Giorgione's heightening of the color harmonies that are so marked in Venetian painting generally,[24] moves from one single, self-possessed figure to another. He is nagged by the expectation of some story, the more so because often there is a story, as in *The Testing of Moses, Judith, The Finding of Paris*. And still more does a story impose itself as a possibility because few of Giorgione's paintings have the large assemblages, the throngs and processions of Fra Angelico, Botticelli, and the Leonardo of the *Adoration of the Magi*. The very relatedness of the figures in Giorgione's paintings leads the viewer to establish a relation among them in order to match the strong relations of the color harmonies.

Finally, as the painting resists a story, the viewer does not gloss over the significations coded into dress and posture and attitude and activity. He gathers the disparate personages into an order of space and color that puts their significations on a par with their existence, because the route has been blocked against a combined external reference to, say, soldier and gypsy. The gypsy is loaded with external reference, and so is the soldier. Only in combination—supremely in the painting—are these individual external references forced, or eased, back into the painting, deeply internalized in a dead heat between the Image of visual perception and the Word of coded reference. The satisfying plenitude of such a performance might go far toward explaining the popularity of a painter otherwise so enigmatic.

The integers of the figures in Giorgione's paintings are not the "numbers" that code them to a single sense, though their simplicity and their relative paucity assure us that they function, taken singly, in a harmonious combination with the other figures in the same painting. Rather, they are like algebraic signs in combination, moving toward abstractness but at the same time carrying the solution in the visual composedness of their concrete presentation. The complexity of the problem merges into the simplicity of the equation, which at once remains unsolvable through its disparities and stands revealed in the organized spaces where its signs are laid out.

Carpaccio's Animals

The large peacocks perched prominently and incongruously in the *Last Supper* of Ghirlandaio and the *Virgin* (figure 16) of Carlo Crivelli are readily deciphered. They signify the pride that Christ overcomes. Since meanings may multiply in the lexicon of the bestiary, the peacock may also signify the glory and beauty of the natural order. These two senses interconnect: at key moments of the Christian story even the glory and beauty of the natural order is thrown into shadow as either an inappropriate occasion or too exclusive a preoccupation, and hence as involving pride. With that we have done, and the bird is coded. The strange and enormous ostrich egg hanging over the Brera *Virgin* (figure 17) of Piero della Francesca, while complex, likewise yields to full decoding, as Millard Meiss has taught us.[1] With these works, and indeed with all others up to a certain point in the fifteenth century, the relation of the visual representation to its significance remains firmly the one characterized by Michel Foucault as "classical."[2]

In all such procedures the mimetic representation, through the organization of the painting, not only sets up the visual cues so that we recognize "dog" or "bird." The visual signifier also enlists another signified: the dog signifies fidelity, the peacock pride and glory, the egg a cosmic order. This set of signifieds lies outside the painting, an intellectual and verbal construct providing a pattern of coherences and a map of correspondences for what the eye takes in. In the interaction set up between visual perception and significance, each reassures the other. The implied schema anchors the figures on the canvas, either to an allegorical system of icons, or to a biblical or classical story, or to some combination of both.

Carpaccio's subversion of the old narrative framework for iconogra-

58

Figure 16. *Virgin*, by Crivelli. Reproduced by courtesy
of the Trustees, The National Gallery, London.

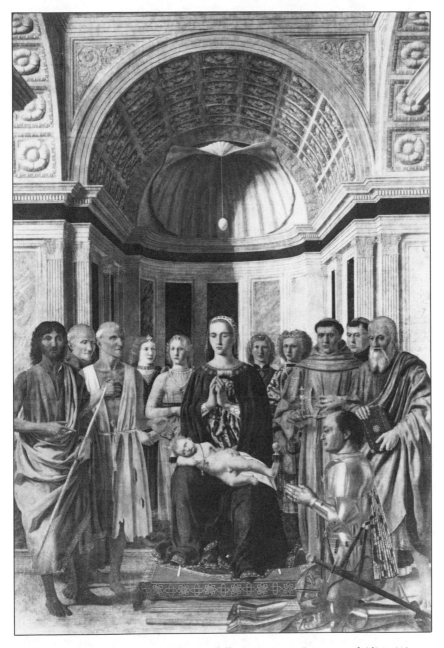

Figure 17. *The Brera Virgin*, by Piero della Francesca. Courtesy of Alinari/Art Resource, Inc., New York, and Laboratorio fotografico della Soprintendenza per i Beni Artistici e Storici, Milan.

phy appears not in the subject matter of his paintings, which does usually involve a story, if sometimes one not often treated. Rather, his iconographic innovation appears in the significance of some objects, chiefly of animals, as they enter his paintings for roles that cannot be subordinated to prior lexical patterns. The paintings themselves on the one hand are almost geometrically plotted out, [3] and space is blocked in them ostentatiously, almost as emphatically as in the work of Piero della Francesca. On the other hand there is a certain openness to his space, a certain care not to crowd its areas with arresting objects, or to fill up a segment of space entirely.[4]

The contrast between the plotting of space and the freedom of large spaces within the plot produces a certain languidity in these paintings, a languidity that invades the angel and the wakeful, couched dog as well as the sleeping saint herself in *The Dream of St. Ursula* (figure 18). The plotting of space nudges the viewer to assign a meaning to the dog lodged in it, but the openness of the space allows the dog to float free for assignment of meaning. As Michel Serres says, somewhat exaggeratedly, "Space is applied to itself, as things to their signs and the work of art towards its own law (*sa loi propre*), that which used to be called its explication."[5] In a sort of languidity the dog reposes, and the viewer, perceiving this, is lulled into accepting as assimilated the new, powerful conflations of the dog's significance.

Carpaccio opens his paintings, and provides a strong index to recoding their matrices of signification, by liberating his strangely placed animals from their iconographic staples of meaning. Since the earliest traditions of visual representation, we may infer, animals have bulked large in the imagination.[6] The paleolithic hunters gave animals the chief role in paintings on the walls of caves. In that paleolithic art we already seem to detect the later themes of the control of nature through overcoming a source of food, of magical access to mysterious forces, and perhaps also the simple skill of mimetic representation. Mimetic skill is itself not so simple. Although we may separate it for purposes of discussion, it cannot be separated in a context of social expression and communication from either control of nature or magical access to mysteries. The animal that "sits still" for mimetic representation has entered an order of control and thereby provided access. Our first theoretical discussions of mimetic skill, those of Plato, occur in a context where order and magic access are very much in question. And something more than just admiration for a trick must lie behind the persistence in antiquity and after of the legends about the mimetic skill of Apelles and Polygnotus.[7]

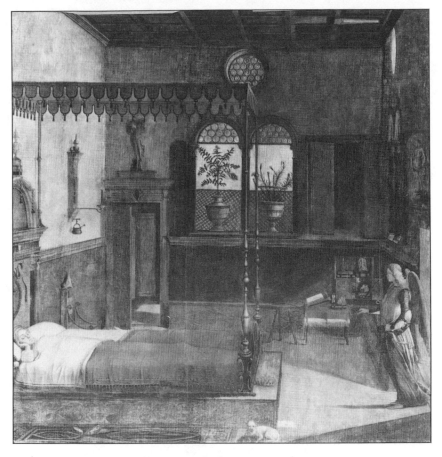

Figure 18. *The Dream of Saint Ursula*, by Carpaccio.

In Carpaccio, there is sometimes a disproportion between his rudimentary and typifying representations of persons and the careful mimetic attention he accords an animal, as in *A Miracle of a Relic of The True Cross* (figure 19), where of all the figures, the one most sharply isolated is the white Maltese-like dog sitting in mysterious solitude near the prow of a gondola in the foreground. The little dog that looks up at the saint's bed in *The Dream of St. Ursula* is as graphically represented as the saint and her visiting angel.

As it happens, a white dog, and sometimes a small white shaggy dog, is often found in the foreground of Northern Primitives, but without the sort of strange isolation and implied contrast that Carpaccio provides.[8] In earlier works the dog crowding against the legs of a gathering group

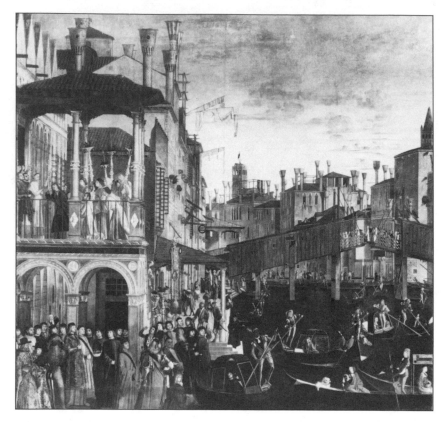

Figure 19. *A Miracle of the Relic of the True Cross*, by Carpaccio. Courtesy of Alinari/Art Resource, Inc., New York, and Accademia, Venice.

serves as a homely reminder of routine life and domesticity. The dog in Hans Memling's *Bathsheba* (figure 20) is surely domestic also, though visually this dog is heavily patterned along lines reminiscent of dogs in Carpaccio's *Two Venetian Ladies*. In the complex arrangement of Memling's painting, the dog is schematized with the slipped-off shoe of Bathsheba; with the green and red and brown of her servant's hanging garments; with a patterned Oriental rug on which it steps; with a cushioned chair, gold-brass basin, and tall brown pot. This dog does not diverge very far from the fidelity of the dog in the bestiaries, nor do such animals as the squirrel and two rabbits in the foreground of Mantegna's *Parnassus* or the dog in his *Wisdom Victorious Over the Vices*.

The iconography associated with bestiaries provides a controlling code for the artistic representation of animals almost up to Carpaccio's

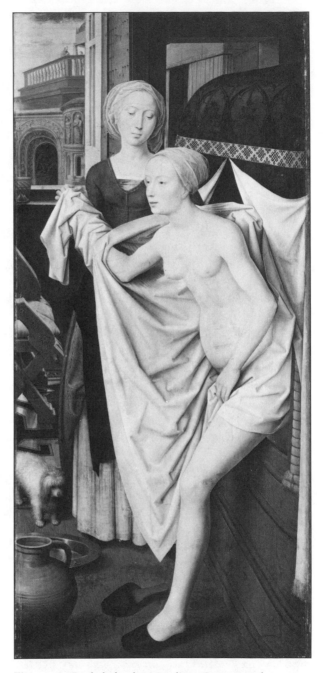

Figure 20. *Bathsheba*, by Memling. Courtesy of Staatsgalerie, Stuttgart, West Germany.

time. Such codes are relatively decipherable, even if their significations tend to vary and to multiply.[9] It may be, as Francis Klingender claims, that "in Aesop's use of the fable the transition from beast-magic to beast-symbol was already completed."[10] Certainly in the two millennia from Aesop to Carpaccio, and especially after the late classical *Physiologus,* animals in visual works are often coded to a lexical sense, sometimes moral as in the bestiaries, sometimes eulogistic or fanciful, as with the simply composite use of signifying animals in heraldry. Although the coat of arms itself in Carpaccio's *Two Venetian Ladies*—a painting where animals figure largely and prominently—contains no animals, the ermine in *The Portrait of a Young Knight* may derive from the coat of arms of the Neapolitan house of Aragon or the dukes of Urbino. It may also, and concurrently, signify purity.[11] Still, the ermine's significance for Carpaccio cannot stop there, since by itself it is arrested in a strange location, as many of his other animals are. And it combines with a host of other animals in that painting.

A plethora of animals can be associated with a specifically Christian iconographic sign for plenary order, the Creation. This medieval tradition persists beyond Carpaccio, as for example in Tintoretto's *The Creation of the Animals.* And it overlaps with another iconographic locus for a profusion of animals, the Apocalypse. Medieval psalters frequently employ animal initials, and the psalms themselves often effectually conflate creation and Apocalypse in the listing of animals. Bosch's *Garden of Earthly Delights,* a work almost exactly contemporary with *The Portrait of a Young Knight*[12] may be taken to enrich its mysteries by a conflation of Creation and Apocalypse through a profusion of animals. Still, there are not enough animals in *The Portrait of a Young Knight* to suggest either Creation, except dimly, or Apocalypse, except intermittently. The animals stand in too great an isolation from each other, in odd perspectival differentiation.[13]

Scenes of hunting, which persist in painting from the paleolithic to our time, themselves may signify something other than ordering domination of nature. In a Christian context they can signify the Fall; the bird of prey, proleptically indicating the Fall, figures in the iconographic repertoire of medieval and later Gardens of Eden. The image of a large wildcat falling upon a large animal, widespread throughout the Near East and the Mediterranean from before the second millennium, is adapted by Carpaccio in the New York *Meditation on the Passion of Christ* (figure 21).

Animals figure largely and variously in this painting, which combines Old and New Testaments by including Job and his typological cue "I

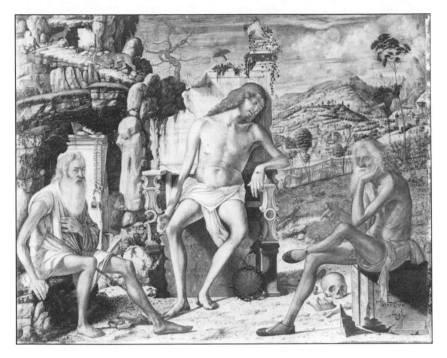

Figure 21. *Meditation on the Passion of Christ,* by Carpaccio. All rights
reserved, The Metropolitan Museum of Art, New York.

know that my Redeemer liveth" in Hebrew letters on the marble block
beside him. Behind Job, a leopard in the middle distance gives almost lei-
surely chase to a horned deer, around a moat surrounding a city—not the
usual setting for this classic predatory act. Behind Job's shoulders two
facing rabbits are playing, ignored by a large weasel in the tall grass.
Most prominent in his isolation, a red parrot is perched unnaturally low
on a small grass tuft between Christ and Job. In the distant city, facing the
other animals to the left of them, a single rider reins in a tiny horse, sur-
rounded by preoccupied, turbaned figures. All this is on the 'lush' right of
the picture. On the 'barren' left, St. Jerome's lion only peeks out between
broken wall and broken rock. Emblematically, a single fawn grazes on a
mountain path, and round a turn further up the path a matching leopard
devours the carcass of a deer. The other "trotting" leopard at once trails
and chases its deer on the right. Still higher, left, a third deer escapes. A
quail-like bird flies away from, and not toward, Christ's head, a sort of
inversion of the Dove of the Holy Ghost, since it flies up and not down
and is black, not white.

This painting includes themes both pastoral and, for a biblical painting, Edenic. Since Christ is the subject, the connection with Eden brings the Redemption into play for the deer. In the space of the whole painting, animals range in association from Eden through Fall to Redemption, with a sense of mystery that all can exist in the same space without temporal elision. Roberto Longhi[14] discusses generally the restrained and mysterious disposition of shadows in Carpaccio's work, and such mysteries come very much into play here, since some of these animals are almost camouflaged by shadow. This fact, natural for animals, introduces a fourth domain—that of a simple natural order—for their signification.[15]

The Hunt in the Valley is dominated by a flight of birds. The strangeness of the prey—it is a heron hunt—angles it away from ordering violence into a sort of genre scene.[16] The landscape is richly delineated, and it is one of the very first paintings given almost wholly to a landscape.[17] As in the later *Portrait of a Young Knight,* the unusual placement of animals in the landscape sets both landscape and animals into a significant relation not referrable to some other code or iconographic lexicon.

In the innovative practice of Carpaccio, however, such further significations as are present outside the painting do not go very far in coding its meaning. The little white dog on the gondola of *A Miracle of the Relic of the True Cross* may be faithful to the gondolier; it perches almost quietly. He may participate in the general luxury that owning such a pampered creature implies—though the white dog at the foot of Saint Ursula's bed or the one on the floor of Saint Augustine's study certainly cannot signify simply luxury. In all three paintings the dog is too isolated, too pointedly framed by its hirsute whiteness in contradiction to all other objects, to be considered a pointer for a genre painting. Aside from the crowding figures, the Venice of *A Miracle* is too geometric,[18] too monochrome in each of its spaces, too empty of any other distracting life, to function as a portrayal of everyday Venice. No such context is provided in which to read the dog, which at the same time occupies a more prominent and central position than the group who constitute the subject and narrative action, the healing of the man obsessed. The white of the dog rhymes with the white of these officiating figures up on the high balcony to the left. We reach them on a diagonal from the dog, a diagonal passing through the prominent, flamboyantly dressed, cockaded negro who steers the neighboring, central canopied gondola.

A failure to offer outside the painting a firm reference other than visual for what the dog implies has the effect of radically altering the balance in the interaction between the visual and its signification. The visual no

longer reassures by assignment to an intellectual order. Yet the incongruity of the figures visually represented turns the painting away from a mere apprehension of the visual.

Carpaccio offers too many puzzles to be seen as showing just the pride in mimetic skill that provides a main focus even in the classical sculpture of animals. On Greek temples, for example, the many "Lapith and Centaur" pediments obviously luxuriate in the counterpoise of strained muscles and complex visual shapes, taking almost as a given the story involved. The myth is not especially interpreted: it is mainly a given occasion for mimetic virtuosity. The story is a set piece, like the *Farnese Bull's* story of Dirce, where animals and humans strain together in a complex virtuoso presentation of mimetic power (figure 22). Some Renaissance works, like Antonio Pollaiuolo's *Battle of Naked Men*, foreground an act of visual mimesis as the subject of the painting. Carpaccio, by contrast with such works, sends out signals for us to arrange his mimetic diction into a syntax, but no preexisting syntax is at hand; we are referred back to the painting. The painting may center around a specific story, here the curing of a man obsessed, but there is more in the painting, often notably the animals, than can be organized around an interpretation of the ideas by the story.

Failing a closed system of signification for the animals in Carpaccio's paintings, his predilection for presenting them in pairs suggests the possibility of nascent contrasts—air animals versus ground ones, tame versus wild, predators versus ruminants, and so on. Sometimes more than one may be present: the strange hawk and heron of *The Portrait of A Young Knight* puts a predator on fish into odd juxtaposition with a predator on other birds (but not the heron). On the ground is another predator, the ermine-weasel, and in the tree still another, a lone eagle or vulture. The singularity of Carpaccio's animals, even when they are ordinary, exhibits a self-referential, enigmatic quality, like the three horses moving on a slight curve and singly, ridden by turbaned figures along a lake in the far distance beyond Christ in the Berlin *Preparations for the Entombment*. What are we to make of the barely visible cows resting by the distant lake in Carpaccio's Lisbon *Adoration*?

Even if they are somewhat mysterious, the many animals in Pisanello's *Vision of Saint Eustache* (figure 23) can all be derived from the iconography of the Creation, though this is transposed to comprise a figure of the Redemption via the miracle of saving and sanctifying hunger. This significance alone makes it different from Carpaccio's *Knight,* who, like Saint Eustache, inhabits a landscape abounding in animals. Carpaccio's con-

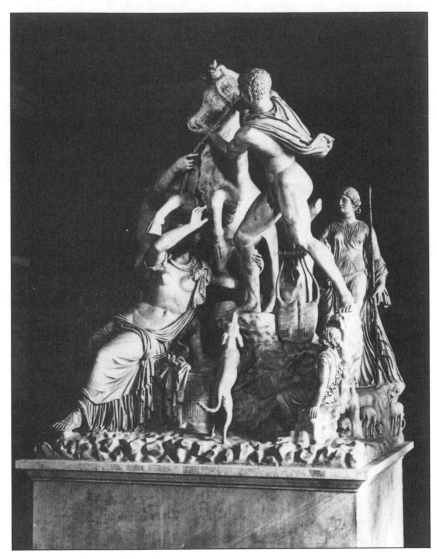

Figure 22. *The Farnese Bull*, Anonymous. Courtesy of Alinari/Art Resource, Inc., New York, and Soprintendenza Archeologica delle Provinci di Napoli e Caserta, Naples.

temporary and sometime associate Giovanni Bellini in his *Madonna of the Meadow* organizes somewhat loosely what are still the usual iconographic references. A horizontal, and reassuringly pastoral, line of cows, some in the water, and one sheep, is broken in that painting by a large Virgin praying over the Child. Both human figures have their eyes closed. At her elbow, below the cows, an open-winged white storklike bird confronts a coiled striking snake, emblematizing the violence of the fallen world. As though to emphasize the point, a vulture sits atop a bare tree. The disposition of these animals and their rendering suggest Carpaccio, but they do not enter his universe of self-subsistent figuration. However, in *A Mythological Subject* (figure 24) of his early contemporary Piero di Cosimo, a sad faun contemplates a nymph stretched dead full-length on the grass, her throat bitten. A huge dog in the right foreground sits as if in obedient attentiveness, belying an inference that it might have killed the nymph. An irresolvable contradiction subsists between the icon of fidelity in the animal's actual posture and the sign of possible savagery that the evidence seems to show. And there is a further contradiction be-

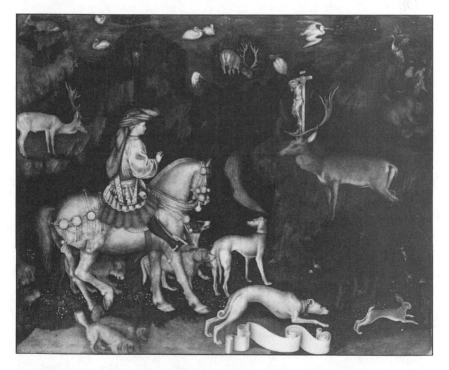

Figure 23. *The Vision of Saint Eustace,* by Pisanello. Reproduced by courtesy of the Trustees, The National Gallery, London.

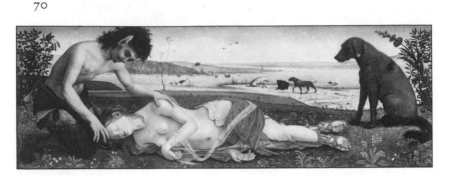

Figure 24. *A Mythological Subject*, by Piero di Cosimo. Reproduced by courtesy of the Trustees, The National Gallery, London.

tween both these significations of the dog and the "simple" large dogs round a distant shore that also contains shadowy cranes and a pelican. On the other hand, the brownish dog in the foreground between the feet of the couple in Van Eyck's *Arnolfini Wedding* simply stands for fidelity and domestic order. It is easily enclosed in a given repertory of significations.

Closest, perhaps, to Carpaccio in his mode of reference is his slightly younger contemporary and compatriot Giorgione. In the *Tempesta* on the building above the woman sits a white bird; and faintly painted on the building over the bridge is a large heraldic animal in red—perhaps ten feet high—a dragon. These two animals, in order and color and size, contrast with each other. There are no other animals in the painting, except perhaps a tiny serpent, and not a single bird in the abundant trees. *Il Tramonto* shows a small Saint George and the Dragon on a ledge-bridge above an opening where, across a sluggish and airy-dark stream, three strange creatures are moving—one under the bridge, one swimming while carrying another, and a third birdlike one, immersed to its shoulders. The last is beginning to crawl out where all are headed, up the short path toward a weary Saint Anthony leaning over a young man while holding a staff. Spaces and prodigious animals link and separate the two saints.

Carpaccio, whose signature is more elaborate than that of most painters, often situates his signature near an animal, as though to hint the privileged role of the animal in touching on something in the identity of the picture. In the polyptych of Grumello dei Zanchi, the Saint Anthony panel has at its center a strange belted boar heading off in the opposite direction from the saint. This boar is not a tempter, not a quarry, not a domes-

tic pet, and yet something of all three: the belt brings the boar into the focus of the tempting demon; the running away makes it look like a quarry; its accommodation in the otherwise bare landscape domesticates it in a normal world to which Saint Anthony is oblivious. His oblivion, perhaps, becomes the point, and the boar enforces the point for being *not* seen by the saint while squarely arresting the viewer's attention and attracting to itself the significations it cannot fulfill. In a drawing of Carpaccio's, on the back of a drawing of two Turkish women, the head of a man stands above the head of a lion. Man and lion here resemble each other in an impossible and at the same time unavoidable kinship, holding the same posture of head and exuding the same languidity.[19] In the Uffizi *Group of Orientals, Jews, and Soldiers,* the large figures in closeup, their weapons as complexly aligned as in Uccello, have their elaborate juxtapositions of posture and color scanned and modified by three white sheep in the middle distance, triangulated by a tree and the spiraling lance of the leftmost soldier. The sheep, by contrast, stand lined up in simple, almost heraldic formation, two of them grazing, one of them lifting his head.

While the saint is flat and asleep in *The Dream of Saint Ursula,* the dog sits at the foot of her bed in wakeful animality, in a preciosity that she will be abandoning, the mute Cassandra of another world. The dog breaks the continuity and portent of the angel's message of death, which the violets of marriage and the myrtle of Venus, the pots on the windowsill, merely negate.[20] The dog in the bedroom here stands like the visible seal upon her lowered threshold of attentiveness, since it perks up for an attention diminished before hers on two counts: she is human, more than animal; and at this moment she has been granted a supernatural prescience. In the Uffizi pen and wash study for this painting, there is another, larger dog, leaping up toward the foot of Ursula's bed between her and the angel. The final work omits this dog and concentrates the effect in the single, pathetically small, pampered and ineffectual animal sitting to one side and below the invisible translation of supernatural message. Michel Serres emphasizes the negative iconographic set of this whole work: it is an anti-Annunciation.[21] But then it is a humbler Annunciation as well. Saint Ursula, though she travels and prepares for her marriage, will remain in the state of the Virgin and undergo a martyrdom. Her destiny is higher as well as more painful than the dog's. At the spiritual level she is awake while sleeping; the dog is locked in a sleep from which it by nature can never wake, however alertly it sits at her bed. The doubled *N* barely decipherable on the white ball of embroidery beside her—infan-

ntia[22]—may be construed as applying to herself (she lives as a little child until she enters heaven) and also to the dog (it remains in a cosmic infancy). She cannot speak while sleeping; that is the root meaning of *in-fantia* (nonspeaking). But the dog can never speak. She listens, though, while the dog cannot hear. All the contrasts between herself and the dog, whatever their logic, are subsumed and opened up by the domestic and anecdotal fact of the represented relationship between maiden and dog. The genre scene leads its serene life in the midst of the gravest and most cosmic portents.

The angel, feather-pen in hand (but where would he write?), approaches Saint Ursula at the apex of a triangle of light. The green outside the windows suggests a light brighter even than bright moonlight. Saint Ursula, her easy repose indicated by the single right hand curled to support her cheek, lies with her eyes closed. The dog, caught on one arm of the triangle of light, lies curled up, looking out at us, at once inviting us to apprehend the scene through its eyes and canceling that possibility by inhabiting a different world from the saint and the angel. For the moment everyone else but the pair in prophetic communication also inhabit a different world: only she and the angel know that she is to die at Cologne. The two graceful, semidraped statuettes high on two walls facing her are more classical than Christian; they too are ambiguous, the sort of sculpture one might still just find in a church. Together with the flower pots, the elaborate candle holder, and other furniture, they add a Flemish note of genre to the painting, assimilating the dog, too, for the set of genre—but only partially. The statues cannot speak, and there are two of them, matching Ursula and the angel, behind whose head one of them is posed. The angel speaks, but he is supernatural; Ursula cannot speak because she is asleep. The IN-FAN-TIA of her pillow is her device here. The only creature that could make a sound is the dog, which sits with jaws set in a kind of watchful silence, a silence that centers the painting and reverberates through it in the very incompleteness and impossibility of iconographic closure. It is both a key and not a key to the five beings who square the room: Ursula, the angel, the two statues, and the dog, which opens the schematism and refers it back to the painting for a signified that is irrecoverable outside of its own order.

In *Theseus Receiving the Embassy of Hippolyta Queen of the Amazons,* a big dog sits poised with its head turned sideways, as if in some other oblivious world, under an Oriental rug draped over a low balcony, against a prominent, light pediment, between the mounted Queen of the Amazons and the seated Theseus. The dog occupies the only intervening space between them, and there is nothing it signifies that can refer to

them. It is also alone. In *Two Venetian Ladies,* the same number of dogs makes an elaborate pattern with four birds. In *The Arrival of Saint Ursula at Cologne,* a large spotted dog sits alone on the dock in the left foreground, as though continuing, enlarging, and estranging the already alien world suggested by the single dog in her bedroom. The only other animal in that large, complex canvas, aside from the horse ridden by a warrior, its head turned away like the dog's, is a large eaglelike bird (of prey?) perched prominently against the sky. The bird sits also with its head pointed out of the picture, in the opposite direction from the horse and the dog. It sits on a diagonal with the dog, and also with the horse, but not the same diagonal. Still, the distance between these two diagonals is exactly spanned by the tilt of the pike of the warrior, also armed with a large sword, who alone approaches the rowboat into which Saint Ursula is beginning to disembark. In *The English Ambassadors Before the Father of Saint Ursula,* a pair of greyhoundlike dogs is nearly blotted out by the head of one of the ambassadors; a third dog accompanies a triad of men on the quai. A fourth, greyhoundlike dog, still darker than the others, is prominently isolated in the distance, its body overlapping the two light spaces of pale rose quai and green canal.

Birds have a complex, different iconography from dogs, in the bestiaries and elsewhere. However, taken singly, they are assigned marked positions in some of Carpaccio's painting, as emphatically placed as they are dimly connected to any signification other than a qualifying and contrasting one. On a balcony along the lower edge of *Saint Ursula Taking Leave of her Father* perches a large bird with red, black and white bands on its throat, next to one document folded and another draped on the balcony. At the bottom of *The Disputation of Saint Stephen* perches a large speckled guinea fowl, dark beside a white pillar, with a medallion giving the date of the painting, between that pillar and the one bearing another medallion of Carpaccio's signature. In *The Return of the Ambassadors to the King of England,* a somewhat large bird of similar shape perches on the steps to the right, near a monkey. The monkey itself, dressed in a luxurious garb, looks almost human. The animal's pensive solitude puts it into relation only with the large bird; it is unassimilable to any of the iconographic stereotypes for apes and monkeys in the Middle Ages and the Renaissance that H. W. Janson classifies.[23]

As in this painting, Carpaccio's birds usually occur in juxtaposition to other animals, and usually enigmatically. In *Two Venetian Ladies* and *Portrait of a Young Knight,* the juxtaposition becomes fairly elaborate. The birds strewn in the background on the grass behind the heads of

kneeling figures in *The Obsequies of Saint Jerome* recall in their multiplicity, disposition, and spacing the common medieval iconography of Saint Francis Preaching to the Birds. They stand, however, to the left of a palm tree on both sides of which, in a line with them, animals of other significance are engaged—one grazing ass, one dog tied to the tree, one mounted horse. Dark against the light stairs on the right of *Saint George Baptizing the Heathen King and Queen,* a bird perches that is almost paired with a large, frontal white greyhound, its head tilted out of the picture. They stand between two turbaned figures seen from the back, pointed past the animals toward the kneeling king and queen above them.

As for prodigious animals in Carpaccio, these carry their usual signification, with only slight differences. Their prodigies are carried in their bodies. In *The Presentation in the Temple,* a large, collared unicorn couches at the foot of the stairs that the Virgin mounts. The unicorn surely signifies the chastity of the Virgin, though it is innovatively pointed in other directions by being on a leash held by a boy who looks up and gestures to the aged priest, as though in prefiguration of the twelve-year-old Christ Among the Doctors. And this unicorn is paired by an obscured rabbit couched near the boy's feet, as though to assimilate it to genre possibilities. Interest in the unicorn and its complex iconography comes to a head, in any case, during the period immediately prior to Carpaccio. The unicorn tapestries in the Cloisters, and those in the Musée de Cluny, are both from the late fifteenth century—1500 and 1480–90 respectively— which places them exactly in Carpaccio's working life.

The lion may signify the majesty and violence of the natural order, and Carpaccio's *Lion of Saint Mark,* set against the view of the city, may be taken to do so. In the Caen *Sacra Conversazione,* on a natural bridge spanning high above the distant city and the holy group below, a white-bearded, walking Saint Jerome moves toward a small domesticated lion with head lowered, its majesty and violence wholly obscured. Majesty and violence flare out as a threat in the iconographically unique *Saint Jerome Leading the Tame Lion into the Monastery* (figure 25). The strangeness of the saint's relation to this prodigious instance of the natural order is strikingly indicated by the near monks and animals, who are speeding to flee in all directions from the calm saint and his obedient lion. They cannot see the obedience for the threat. But the assimilation of all such relations into a *Pax Christiana* is indicated by the calm of the distant figures, grazing birds and several groups of people undisturbedly going about their business.

A dragon lies coiled and smiling behind Carpaccio's mirror-holding

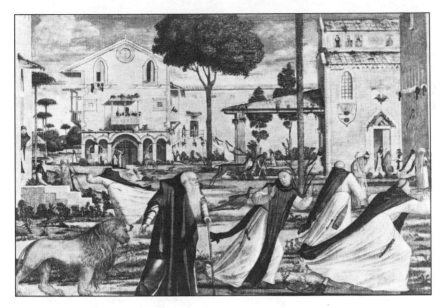

Figure 25. *Saint Jerome Leading the Tame Lion into the Monastery,* by Carpaccio. Courtesy of Alinari/Art Resource, Inc., New York, and Scuola di S. Giorgio e Trifone, Venice.

Prudence, its eye tilted up to her as though allowing its own containment by her force. The dragon seems to warn those who look directly into the outward-facing mirror that they face, in effect, the alternatives of Prudence or Dragon. In *Saint George Fighting the Dragon* (figure 26) the threat of the creature is underscored by the grisly half-eaten torsos, one of a nude man whose genitals remain intact, and one of a still-collared woman, barebreasted.[24] Miscellaneous skulls and bones are strewn all along the foreground of the picture under the full horizontal group of mounted saint, transfixing lance, and dying dragon. The rescued Princess of Trebizond stands much less conspicuously in the background behind the saint. The half-eaten woman pulls the princess into a visual antithesis. The next in the series, *The Triumph of Saint George,* is also iconographically unusual, compared, say, to the slightly earlier Saint Georges-with-slain-dragons of Piero della Francesca and Paolo Uccello. Saint George displays the limp, dead beast while almost surrounded by a large, celebrating crowd in an Oriental city.[25]

In all these paintings the energy has gone not into redefining the animal but into altering its context. The same may be said for *Saint Tryphon Exorcising the Daughter of the Emperor Gordianus,* which stands near-

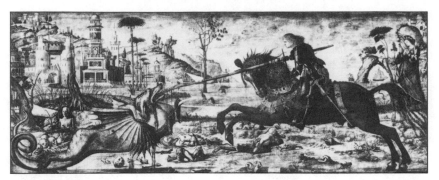

Figure 26. *Saint George Fighting the Dragon,* by Carpaccio. Courtesy of Alinari/Art Resource, Inc., New York, and Scuola di S. Giorgio e Trifone, Venice.

by on another wall of the Scuola di San Giorgio. The mere act of prayer on the part of the little saint has seemed to call forth the dog-sized prodigious basilisk that stands stalled before him. What Michel Serres says of the first Saint George, in which he enumerates the coherences among the orders of animal, vegetable and mineral, may be said of all these paintings: it is not a problem, but the emblem of solutions.[26] The animals in these paintings, by being freed from their usual contexts, and often from any simple form of their prior significations, are "as much subjects as the subjects" themselves.

Serres says this of the birds and dogs in *Two Venetian Ladies*[27] (figure 27), but it may be said of all. In that particular painting we cannot follow him by allowing the doves to be just an emblem of Eros, the vases of fecundity, and the pomegranate of fructification.[28] Although dressed in a way that suggests they are about to go to a ball, these two women sit hunched in a languid immobility that seems totally preoccupied with daydreaming. They stand in no full relation to Eros, or to fructification. They do not look at their pets. The animals strangely echo that immobility—especially the birds, which sit unnaturally still, unnaturally close to birds of other species and to the dogs. This area is strangely crowded for them, while spacious for the varied and assured designs and compositional strategies of the painting generally. They figure in an organization that led Ruskin to call it the greatest painting in the world.[29]

The white-collared dog, seated in an impossible posture, looks out at us, while the foreground woman holds its paw limply in her left hand. With her right hand she holds a long, chewed green stick that the larger dog, only his head and paws visible, bares his teeth to receive. He looks one way across the painting, she the other way. His left forepaw strangely

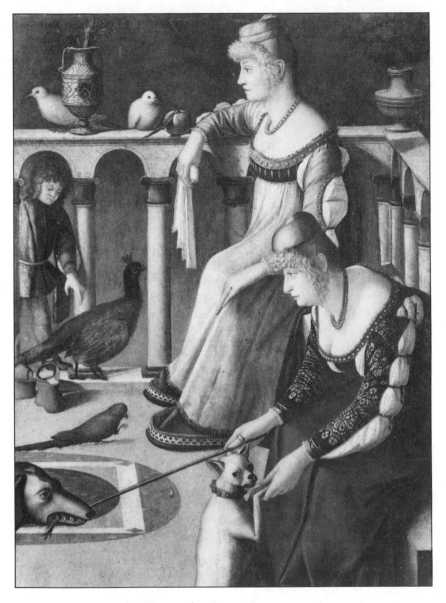

Figure 27. *Two Venetian Women,* by Carpaccio.
Courtesy of Museo Correr, Venice.

mimes her gesture by holding down a folded and slightly crumpled piece of paper. This looks like a letter whose messages would be forever closed to him.

The third person in the picture—the boy in the left background—seems to be reaching forward to mirror her gestures by petting the peacock, who takes no notice of him, crowded behind it and almost on top of it. The whole assemblage—different birds, different dogs, boy, women, vases, pomegranate, the maze of squares in circles on the floor, white pillars spacing the greenish walls—presents a stasis of full visual organization and impossible congruences, a dead heat of figuration. The doubling of the similar women, the similar doves, and the dissimilar dogs, offers congruences to sharpen the incongruity by contrast.

Doubling distributes the mystery, simplifies it, and multiplies it. In *Ceyx and Alcyone* we are shown a deer and a rabbit to complicate the two nearly billing birds. In *The Nativity of the Virgin* two rabbits play like cats on the background floor. In the Brera *Disputation of Saint Stephen,* the foreground guinea hen, though shut off by the solid procession of figures, triangulates with two other animal representations in the picture, a white horse and rider on the left, and the statue of a white horse and rider in exactly the same posture atop a tall pedestal held up by sculpted pillars in the background. Those pillars are seen between two plainer foreground pillars. Hen, real horse, and statue horse comprise a symmetrical visual order and a lopsided logical one.

The *Saint Augustine in his Study* (figure 28) contains only one animal, the shaggy little white dog looking up in the middle of the floor. Yet the animal's singularity qualifies the exact order of the volumes around the study, which may be counted, as Serres informs us, [30] to exactly the ninety-four the saint lists as his works in the *Retractationes*. The luxury of such a dog counters the austere seriousness of the studying saint, and its live collectedness seems out of place in the traditionally crowded miscellany of inanimate objects in the *studiolo*. Yet this *studiolo* is comparatively uncluttered. It has broad spaces, as though to make room for the dog. If it is a Maltese dog, does the painter hint at the span of the saint's consciousness between Rome and Africa, midway between which stands the Island of Malta?

As Jan Lauts says, "Carpaccio generally works with a relatively small number of stock figures and motifs."[31] At the same time he works on a large scale, as attested by his total work's unusual preponderance of multiple paintings in assigned series. This preponderance would be even more marked if we still had the large Ducal Palace murals on which he spent much of his time in early maturity, works lost in the fire of 1577.

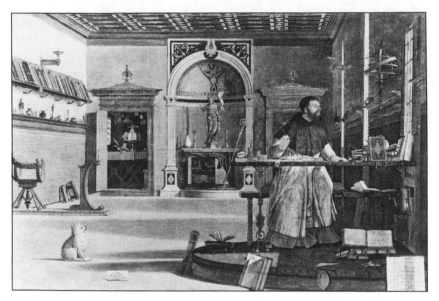

Figure 28. *Saint Augustine in His Study,* by Carpaccio. (Alternate title: *Saint Jerome in His Study.*) Courtesy of Alinari/Art Resource, Inc., New York, and Scuola di S. Giorgio e Trifone, Venice.

The discrepancy between a complex presentation and a small repertoire is modified, I have been arguing, by the redefinition not only of what the animals in his paintings signify, but by their very mode of signification, referred almost always back to the painting itself. Such a discrepancy appears most remarkably, perhaps, in the *Young Knight in a Landscape* (plate 3), where elaborate, and undeflectably significant, color juxtapositions are matched by the presentation of the figure in an unusual position—in a landscape.[32] While he seems to look forth alone, he is accompanied by the somewhat distant black-and-yellow checkered page behind him. The animals are composed singly, and isolated from one another. Out of perspective against the clouds a heron and a falcon are engaged in improbable and unnatural combat.[33] Off by himself sits another bird of prey, and at the foot of his nearly bare tree sits a dog somewhat like a Saint Bernard in a posture so anthropoidlike that Serres takes it for a cross between a dog and a monkey.[34] In a pastoral scene, water birds, a white rabbit, and a deer turned away to the water are clustered below a tree in leaf. The head and shoulders of a brown-eared white dog trail the page's horse. In the flowers to one side of the knight runs the white ermine. The knight's hand firmly clasps his sword, and he almost faces us, though he looks off and down to some undefined threat. His back is to

every single one of these animals, and they cannot stand for whatever threat he is at that moment facing. They fill out but complicate his world.

In another iconographic connection, Carpaccio shows a marked predilection for northern places—England and Cologne—and for Oriental locales. He makes a point of Orientalizing his biblical scenes rather than domesticating them to Italy, the usual practice. Often they derive from the Oriental Other to Venice at this time, the Turks. Orientals are other within the human sphere, as animals are other within the world of animate creatures. Both sets of aliens converge, without being allowed the partial assignment to an estranging system. They harmonize in the order of the painting because they are not coded into some order prior to it.

Bosch: The Limits and Glories

of Visual Signification

En face du discours, il y a la figure-image; dans le discours il y a la figure-forme. Le redoublement de l'une sur l'autre est ce qui permet peut-être à la poésie de représenter la distance présentante.

J. F. Lyotard, *Discours Figure*

Panofsky concludes his masterly *Early Netherlandish Painting* by demurring before the task of providing for Hieronymus Bosch any coordinate set of iconological principles: "In spite of all the ingenious, erudite and in part extremely useful research devoted to the task of 'decoding Jerome Bosch,' I cannot help feeling that the real secret of his magnificent nightmares and daydreams has still to be disclosed. We have bored a few holes through the door of the locked room; but somehow we do not seem to have discovered the key. . . ." He goes on, characteristically, to quote what is itself a quotation by Ficino's translator: "This too high for my wit/I prefer to omit."[1]

It is striking that Panofsky's combination of massive learning, deep connoisseurship, and originating subtlety at iconological formulation cannot establish a ground for expounding "the real secret" of signification in Bosch's paintings. Without overlooking the half-lights and ironies of Panofsky's concluding statement here, I should like to explore further the cue that he has in fact given us. As with Botticelli, Giorgione, and Carpaccio, we must go beyond the principles offered in this one modern theory of visual signification—*grosso modo,* of iconology—to begin to make sense of what is going on in such a comprehensive painting as *The Garden of Earthly Delights* (plate 5).

Bosch's new direction involves a new set of dimensions for the images he uses. The ordering and the profuse array of entities in this vast painting suggest an encyclopedic look at the human comedy, the definition of Dante combined with the variety of Chaucer. While the adaptation of a conventional afterlife triptych reinforces this sense of order, the painting energetically realigns it by presenting complex, original combinations for the constituents of its dozens of original figures. It further complicates its

signs by setting these figures into complex and original combinations of relationship to each other. The triptych order holds these in place, a fixity across which they can swarm, while the viewer alternates dialectically between the panorama of the whole and the microscopic sharpness of the significant, myriad parts.

To begin with a "single" image in *The Garden of Earthly Delights*, take the pair englobed, along with a strawberry inside a crystal ball, afloat the largest of the two ponds in the center panel of that painting (figure 29). Crystal has an iconographic history and so do lovers, but a crystal englobing lovers does not. Rather, the crystal as a motif appears in the outer wings of this triptych itself when closed: a crystalline sphere represents the third day of Creation. The association with crystal generally, and with this counterpoised large inclusive sphere specifically, would give a "positive" or "paradisal" cast to the lovers. Yet many interpreters read this center panel as a portrayal of folly, and certainly these lovers, like others in the center panel, seem to be incapacitated as well as absorbed. For one thing, they seem unaware of the strawberrylike fruit enclosed with them in the crystal—itself a puzzling addition as a theme or tradition but quite understandable as a motif.[2] The strawberry suggests indulgence, the connection of exquisite gluttony with refined lechery, as in the larger strawberry. Juan de Siguena very early called the whole *Garden of Earthly Delights* "The Strawberry Plant."

In its actual pictorial presence, however, this berry, which carries straws on its surface like a strawberry, is rounder than strawberries usually are. And it rhymes with three nearer rounded red fruitlike objects, two of them simple rounds, of which the most distinctly identifiable is a cherry with a stem immediately below. One of these fruits rests in the half-splayed groin of an upside-down naked man whose head and shoulders are entirely submerged. This is a giant sectioned berry or pomegranate out of which pokes a long-beaked bird that pecks a smaller berry-laden stem growing out of the opening in the big red berry. Further on, in a line from the englobed lovers through the upside-down man, there is a group swimming round a giant grape. Then there is a still larger, paler berry-pomegranate festooned with growths out of which two people peer, one of them reaching over to the grape stem, while out of the other side a third foot is kicking a smaller hole. The third object is a complex composite fruit with a long spiny tail and a window out of which a man looks in the opposite direction.

The englobed lovers are pointed toward, but are not looking at, the Adam and Eve who dominate the left or "Paradise" panel. They are also

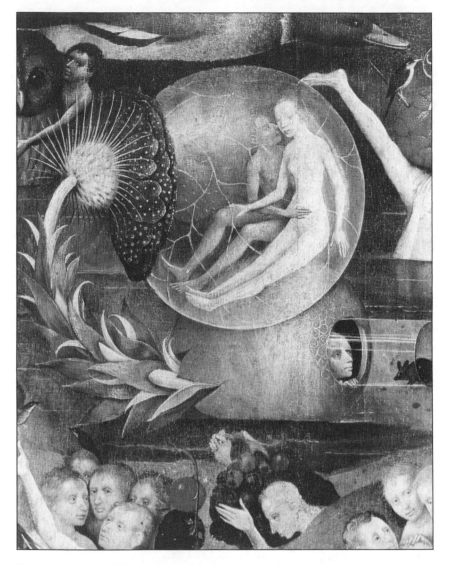

Figure 29. Detail of the Lovers Globed in Glass, *Garden of Earthly Delights*, by Bosch. Courtesy of Prado Museum, Madrid.

in a line with this Adam and Eve, who are sometimes taken to contain cues of less than paradisal bearing.[3] Cracks seem to mar the surface of the crystal, and it floats unstably and mysteriously atop the composite fruit. Pressed against the globe like a sponge is a fruitlike flower of speckled black that grows out of the end of a thistle, itself growing from the tail of

the large red fruit-boat. This spongelike black adhesion would prevent
the lovers from seeing Adam and Eve, were they to look. Their crystal,
however, since we see through it, is nearly transparent, except for the
black vegetable adhesion that is their point of connection with the single
man-in-a-fruit. He is likewise englobed, except that he looks out of his
aperture. Immediately below them, along the shore, are the heads of a
close-packed motley crowd. Above them, almost touching the top of the
crystal globe, is an outsize duck or goose in straight flight. To their left,
again in line with Adam and Eve, a single man embraces a murky owl, a
bird that can be taken in itself to represent either wisdom or heresy.[4]

To further frustrate univocal readings, the embrace in this context can
be assimilated to the erotic, in which the owl would be something like an
allegorized human. But it can also, of course, be assimilated to the doc-
trinal. Or to the hosts of other birds near and far in this panel—them-
selves susceptible of separate iconographic readings.[5] The wings of the
duck-goose brush the head of this owl, which is so outsize that, if the man
is normal size, it would be twelve feet or so high. The owl stands upright
and still, unnaturally so, especially as it is submerged chest-deep in the
same water. The man embracing the owl does not look at it; he glances
sidelong, and his look to the distance is in marked contrast to the self-
absorption or close-range vision of all those nearby. If he is looking at
anyone or anything, he is looking through a side of the crystal globe not
visible to us, and through to the lovers, though the same black adhesion
may be blocking his view.

Questions of iconographic combination, of iconological syntax, of per-
spective, of scale, of color symbolism, and of course, of the final bearing
for this typically involuted detail, and of the whole picture—all these
questions crowd in upon us here. Taking color as an example: given the
rhyming of the neighboring red fruit, the large pineapple-tailed boatlike
one shades off into lighter reds and whites on its tail, containing the enig-
matic contrast of "fading" as an accompaniment to both chromatic dif-
ferentiation and vegetable complexity. The tail does not end, though: it
produces a fibrous pistil that sprouts in filamentlike shoots, all of white.
This white pistil in turn extrudes as its flower the sponge- or bloblike ex-
crescence of bluish black shading into brown and flecked with seeds
whiter and larger than those on the strawberries, but distributed in a sim-
ilar pattern. This pressing flower has affinities—distant ones—with a
peacock's tail (and its iconography), and closer ones with the truffle, the
beef heart, a darkened version of a lung, a mashed version of a bunch of
grapes, and doubtless others. It is in fact indistinguishable, the sort of

composite biomorphic form that Hans Arp called a "concretion," though in modern sculpture such separate entities as fruit and breast are wholly fused into one "word," whereas in each of Bosch's figures the constituents are distinct and contrasting, a "complex sentence." The man looking out of the composite fruit peers not through a hole like some others and not out of a window but down a horizontal tube of glass up which a rabbit-rat seems to be moving—and all this introduces still other questions.

Reinforcing the grape cluster as a constituent of this composite image are some objects in the neighborhood—the outsize bunch of grapes just below and to the right, bluish shading to black. And directly to the right is an even larger bunch of grapes. Both these are being eaten, whereas the composite "bunch"-flower only presses against the glass bubble of the couple, who are not even eating their "strawberry." This, as a red object, rhymes with the cherry immediately below the flower and to the right of the bluish-black grape cluster. Perched atop the head of a black woman is the cherry, one of the several which are seeded through the center panel. Each is an iconographic extension of the black among the Magi, except that in *The Garden of Earthly Delights* such figures usually appear singly. Another black woman, with bluish highlights on her body, engages in an embrace similar to that of the englobed couple: she and her lover are surrounded by gigantic birds that look off into a distance possibly including the englobed couple. They are red-crested; and black, in this whole segment of the middle panel, is juxtaposed to red in various combinations, just as it is more fiercely in the red fires and black darknesses of the "infernal" right panel. Grapes are black enough, then, that a blackish cluster, in its main role as a flower, still may be assimilated partially to them. Together they enter, through their color, a patterning of somewhat different objects in the neighborhood and very different objects at a distance. Blue, too, rhymes—or rather it casts its hue everywhere, not only over "flower" and grapes and black woman but on the water—more distantly than on the sky. The crystal globe contains a light bluish hue that immediately suggests a transparency letting through the blue of the water. But it could also be a reflection of the sky.

Even Gombrich's syncretic formula will not cover such cases as these. "A motif in a painting by Hieronymous Bosch," he says, "may *represent* a broken vessel, *symbolize* the sin of gluttony and *express* an unconscious sexual fantasy on the part of the artist, but to us the three levels of meaning remain quite distinct."[6] Leaving aside the philosophical question of whether levels in a single wordless painted object can remain "distinct," even such efforts to present the beginnings of a comprehensive account

must fall short. They are too univocal, too tidy, too tied to the single-gauge explication of what in such painting as this has been brought to a pitch of interpretation. And it is the combination of motifs in a single figure, rather than the richness of a single motif, that is most striking. "Represent," "symbolize," and "express" leave us about where we began in trying to read sense into the associations and nexuses of visual cue in the crystal-globed lovers-with-strawberry and the objects in their neighborhood, let alone their position in the whole *Garden of Earthly Delights.* Personifications of ideas such as those Gombrich finds in Rubens, in the Didactic tradition that can set visual description against definition in Leonardo's "Allegory of Pleasure," in the emblems of Ripa, in the *imprese* of seventeenth century tradition and the later "Icones Symbolicae" of Christophoro Giarda, in the Hieroglyphics of Horapollo—even in the anagogical and mystical symbols of Christianity—all these, as Gombrich reads them, are univocal entries, some richer than others, in a separate lexicon of iconic staples. But we must ask, last and indeed first, how radically, and why, Bosch has transformed the staples, and why he has radically turned them into visual metaphors by linking dissimilar staples. "Where symbols are believed not to be conventional but essential," Gombrich well says in discussing the discrepancy between Ficino's serpent-with-a-tail-in-its-mouth and Horapollo's,[7] "their interpretation in itself must be left to inspiration and intuition." Just so, if one wishes not ever really to discuss the most engaging cases of signification. But Bosch's painting forces us beyond such lexica, beyond even the "confluence of traditions" that Gombrich finds in the *imprese* after the Platonizing of Ficino.[8]

Already in 1602, José de Sigüença refers to Bosch's "macaronic" manner.[9] *The Garden of Delights,* of which de Sigüença speaks, is indeed a composite and can only be understood as such, and as a composite that redefines its own conditions rather than through one or another univocal key. It is, in fact, a composite itself made of composites. Indeed, Bosch's less complex paintings pose a comparable problem of transformed iconographic sense. As Charles de Tolnay points out,[10] the Rotterdam *Prodigal Son* (figure 30) picks up the classical motif of Hercules at the Crossroads and adapts it to the Christian theme of the Prodigal Son. Even if it is so, this classic iconological transposition, right in line with Panofsky's description,[11] raises some quite new typological questions: the Prodigal Son is an anti-Hercules both as a failure and as a submitter. At the same time the Prodigal Son in himself is scripturally an Everyman figure, linking Old and New Testament, a sinner in his departure and a be-

Figure 30. *The Prodigal Son*, by Bosch. Courtesy
of Museum Boymans-van Beuningen, Rotterdam.

liever in his return. And if his father is an analogue for the Father, then
Hercules' heavenly father Zeus and earthly father Amphitryon enter into
a different relationship, not at all seen in this picture of Bosch but connec-
table through the typology. They are connected in a strange, distorted
way, too, if the fact that the young man is prematurely grey be connected
to the theme and the motif: the son too shares in the father, within the
Christian sphere, whereas the classical Hercules never gets grey but dies
abruptly on his pyre. The seedy inn, possibly a brothel, of the painting
picks up and transposes the philandering of Hercules; it debases it. Lotte
Brand Philip, taking in the dog, the owl, the thread in the hat, sees, too, in
this canvas a Saturnian cast, which gives an astrological overlay to the

picture.[12] This overlay is hard to make primary to the picture and still leave motif and theme emphatic; the overlay has both classical and Christian connections, like the motif and the theme themselves.[13] But "Saturnian" will not connect specifically with either Hercules or Prodigal Son. It interprets them; they interpret it. Bosch here mixes a free play of signifiers with a fixed conjunction of signifieds, and the specificity of the conjunction is reinforced by the careful attention to pictorial detail. This triple interlocking procedure is stepped up in *The Garden of Earthly Delights,* where the signifiers proliferate and the signifieds are isolated into fixity. The pictorial detail attains a sharpness and clarity reminiscent of the miniaturists and of Van Eyck.[14]

This is but one example. As de Tolnay says of another painting,[15] "It would seem Bosch wanted to honor (the woman taken in adultery)"—a statement that will carry us far in the inversions of his work, not least in *The Garden of Earthly Delights.* What, indeed, are we to make of a concert in an egg? What are we to make of a boat with a tree for a mast—in Bosch or for that matter in Leonardo—even given the "Dionysiac" motif of the mast sprouting when Orpheus is aboard? *The Ship of Fools* (figure 31) is one of Bosch's simpler paintings, and the mast of the ship dominates its vertical axis. In the foliage of the tree-mast a small death's-head is concealed, above a spread crescent-banner, itself standing above a roast chicken tied with a ribbon to the body of the mast that a man holding a knife reaches up to cut. He protrudes from a lower burst of foliage, almost tangled in the guy-ropes that are tied just below the chicken.

In de Siguença's words, Bosch "ventures to reveal the inner man." He does so, as he must, in resolutely outward visible forms and shapes. And, according to Otto Benesch, Bosch is resolutely significant at every turn: "There is not a single technical achievement in his painting and drawing which is not conditioned by one element or another of the *picture content* . . . no picture content . . . not tinged by the artists's . . . manner of *seeing.*"[16] Let us pursue the impetus of Benesch's italics further.

It is no wonder that, faced with the plethoras and enigmas of this or another painting by Bosch, interpreters have tried to impose upon it some univocal order consonant with a traditional conception of how significations in paintings connect. Wilhelm Fränger, on scant evidence, enlists Bosch in the Adamite Brethren and then proceeds to refer every condensed mystery of his to some specific mystery of theirs.[17]

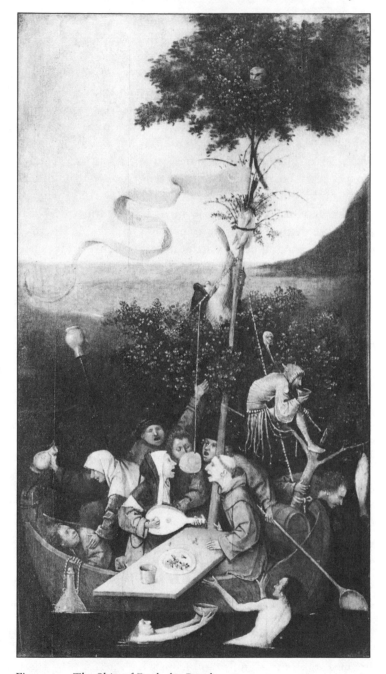

Figure 31. *The Ship of Fools,* by Bosch.
Courtesy of the Louvre, Paris.

Others, reading astrological or alchemical symbolism into a few details of a given painting, then in effect turn that painting into an exposition of some specific astrological or alchemical viewpoint.[18] The intent, of course, may rest simply with identifying one source for Bosch in alchemy or astrology. But it should be seen that such sources compound the difficulty of interpreting a work, while of course at the same time helping to solve it. De Tolnay, acutely sifting all these claims, himself keeps opting for the sexual interpretations of Dirk Bax and others, according to which, in line with fifteenth century and earlier dream interpretation, various images represent the male and female organs, not just the bagpipe but anything bulbous or sticklike and pointed, or round and elongated, or concave like the oyster shell.[19] Such interpretation, while not "wrong," does more than (permissibly, in my view) break one severe canon of art-historical iconographers by adapting a twentieth century figure, Freud, to explain fifteenth century symbols. It also creates the problem of what sort of dialectical use we may make of the Freudian dreamwork when dream and reality are thus put on a par. Bosch confounds, more than usually, our hermeneutic strategies. Even when the large composite fruit discussed above is seen as a symbol, it is complicated enough to be breast, vagina, penis, and body and womb-with-man-peeking-out or bodies-in-conjunction, all at once. This much condensation is possible but unlikely in a single dream image. And then how do we interpret the real bodies surrounding the fruit, not to mention, once again, the englobed bodies and the globe itself against which its perhaps rubbery excrescence presses? Moreover, the whitish shoots of the stemlike protuberance, the white filaments strung out of the pistil, and the rindlike red belly of the fruit could be tough, while some parts, like the "flower" itself, could be tender—a variety of textures to accompany a variety of related growths. These are not easily assimilable to the simple softness of flesh. And if these attributes are to be translated into sexual significance, a principle of translation is called for. In the dream books of the fifteenth century, de Tolnay tells us, the strawberry represents lust. How then do we align the strawberries, mostly of colossal size, whether enjoyed or not, with the actual lovers, with the other fruits, with the other plants and animals, with the ponds and shores and spaces, in the center panel? And, finally, what value do we assign to this sexuality? To call it lust, to refer to the medieval tradition associating *luxuria* with *gula,* locks this painting and others into staples of signification from which it seems by the ferocity and outlandishness of its invented combinations to be trying to escape. And yet to assimilate *The Garden of Earthly Delights* to the surrealist celebra-

tions of sexuality in Tanguy or Max Ernst or Matta or Dali or André Masson or Paul Delvaux or Hans Belmer[20] is to perform upon it a simplification that anachronistically drains it of all but an anthropologically qualified religious content.

The very richness of Bosch's iconography implies a wealth of sources, and for all his work he draws deeply on traditional Christian motifs and themes. The Last Judgment, the Temptation of Saint Anthony, (both of which he painted many times), the Saint Christopher, the Epiphany, the Marriage in Cana, Christ Before Pilate, The Adoration of the Shepherds, The Seven Deadly Sins, Saint John on Patmos, Saint Jerome, Saint John the Baptist—these constitute the preponderant subjects of his work. In the light of this dominant Christian-devotional element, and especially of the *Last Judgments* and *Saint Anthony's,* we must see even *The Garden of Earthly Delights* with its Adam and Eve on the right and its Inferno on the left as firmly contained by the iconography of Creation and Apocalypse.

One by one Bosch's images accrue the associations of their tradition, and associations are added. In the Philadelphia *Ecce Homo* there is a beetle on the banner, lower left, and men are shown to be like insects,[21] as insects elsewhere in Bosch act like men. Leading to a further combination, Barbara Babcock cites ancient *adunata* and medieval drôleries of animals dominating humans to illustrate Bosch's assimilation of "symbolic inversion" from his tradition.[22] The birdlike Satan who "gulps down sinners as if they were grapes" in *The Garden of Earthly Delights* comes from Tondalus, as does the frozen pond and a few other details, in this and other paintings.[23] This twelfth-century vision was published in a Flemish translation in 1472 and in Bosch's native's Hertogenbosch in 1484, right at the point of his prime. Still, Jean Combe qualifies the derivation from Tondalus by citing details from fifteenth-century iconographic motifs. It could be that such figures as the giant demon on a flying fish and others are suggested by Dürer's *Four Horsemen of the Apocalypse.*[24]

The crystal ball round Christ in the Madrid *Saint Christopher* does seem plausibly to hint at the untransitory nature of the Christian experience [25] and to shed light on the crystal ball englobing the lovers, as well as on the large crystal ball of the third day of Creation that takes up the whole of the closed shutters of *The Garden of Earthly Delights.* In the Chrystler Collection's *Temptation of Saint Anthony* a bird demon reads mass, alluding thereby to the black mass, as again to inversion between man and beast, and the Saint Anthony conforms to the Flemish type of solitary saint mediating in a landscape.[26] A. P. Mirimonde offers a

"positive" reading (rather than the "lustful" one) of the bird with a fruit in its beak on the vessel carried by the black king in the *Epiphany:* he claims this is a parrot, not a pelican, holding in his beak the cherry of the paradise promised to man.[27] If so, this sheds light not just on one dense detail of that painting but on other birds, other berries, and other blacks, in *The Garden of Earthly Delights,* and elsewhere in Bosch.

Indeed, Bosch's birds seem always supernatural, and alternately—or even, if it were possible, sometimes simultaneously—paradisal, neutral, and infernal. We cannot say purgatorial, unless all of his work be taken as the sort of visual purgatory that it presses toward being. Bosch, like those in the main line of early medieval tradition (but not Dante), in his explicit representations favors heaven and hell against purgatory.

Dirk Bax traces Bosch's animals to medieval bestiaries, and to the *Legenda Aurea,* published in Gouda in 1482.[28] De Tolnay reads the golden calf, monsters, and the swan, as symbols of heresy.[29] But the swan is also a symbol of music.[30]

There are, in sum, many currents of symbolic usage in the middle ages that lead to Bosch—the tradition of the mystic vision in Tondalus and others, the tradition of alchemy, specific northern pictorial traditions as these assimilate the manifold Christian symbology, the traditions in literature that find a salient representation in Bosch's own *Ship of Fools,* dream books, the *Hieroglyphics* of Horapollo, and the folk assumptions that lead to the proverbs that Bosch sometimes exemplifies or quotes.

And yet for all this, the hosts of individual, composite images like the englobed lovers in *The Garden of Earthly Delights* uniformly lack a source for the composite, even if one can be found for the separate constituent. Each of these other sources has its own orientation of signifier to signified, its own canons of sequence. Tondalus offers his own sequence, which is that of a serial voyage, something different from *The Garden of Earthly Delights.* As a painting it is spatial to begin with, and it has the air of drawing up the spatial sweep by which we apprehend it into the large technique of signification linking and also separating the entities that proliferate on its three open panels. The panels are sealed one from another, and yet the interassociations, of color and figure and gesture and collocation, make of them one cosmos as well as three separate realms.

Whatever purpose *The Garden of Earthly Delights* may have been painted for, the partition of it into three panels conventionally aligns the whole open painting, as well as individual details, with a religious organization of experience. It resembles a *Last Judgment* if the panels are taken separately, a *Temptation of Saint Anthony* if they are taken together. The closed panels, too, universalize the devotional intent of the work by showing the whole of creation. The inscription combines Psalms 32:9 and 143:5: "Ipse dixit et facta sunt / Ipse mandavit et creata sunt."[31]

Each of the three open panels, read for itself vertically, offers a self-inclusive set of panoramic scenes, with the focus in each panel just above the center. In the left panel, above Adam and Eve, picking up the red of the garment of Christ who stands between them, stands a large central tower, which is also a plant, a tree, and a fountain. Its scalloped leaves-petals, piercing yellow fruit, and berries are based on a plant "wheel" out of whose "felloe" an owl peers. The involutions carry us beyond the iconography of Paradise in the Bible or in art. So does the island on which this accretion-erection-growth is placed, a cornucopia/wreckage of pearls and berries that includes test-tubelike cylinders of color-reflecting glass, atop two of which sit birds on a smaller scale than the two above them or the peering owl.

This tower-tree in a pool has certain resemblances to the one in the pool higher up on the central panel, though that one has sharper appendages and a larger round for a base, which is a ball rather than a wheel, with nude reclining figures active on its rim. Its color is prevailingly blue. All of these attributes escape the iconographic set in which the whole "Judgment"-like painting seems organized. Mirimonde, like de Tolnay and others, calls the whole center panel a "folie érotique" and "un réquisitoire implacable contre la luxure."[32] But this reading of the center panel is not only disputed strongly by those who read it as a celebration of erotic activity. It ignores the center panel's analogues with the left "Paradise" panel: the towers, the general coloration, the pools, and the "innocence" of the many nude figures, who resemble Adam and Eve more than they resemble the tormented, metamorphosed beings on the "infernal" right panel. Moreover, Bosch in the fountains of this painting has adapted not only features of the towns he knew but such iconographic predecessors as

Van Eyck's *Adoration of the Mystic Lamb,* where a central fountain emits streamlets of water from a circular series of jets, much as in Bosch. That composite painting, too, has a flower-besprent meadow like that of Bosch's left panel, and towers in the distance.

Both the left and the center panels of *The Garden of Earthly Delights* are dominated by these water-filled depressions arranged in vertical ascendancy, whereas through the middle of the right panel runs a dark stream into which the large monstrous cripple, with figures dancing round the "sexual" bagpipe on his hat, dips a tree-stump half-leg into a boat that would be a shoe.

Read horizontally instead of vertically, then, the left and center panel outweigh the right panel—the center assimilates to the Paradisal left. Furthermore, Combe tells us that the mounts of the central panel are symbols of Christ in the bestiaries of the period—those of Philippe de Thaon, Guillaume de Normandie, among others.[33] These are the unicorn, the lion, the panther, the bull, the stag, the weasel (who destroys serpents), and the griffin, who echoes a griffin of Martin Schongauer.[34] Even the center panel of the *Hay Wain* (figure 32), which is usually taken as an indictment of worldly obliviousness in line with this or that Dutch proverb,[35] mingles Hellish and Paradisal figures atop the load of hay. The impressive blue demon, to be sure, has a monstrous and obviously useless appendage hanging where a penis would be, dragging on the ground and tipped with a peacock feather. But humans change to composite demons as we read the painting progressively to the right, in the direction of the wain's own progress. At the left of the procession, behind the wain, moves a stately, orderly band that includes clerics and a sagelike elder. This makes it hard to take the dominant center of the painting as simply sinful, or to assume that the Christ who watches upon the whole wain from the top of the painting is as simply locked into the oblivion of deploration that is indicated by the Eye-of-God at the center of *The Seven Deadly Sins* tondo (figure 33). Animals in pairs are represented in the Flood and Hell grisaille from Rotterdam, and perhaps the progress of the wain may be assimilated to that iconographic motif as well.

In *The Garden of Earthly Delights* there are almost enough animals for an ark, almost enough confusion for a flood. And water abounds as well. There is, in addition to the invented animals and scenes I have not yet discussed, a sort of overlay of the conventional iconographic elements one upon the other, Paradise over Judgment, possibly even over Flood, to the point where we cannot other than arbitrarily detach them and assign signification. Still less will the intricate contradictions of the evolved sign-

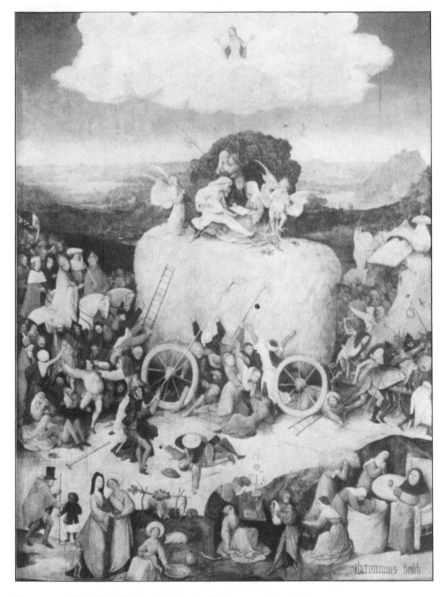

Figure 32. *The Hay Wain,* by Bosch. Courtesy of Scala/Art Resource, Inc., New York, and the Prado, Madrid.

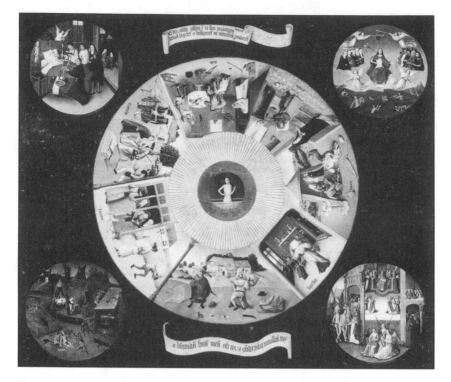

Figure 33. *The Seven Deadly Sins,* by Bosch. Courtesy of
Scala/Art Resource, Inc., New York, and the Prado, Madrid.

clusters in *The Garden of Earthly Delights* endorse the sort of values that
would have Bosch either simply praising or simply damning a simple if
polymorphously perverse sexuality. This freedom with the themes and
motifs of the Flood would be countenanced by the fact that in his paint-
ing of *The Flood* itself, Bosch does not follow the iconographic tradition
but goes back directly to the biblical text, which inspires him with a gran-
diose vision of an entirely new kind.[36]

The directness of painted images, their wordlessness, already contains
the possibility of going beyond levels of signification, in some version of
Dante's fourfold allegory. It is as though the *Four Mirrors* of Vincent of
Beauvais[37] were fused into one, and Bosch had managed to show us in a
single panorama the Mirror of Nature, the Mirror of Knowledge, the Mir-
ror of Morality, and the Mirror of History, without being turned aside by
lexical considerations from discriminating among them. What Emile Mâle
says of the Mirror of Morality strikes a note that accords with *The Garden*

of Earthly Delights: "The Vices are no longer personified but are represented by scenes of action on a medallion beneath each Virtue."[38] If we imagine Bosch as digesting the actions back again into new personifications and then obscuring the distinction only sometimes between Vices and Virtues, we come close to the significative structure of *The Garden of Earthly Delights.* Bosch's work generally offers modifications and complications of any single attitude, religious or other. Breughel's "Dulle Griet," by comparison, spreads a havoc more all-encompassing than anything in Bosch, and his "Tower of Babel" exhibits a society vastly and protractedly engaged in a more single-minded blindness than any Bosch can be found to suggest.

Contradictions of possibility, and not just iconographic complexity, plague our reading of *The Wedding at Cana* (plate 6). If Combe is right, this wedding has elements of the Last Supper.[39] The most pronouncedly evil elements in this canvas are confined to the top left and top middle—a bagpiper at whose feet is a tipped jug below which a man cranes to catch the falling drops. Beyond these, a whole swan is borne in, and a boar's head, on a gold platter, beside a strange-winged Cupid. But Cupid, pagan and ineffectual though he be, would not be out of place at a wedding ceremony, and swan was served once a year at the orthodox Brotherhood of the Swan in 's Hertogenbosch, of which Bosch was a member.[40] The central alcove itself resembles a chapel in structure. There are twelve vessels on the sideboard of this room, and its front is also segmented into twelve. The number, used in the format of a religious dining scene, may contain some hint of the disciples at the Last Supper (whereas this is The First Miracle), more plausibly than of the zodiac. Of these twelve vessels, one is a simple pot, one seems to be a dragon, one possibly a woman sweeping with an orb on her back, one a pair of what could be devils back-to-back with a ball of metal above them that looks as though it could not serve for a vessel. Good and evil mix here. This particular painting seems to make a point of presenting many mysteries, not least the activity and size of the young celebrant at the center of the picture whose back is to us and whose relation to the Miracle has no firm indication. There are, in Bosch's work generally, many people with their backs turned—an icon of simultaneous revelation and concealment. It looks as though this one is celebrating a kind of prefigurating Mass shadowed by elements of the Black Mass. In the light of such possibilities, the outsize face peeking through foliage into the open window cannot be reduced simply to a figure in a genre scene. However, the celebrant cannot be wholly evil—he alone is crowned with flowers, and of the many flowers strewn on the

table only the one before him holds two blossoms. His jewel-studded chair must be a chair of honor; the others are stools and benches. And its back shows a priest blessing a woman, if not two prophets. Nor can we really say that those around the table are inattentive to the Miracle, though they are certainly not attentive to it either. Rather, they are absorbed in its mysterious implications, and their visual situation reverberates with the full absorption of those complexities into the scene. Christ blesses the group in a dark blue robe whose color almost rhymes with those of six others, but exactly with none. The platter before him is in line on one axis with the young celebrant's gold chair. On another axis it is in line with the swan-and-boar-bearing gold tray, and with the gold hat of a mysterious Oriental-like figure on the right.

Into a rudimentary trefoil window peers an animal of the same brown as the building, a sort of giant salamander, its thick neck hanging over just visibly in the present state of the painting. In line with Cupid's arrow, it is on an axis with the white-garbed bride and with the left of the two dogs below on the pavement where water-wine is being poured. The salamander and the dogs are the only live animals in the painting, but they already suggest a larger world than that of the room in which the wedding feast is being celebrated. (The dogs may have been repainted in the eighteenth century. There is no reason to believe they were not there to begin with.)

Here there is a strenuous and at the same time placid attempt to catch the metamorphosis of the first miracle, and its typological connection with the Eucharist, in the mysterious flush of its actual happening. The figures in the painting do not stand as themes or motifs, separately or together, and the personages in the painting, for all their variety and homeliness, do not offer a spectrum of social types and reactions. Time and Space, through a perfused involvement in the change from water into wine, come into perspective as they come into question.

Bosch may break an iconographic tradition to assert a religious one, as when in the Philadelphia *Epiphany* he gives to the presenting Magi objects that look like the chalice and the monstrance associated with mass. Within his work he creates conventions of his own. The torments on the right panel of *The Garden of Earthly Delights* find many predecessors in his other *Temptations* and *Judgments*. The Vienna *Last Judgment* shows transpiercing knives, creatures with their armor grown

to their bodies, fierce spoonbills, semilizards and semibirds, large-headed animals on foreshortened bodies, tents upon tents, and the variety of scale so notable in *The Garden of Earthly Delights*.

In the Bruges *Last Judgment* there is a peering owl, a harp upon which a man is strung, a brown bird atop a blue bagpipe with four figures round the rim. These are in the center panel, along with a blue-faced devil raising a sword to whip a man who sits bleeding astraddle the blade of a giant knife that itself splits a large mussel.[41] All such figures echo *The Garden of Earthly Delights*, as does the head turning into a lizard, a metamorphosis grimmer and more fantastic than anything in Ovid, as are the giant man-devil with bird-fish back and a torture wheel emerging from the front of his hollow chest, or the deerhorned devil behind him leading a troop. These are composites of evil, like those in *The Garden of Earthly Delights*, transmutations of duress into impossibility.

These are all in the center panel. The left panel offers different congealings of image, many of them vaguely paradisal, like those in the center panel of *The Garden of Earthly Delights*. We are shown broken fruit, multiple towers, white birds, and a unicorn rider. In the lower left a man pulls the stem of a giant berry growing from a blue-green beak-flange, itself growing from a split-thorny red fruit-flower enclosing a green-black huger berry about four feet across, behind which is a naked loverlike figure in prayer, facing three naked kneeling figures, one extending a hand hiding a white bird. They are listening to a harping, red-cloaked figure who wears the rudimentary armature of angel wings on his back. Above all this floats a boat like a Ship of Fools but with white harping angels, fruit, a pushing unicorn, more white figures, a split fruit spouting sprouts, a swimming man, a drinking animal, a man riding backwards on a peacock and carrying a white double-stemmed pole from which a berry hangs. A gooselike bird watches this scene of suffused delight that has not found its way through to a triumphant salvation but certainly does not succumb, either, to the damnation of the other panels.

The Garden of Earthly Delights, in its initial impression, is Bosch's most hopeful painting, except perhaps for the Venice *Apocalypse*. Yet the right panel is more emphatically infernal than the other two panels are some version of the paradisal. The left panel is a Paradise in so far as it includes Adam and Eve. Yet at its left-hand bottom edge is a dark pool with a red rim, and round the pool are small versions of the monstrous lizards in Bosch's infernal iconography. The group is dominated by a three-headed salamander and a two-legged whiskered frog-snake encased in a prickly pear of a body.

There are, then, manifest contradictions within this one panel. The panels are not coordinate with one another, since the right more simply represents an inferno than the other two represent whatever they contain. Individual symbols are not coordinate with each other on the same system of signification. Bosch warps as well as constructs his code. Christological animals stand as compound allegories, while alchemical emblems, when they occur, are constituents of a physical-spiritual system. Alchemical emblems serve as at once clues and tools for releasing the secrets of the universe. That system is held up here, through Bosch's deformations, for wonder and folly at the same time. Other symbols indicate the presence of some fact, as the swamp tulip in *The Cure of Folly* (figure 34) signifies a thief,[42] a simple iconic cue. And more complex iconic cues, like the swan on the banner of the house the Prodigal Son looks back at (prostitution, but also perhaps song),[43] still do not reach the level of schematized allegories and emblems.

This mix of iconographic foci forbids our taking the simple oppositions within Bosch's painting for a simple system, as Ludwig von Baldass does: "Bosch painted, in the last analysis, a paraphrase of [Zoroaster's doctrine of the conflict between Ahura Mazda and Ahriman], though he clothed it in the garb of medieval Catholicism."[44] The "garb" of Bosch does not cover a stable body, nor is the garb stable. Simplifying solutions have here driven the sober art historian to the desperate expedient of applying an ancient Manicheanism to Bosch. Zoroastrianism offers no current of historical continuity to a painting that shows great richness of continuity with the traditions it transposes and transforms.

Sometimes Bosch offers us a sort of balance, as Walter S. Gibson[45] points out of *The Seven Deadly Sins* tondo: "In combining the Seven Deadly Sins and the Man of Sorrow, Bosch's Eye of God thus presents a twofold image; while it resembles Deguillaville's Mirror of Conscience in that it shows a man what he is, it also shows him what he should strive to be." This entire canvas itself was balanced by *The Seven Sacraments*, which de Sigüença tells us hung beside it in Philip II's bedchamber at the Escorial.[46]

In the great triptychs of the middle period, Bosch builds overall counterbalances into the large segments of the canvas. The reverse of *Saint John on Patmos,* as he awaits the Revelation, is a representation of the Passion, one recalling the Boston 'Ecce Homo.' [47] The Rotterdam *Flood and Hell* has medallions on its reverse with (undeciphered) biblical sayings. Christ stumbles carrying the large cross at an angle over his shoulder in a large, hostile crowd in the Vienna *Christ Carrying the Cross* (fig-

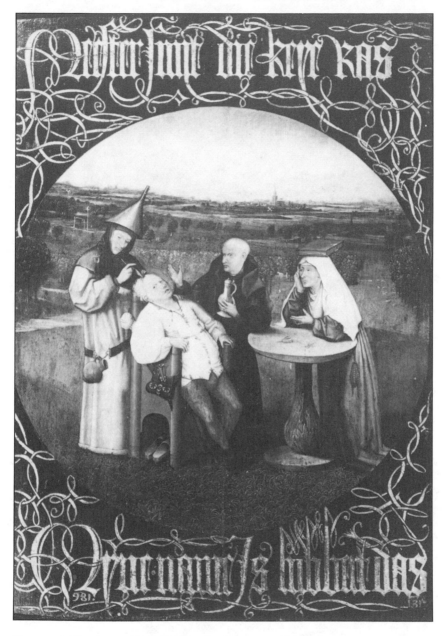

Figure 34. *The Cure of Folly,* by Bosch. Courtesy of Scala/Art Resource, Inc., New York, and the Prado, Madrid.

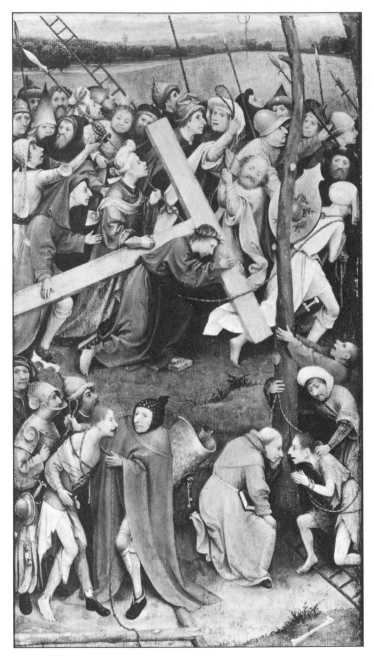

Figure 35. *Christ Carrying the Cross,* by Bosch.
Courtesy of Alinari/Art Resource, Inc., New York,
and Kunsthistorisches Museum, Vienna.

ure 35). On its reverse in a dark circle the Christ Child, all alone, walks upright while pushing a walking frame on wheels and carrying easily a slender windmill on a stick (figure 36). (The Brussels *Temptation of Saint Anthony* shows a red dwarf using such a walking frame.) The windmill is nearly at the same angle as the cross in the main painting, and it has nearly the same shape as the large Tau cross. Here typological figuration has been revised so as to be included within the single life of Christ. A scene with no biblical and little iconographic authority has been invented and presented so as to mount a number of balancing contrasts: infancy/bitter maturity, past/future, ease/pain, play/reality, triviality/momentousness, light windmill/heavy cross, naked child/clothed Christ, uncrowned/crowned, aided walking/stumbling, and perhaps others. The *Hay Wain* has a traditional Paradise on its left panel, with the serial presentation of scenes of the Garden from the Creation of Eve to the Expulsion. Its right panel is an Inferno. These traditional images balance the center panel, which may represent some proverb but is not traditional. Lovers atop the load of hay are attended by an angel at the left, a devil at the right, and Christ looking on from above at their activity, in this instance probably a representation of lust, since the lovers are "serially" first listening to music and then hidden in the bushes above and behind the wain. All this, the three panels and the moving wain, are echoed and redefined by the figure on the reverse outer panels, a vagabond, worn and resolute, making his way through a world that presents various serial instances of sin across its whole visible extent.

The Garden of Earthly Delights is balanced by a reverse showing the Creation on a Third Day that presents a reduced form of the abundant flora and fauna of the main panels, with far more emptiness surrounding them. On the wings of the Lisbon *Temptation of Saint Anthony* are the Kiss of Judas and Christ Carrying the Cross—more obvious correspondences than these others. Much less obvious, and indeed somewhat mysterious, is the Mass of Saint Gregory that somehow balances the Madrid *Epiphany* on the outer side of its wings. Lotte Brand Philip finds a balance within the *Epiphany* itself: "It is quite obvious that Bosch . . . represents the same three Kings who are worshiping Christ as the three Kings who are under the influence of the Antichrist," a conclusion she comes to by adducing "several superimposed sources."[48] What are we to make, though, of the bird with a human head pecking on the casket of myrrh, of the half-naked man at the door of his hut?

In the light of such powerful interplay, we may look for significance in the fact that the *Virgin and Child with Saint John* was originally a set of

Figure 36. *Reverse of Christ Carrying the Cross,*
by Bosch. Courtesy of Alinari/Art Resource, Inc.,
New York, and Kunsthistorisches Museum, Vienna.

folding panels for a large clock. And fusions take place in the individual iconographic details, as in the positive and negative sides of the swan— beauty and foul flesh, or prostitution and music. Bax notes[49] that the mother and child atop a rat in the Lisbon *Temptation* parody the Flight into Egypt. In the Brussels *Temptation* the shadow of a giant rat is thrown on the submerged castle wall. A broken fruit serves as a tent in the Lisbon *Temptation,* and the breaking surely signifies the vanity of transitoriness as well as empty lust, but the tent, given other contradictory signs in Bosch, may not simply signify an untrustworthy shelter. There is, in fact, the further powerful possibility that to turn a fruit into a tent leads in the direction of making the natural into the cultural, with a resultant amplification of the psychological into the physical, and a concurrent obfuscation of scale, since no fruit is large enough to serve as a tent. In the same painting the center panel is an unfinished tower that has sculpted on its broken side its own panels of foolishness and condemnation. Somehow, in the mysterious *Wedding at Cana,* a sense of the transformation of water into wine perfuses the picture, even though the guests seem not to notice, and the tiny heretical celebrant of something like mass dominates the center of the picture. He himself is in counterbalance to the larger but less conspicuous figure of Christ, and the balance performs a sort of judgment on the world into which extraworldly events must be assimilated. Indeed, the preponderant bulk of Bosch's paintings have some tinge of judgment about them, even if they are not among his many *Judgments.* One effect of the iconographic transformations is to activate the scene so as to subject all of its representations to a process of judgment. The insistence on not resting with traditional iconography forces an act of judgment among the many representations, as well as the act of deciphering an individual representation. This act of judgment flattens out the iconographic wrinkles and subordinates their particular internal structures to the large posing assessment they are thereby made to undergo.

What are we to make, especially in *The Garden of Earthly Delights,* of its persistent changes of scale? It is usually animals who are subjected to these changes, though the mostly human figure in the center of the upper right panel is gigantic enough to have human beings run round the circle of his hat. The devil in iconographic tradition is sometimes a giant. For Bosch's triptych the change of scale begins, in

effect, with the most dominant figure of the closed reverse panels, the diminutive God who sits above the large crystal globe, apart in his cavelike broken aperture of dim light.

Bosch offers not a single change of scale, but an arbitrary shift across the whole range of his painting. No one of the owls in *The Garden of Earthly Delights* is the same size. The owl that peers from the felloe of the wheel-tower-plant in the upper center of the left "paradise" panel is of a natural size, and this accords with the general adherence in that panel to a natural scale and perspective, though some of its creatures seem to be miniaturized. In the center panel, as noted above, one owl is gigantic, perhaps twelve feet high, out in the open and unnaturally up to its chest in water. A second owl, atop a topsy-turvy back-to-back dancing pair or monster, looks out at the far right of the center panel. It is perhaps four feet tall. This is almost within natural range for *Bubo Bubo*, the largest European owl. Such size accords well with the variety of perspective and scale in the large, dominant center panel, where eggs and cherries, pomegranates and oyster shells, grapes and strawberries, attain monstrous size. The only beings who remain in scale are the humans. The right "Infernal" panel repeats this variety of scale, and there too the natural human beings likewise remain in scale. The mysterious celebrant at the center of *The Marriage at Cana* is also either out of scale or a child—we cannot tell which.

The development of perspective, largely in Italy, had been brought to high theoretical complexity fifty years before Bosch's peak. That development continued throughout Italy during his working years.[50] The currents across the Alps were well established by this time in both directions from North to South.[51] Now Panofsky characterizes Van Eyck in this regard as reconciling the infinitely large with the infinitesimally small.[52] Bosch is a master, one who would have assimilated the developments in perspective of Alberti and Piero della Francesca, and who would also have been aware of what the towering Van Eyck had done within his own tradition.

It fits consonantly with such developments to see Bosch as someone who was able to go Van Eyck one better. He does not so much reconcile the infinitely large with the infinitesimally small as at once sharpen and erase the contours of figural relationship between the spiritual-psychological and the visual. Perspective and scale are a chief means of bringing such a figural transformation into the visual realm. A bird twelve feet high forces upon us the figural function into which its visual representation has been transposed. Human beings who are surrounded by such

huge birds cannot be placed univocally in a visible world; they must be referred to a spiritual one. But if the scale of gigantism varies within a panel, and all the more from panel to panel, then the spiritual significances at the same time resist the sort of full schematic allegorization that is consonant with prior medieval representations. The spiritual significances return, circuitously as it were, back to the visual again, especially if the human beings remain firmly in scale and in perspective. The elaboration of Dante and his illustrators has been achieved without the strong tie to the literal on which Dante insisted. We see such perspectival invention, according to de Tolnay, even in the already spiritual realms of the Venice *Paradise:* "In earlier representations . . . the light heavenly spheres were always shown frontally and were not so deep."[53] Bosch's *Prodigal Son* is not a giant, but he is enormous in size by contrast with figures in the near distance, and even more so by contrast with the tiny figures walking away in that further distance, and the tiny indifferent birds and cows who on a much smaller scale repeat the dominant indifference of some of those in the near distance. The woman peering out the kitchen window might be looking after him, and the indifference may be said to take over progressively as the distance toward which he is walking swallows up this traveler. The Brussels *Crucifixion,* in a juxtaposition reminiscent of Piero della Francesca's *Baptism,* places a large Christ squarely against a whole town in the distant background. Certain disproportions modify this, as notably that the three or four birds in the landscape are larger than the figures in the distance, some of them a neutral black, with their backs turned. In the Rotterdam *Saint Christopher* the animals for the most part seem to be ignoring the central figure. They are in natural scale, it would seem; if so, Saint Christopher is a giant (as he is often represented).

Distances recede from distances in the Ghent *Saint Jerome.* Just behind his cave are wrecked building parts, a lion, a weasel-like creature, an owl, and an upside-down woodpecker. On the shore of a distant pond are white birds, barely visible, and ibis under a tree. Beyond this, tiny figures walk a winding lane to a still more distant village, and white horsemen under trees move ahead of two other miniscule figures. In the *Saint Christopher,* too, church spires are visible in a distance beyond an already distant background.

By another and perhaps opposite strategy, Bosch brings the viewer squarely up to the picture plane. In the Ghent *Christ Carrying the Cross,* faces seen full size and in closeup occupy the entire picture plane. The effect is that of a focusing and truncation since canvases carrying faces of

this size are usually much larger at this period and much more complex in their distribution of personnel and organization of space. Similarly, if it is a faithful copy, the Brussels *Adoration of the Shepherds* shows the huge muzzles of animals overhanging the crib of the Christ Child and dominating the canvas, at least four times the size of the shepherd in the near distance and his tiny sheep.

Bosch varies his scale, then, from painting to painting, and he manipulates scale freely. But only in the major triptychs does he mingle the varieties of perspective. Memling, too, accommodated varieties of scale—in his 'Flemish' side the miniaturelike figures of the *Saint Ursula,* and in his 'Italian' side the large Christ at the center of his Antwerp triptych. There is an implied difference of scale in Van Eyck himself, if one sets the large heads of his portraits against the careful miniaturelike perspective of his more panoramic canvases. In *The Garden of Earthly Delights* the viewer's closeness to the picture plane and the relative size of the persons and creatures shown have entered a complex matrix of distortion where bearings cannot be had. This appears most notably, again, in the marked differences of scale for handling the birds. Those creatures themselves are of markedly varied scale, and birds in a wide range of sizes do to this day profusely populate the landscape of the Low Countries, especially out in the fields; Bosch's wife owned a country retreat well away from the town.

The handling of birds in *The Garden of Earthly Delights* distorts not only perspective; it also abrogates the natural territoriality according to which birds are disturbed if their space is infringed upon.[54] And it annuls the natural shyness between men and large birds, catapulting thereby their visual relations into the realm of that which is not visible.

Carrying a further emphasis toward a fusion of the visual and the unallegorized spiritual is the manipulation of space in the panels of this painting. The left contains the single human figures of Adam and Eve, a young Christ-like God between them. In the center panel, various groups comport themselves and disport themselves in patterned circles. In the right panel, a still greater crowding takes over; some persons are packed through the entrails of an enthroned devil, globed, and dropped as excrement. And also on the right panel, at stretches a vastness of void prevails; there are areas where no living creature penetrates.

Consider Breughel's *Netherlandish Proverbs:* some hundred or so proverbs are represented on a single canvas by being acted out in separate groups. The effect is one of crowding, and of the spiritual character of that crowding. We have the same effect in his *Children's Games,* where hordes of little clusters are disposed around a village square. Now no vil-

lage square could contain so many groups. If it did, they could not possibly be so disparate. And so many children would not be allowed to run free without supervision. An iconographic mix supervenes here, between the painted village street and the painted crowd. Especially in *Netherlandish Proverbs,* many of the activities are private or unseemly, embarrassing in such a setting. Others are unnatural, the sorts of things nobody would do or could do. Considering Breughel's painting as a distillate of Bosch's practice, we can match in *The Garden of Earthly Delights* all of these discrepancies. More extravagantly than in its show of crowds where none might usually be found, Bosch's triptych offers crowds caught in a landscape where even single people may not be found. Paradise is not near at hand, naked people do not wander in groups through a fantastic garden, hell is not parallel to this world but a successor to it—in all of Bosch's other paintings as in medieval iconography generally. This apocalyptic time-set shows sharply on the many Last Judgments to be found sculpted over the doors of cathedrals, where clearly for all present the moment of death has been passed.

In *The Garden of Earthly Delights,* the selective jumbling of scale reinforces the iconographic incongruity. Birds do not stand still for people, let alone feed them giant cherries or marshal round them in open phalanx or allow themselves to be ridden. But what criteria do we have for the conduct of supernaturally giant birds?

Two traditions contemporaneous with Bosch have been adduced to account for the disposition of figures in such paintings, the tapestry and the miniature. Now each of these implies a particular social context, and therewith an orientation of its communicative act toward the viewer, as well as some conventions of scale. Each also implies an iconographic repertoire. Just as Bosch's painting may neither conclusively be set on the altar of a church nor confidently excluded from the altar, so, given its size and the medium itself, *The Garden of Earthly Delights* cannot be assimilated to either tapestry or miniature. This is, to be sure, obvious. Not so obvious is the consequence of this freedom with which Bosch manipulates just some of the conventions of shrinking scale for miniature—particularly the smaller birds in the left and center panels. Benesch, speaking purely of their visual properties, says of his paintings that "they lack that daylight clarity of Flemish painting and possess . . . the slightly veiled quality of the colours of a tapestry."[55] This is too simple; such a "slightly veiled" quality Dürer shares with Bosch, as against Van Eyck. "Bodies and objects are not modelled in the round but are conceived as parts of a flat surface." This, again, is too simple. The Eve and the other women

with their spread, flowing golden hair are as fully rounded as the figures of Lucas Cranach, or Van Eyck; and it is the vertical disposition of the objects in each panel rather than the handling of individual figures that produces a sense of tapestrylike flatness. On a tapestry, too, the figures are much larger with respect to the frame than any but the gigantic figures of Bosch. He has, in a sense, applied the scale of miniature to the space-plotting of tapestry—and then he has jumbled both. Moreover, the distinctness of individual figures, as well as the sharpness of color contrasts, recalls miniature more than it suggests tapestry. There are other packed triptychs, such as the one from Bruges at Chicago noted by Panofsky as anticipating Bosch.[56] Bosch, however, has made his packing significant by varying it considerably. He is also close enough to the medieval tradition of serial presentation to adapt it on occasion: The Creation of Eve, the Temptation, and the Expulsion are serially presented on the Vienna *Last Judgment.* Of the events in the panels of *The Garden of Earthly Delights,* either within a single panel or from panel to panel, we cannot decide on whether what is simultaneous in space is thought of as simultaneous in time or as serial. We may indeed treat these representations as simultaneous in time also, but Bosch's jumbling and distortion of other conventions allows a shadow to pass across this time convention too. We cannot dissociate particularly the center panel from the possibility of the seriality to which the spatial disposition of the separate groups may easily be assimilated.

The same sort of freedom shows in Bosch's use of color, which ranges from the conventional-naturalistic and the conventional-iconographic to the arbitrary and fantastic. Fire is red, hellfire is blackish red. Bodies are rosy white, and yet here and there in the central panel appear softly shaded black bodies. Plants are green in nature; they are rarely blue, pinkish-red, or livid black. Certainly they are not so in painting, and to attach such colors to such growths affords a powerful double disjunction to the natural landscape of Bosch. This is no *sfumato,* but an arresting of "plant" before unnatural color, coupled with a release of "blue" or "black" or "red" from coded iconographic function. The eyes and the emotions are forced to redefine themselves as they digest such perceptions. They simultaneously face the rainbowing, exactly naturalistic plumage of birds while taking in the riotous and ominous supernatural juxtaposition of colors in devil composites. One of these is the white-headed and -hooded yellow-triangle-eared, giant mouse-otter, trousered-legged in a yellow-dotted bluish black while a large light-bluish shield has grown to his back (plate 4). The shield itself carries, in a sharp mix of

blue and white, a severed hand pierced by a dagger balancing a single die atop two of its upright fingers. The mouse-otter clutches a black pincer-hand round the tannish-pink neck of a prostrate naked human victim. The die on the severed, knife-pierced hand, larger than life, rhymes with another die, still larger, in line with it above, atop the blond head of a woman whose eyes are shut, perhaps in horror at the demonic creatures pressing round her. Her die seems to be lightly supported in back by a branch-pike, slung from which is an eviscerated man carried by a giant hunter rabbit. Dice of natural size lie to the left on something like a back-gammon board, below which a goggle-eyed demon has a headdress—ears whose shape, whiteness, and erminelike spots rhyme with the mouse-otter's tail. In visual passages like these the symbology of color interweaves with a discordant array of thematically rich shapes and images.

Color is simpler, while strong in iconographic thrust, in Bosch's smaller works. In *The Cure of Folly* red attaches to a man's pants, to the book atop the nun's head, and to the wound being cured. Red in *The Garden of Earthly Delights* runs a gamut of figurations and obfuscations—hellfire, bloody lake, unnatural intestine-plant, body-shading, strawberry and cherry, bird-streaks, bagpipe, tent, lobster shell, sail on infernal lake, hell flag, roasting bodies. Unpacking the relations of signification among these attachments of color to objects, including their associations of iconographic history, would take very long indeed. And all of these occur in the center panel and the right panel. In the left panel, aside from bird-streakings, the reds are relatable: the earth rim of the lower pool, the garment of God, the fruit growing on the tree behind Adam, the plant at the center of the upper pool, and the bank outcropping at its right edge. All these reds have different tonalities, and yet all are vaguely associable as giving off the flush of *Paradise*. Still none, except the red robe of God, has a firm base in any iconographic lexicon.

Gold and green in *The Garden of Earthly Delights* is natural or supernatural, but not schematic. The ground in the left panel and the center panel shades from bright or dark green in the shadow to golden green in what seems to be the sunlight. Ground and upper sky in the right panel are a dark green, while the throne of the eating-defecating bird devil is gold. Gold are the "shoe" urns encasing his spindly legs, and gold is the large harp-torture instrument—and the gilding of the open book it sits on.[57] Gold are the coronet and the crescent atop the gold-shaded headdress of the devil nuns or prostitutes who are gathered behind the throne of the bird-devil, and gold or reddish gold is the hair of the multitudes of naked beauties in the center panel, as of Eve.

In *The Wedding at Cana*, as noted, a progression of blue gowns takes a cue from the blue of Christ's. Only the bride is clothed in white, but another woman is coiffed in white. The groom is clothed in pink, as is a magician figure holding a wand. Another mysterious figure on the right wears an Oriental-like hat. His green scarf almost rhymes with the gown of the young celebrant, and also that of the bejewelled and braided beauty who drinks absorbedly from a saucer. Green and gold are elaborated in the flowered panel of green on gold given much space in the upper right; that pattern is reversed by the gold on green of the scalloped outer piece framing this panel.

In another movement, if again the copy is faithful (or if the work is an original, as I believe it to be), a complex set of figures in the Galleria Cramer's *Contest of Carnival and Lent* is cast in a sort of grisaille tinted by the olive green of its background, one small color range encompassing a variety of images, as in some of the work of Mantegna.[58] The color varnishes over such figures as those of the dark faces peering through the right window at a wurst and a pigeon on a spit, or the fish carried atop a platter on the invisible head of a man or woman, or the monk who appears to be kissing this fish in some kind of anguish. In the Ghent *Christ Carrying the Cross*, the complexions of the large faces are set into sharp contrast in a range from flesh color to livid to pale to dark. A woman carrying the veronica wears a blue and yellow headdress and yellow earrings; she has a look of bliss at her center of shuddering. A man on the right has a rope around his neck and a coin on his wound. It is presumably the bad thief about to be hung, and he is clad in brown. Wedged above his face is that of a magelike figure, eyes closed, whose hat has a blue band peppered with yellow starlike dots. The tapering hat shows red yellow and blue in a rainbow configuration, and it is topped by a gold button and tassel with two gold hangings.

All these colors displace one universe of signification into the recombinations of a new spiritualized universe, envisioned hue by hue.

Thه works of Bosch's maturity are nearly all temptations," Combe says.[59] It would be more accurate to say that they contain an element of temptation. They also contain an element of Encyclopedia, a widespread form for medieval Latin writers we find extended as variously as the *Divina Commedia* and the *Biblia Pauperum* of the cathedrals. Indeed, even the Temptation of Saint Anthony, which Bosch painted or drew

perhaps as many as nine times, contains also an element of Encyclopedia, just as does that later work inspired by one of them, Flaubert's *La Tentation de Saint Antoine*. Unlike Flaubert's protagonist, the Saint Anthony of Bosch does not even notice most of these temptations. They proliferate and seethe around him, in the air above his head or concealed and waiting for him in some recess.

The existence of other *Temptations of Saint Anthony* in iconographic tradition, as well as the title affixed to Bosch's, firmly anchors them in an overall preliminary signification. It firmly anchors in the diabolical all the figures of a given Temptation. But the freedom of overall general representation in *The Garden of Earthly Delights* precludes our confining its particular representations to a single framing type, let alone to a univocal reading. So we cannot see the encyclopedic thrust of that work as providing only a summary of creatures inside a given framework.

A temporal dimension haunts the three panels, easing the viewer without focused iconological shock into a suspension of ordinary spatial association. There is a beginning on the left, the beginning of mankind, in addition to the punishment of individual sinners singly and in large groups. This temporal dimension has already been suggested in the reverse; the shut panels, before they are opened, show the Third Day of Creation, an event that precedes the Creation of Adam, and of Eve. Yet the reverse also is spatial, and in its spatial inclusiveness it is emphasized that the island with its undulating plain of vegetation and a few creatures is entirely surrounded by water.[60] However, even this reverse by itself, before it is opened to show the triptych, suggests the effects of time. As Gombrich says, "The bright curved streaks under the thundercloud on the left wing of the triptych cannot be all reflections on one enclosing surface."[61] Seen spatially—and the painting must be seen primarily as spatial, in the absence of limiting cues—the panels, and the reverse, supplement each other rather than succeed each other, though the Creation of Eve is one distinct limiting cue.[62]

Many features of the center panel of *The Garden of Earthly Delights*, as I have summarized them above, link it to the left "Paradise" panel. And other features link it to the Inferno at the right. But there the discontinuities as well as the continuities with the other panels rule out associating the entire painting under a single title heading. Any interpretation that would do so must ignore either the continuities or the discontinuities. In one sense this abstention from a single subject refers the viewer even more to the overall painting. Certain of the effects in the reverse do this too, as Nicolas Calas reads them, (though we need not follow him

in referring these effects to an Augustinian principle of moral antithesis): "By reducing the contrast between sunlight and moonlight to shades of grey and also reducing the difference in darkness between the *tenebra* enveloping the transparent globe and filling its lower depth to tonalities of grey,"[63] the coloration reinforces the sense that this globe is all-inclusive. It also dims the scene, as though throwing a veil over the whole. The blue bubble of the bird-demon's excrement englobes and veils two falling sinners.

Veils recur in the open triptych. The couple enclosed in a glass bubble have their sight blocked in the direction of Eden, and the bubble does not afford full transparency for them or for us. The pattern of cracks over the lovers' bubble or globe recalls the pattern of faults on the reverse of the crystal globe of Creation. The devil's buttocks-mirror blurs for the toad-and-reptile-afflicted nude who looks into it at the foot of the blue bird-demon's throne. Lovers just below the procession of miraculous animals try to look out under the half-sphere of a transparent veil, and the tent occupied by others next to them serves as a veil, we may say, rather than a shelter, in a landscape where no shelter seems to be needed. Two glass tubes veil another small group nearby. Here and there limbs are veiled by semitransparent water.

The symbology of such motifs verges on the encyclopedic. Again, for not being included in a single system of reference, it operates more freely—more directly on the visual field—to form its own system, one that cannot be called either exhaustive, or the contrary, because no criterion is given to permit a generalization of the motif. Each instance of a motif faces us, somewhat but not wholly enigmatic in theme. There are several kinds of berries in several sizes. (Size itself, in a sense, has become a motif here, for being liberated from perspectival constraints.) There are birds in several kinds and sizes. Towers of varying shapes. Fish and other animals. Plants. Minerals. Holes and structures. Pools and other bodies of water. Knives and other implements. Musical instruments. There are instances, too, of donation—most markedly the donation of God to Adam and Eve. Of coordination and cooperation, verging on love. And then of domination, in the Infernal panel. There is union and separation, herding, perhaps pursuit. There are processions, and scrambles. There are boats and other floating or swimming objects, recalling both motifs in Bosch's *The Ship of Fools*, itself more sinister, and richer in implication, than its source, the poem of Sebastian Brandt.[64] On the right there are strange organs, most notably the giant ears separated by a knife in the right panel.[65]

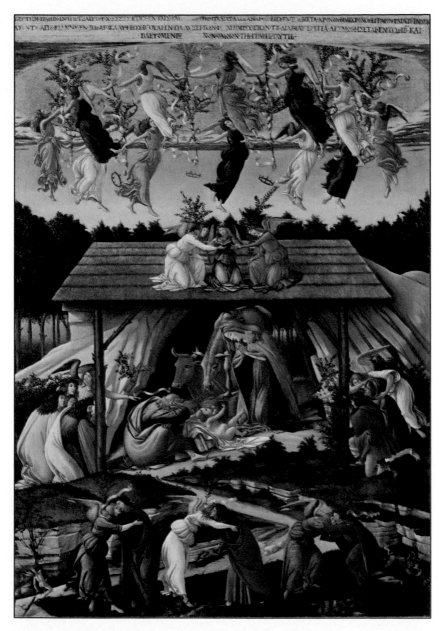

Plate 1. *The Mystic Nativity,* by Botticelli. Reproduced by courtesy of the Trustees, The National Gallery, London.

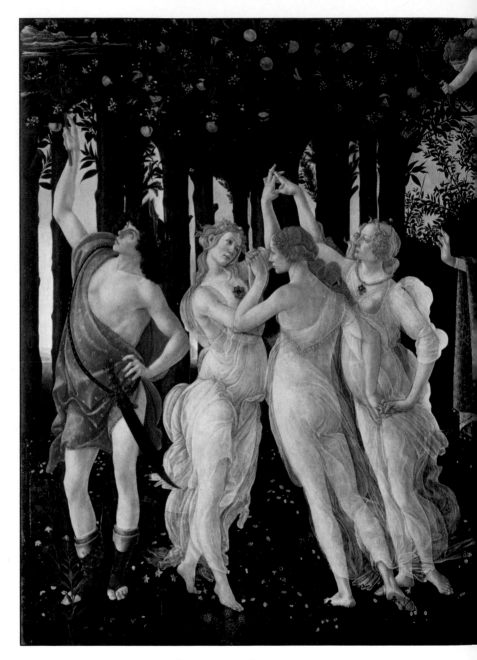

Plate 2. *Primavera,* by Botticelli. Courtesy of
David Lees and the Galleria degli Uffizi, Florence.

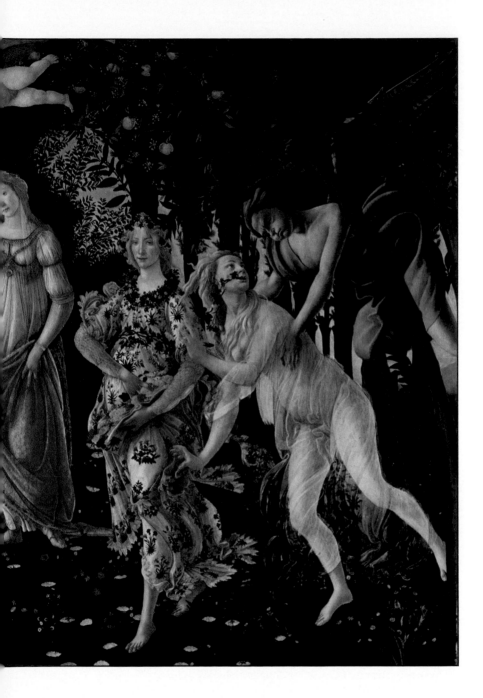

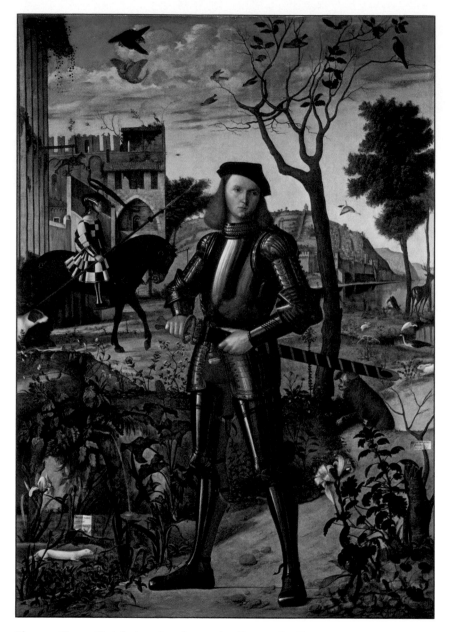

Plate 3. *Young Knight in a Landscape*, by Carpaccio. Courtesy
of Thyssen-Bornemisza Collection, Lugano, Switzerland.

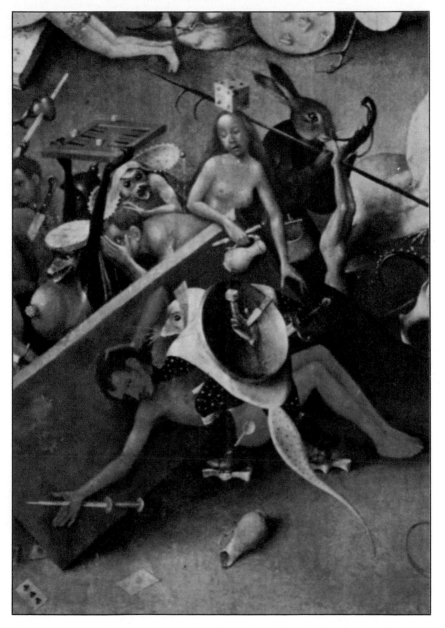

Plate 4. Detail of the Mouse-Otter, *Garden of Earthly Delights,* by Bosch.
Courtesy of Prado Museum, Madrid.

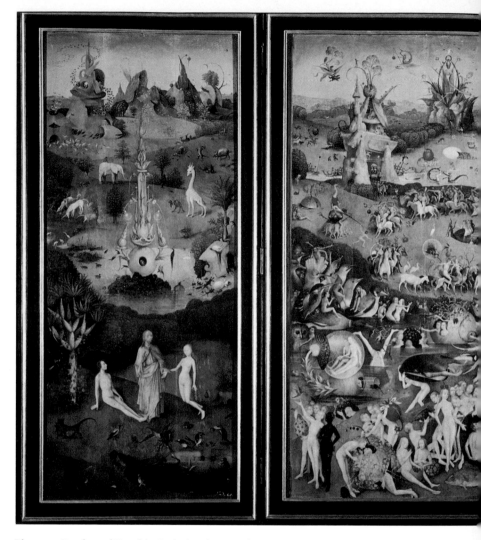

Plate 5. *Garden of Earthly Delights,* by Bosch.
Courtesy of Prado Museum, Madrid.

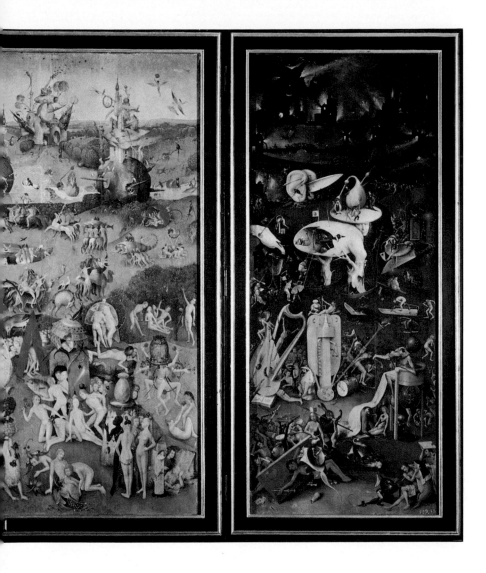

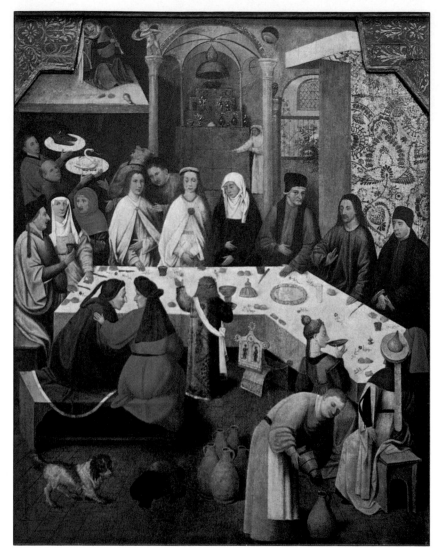

Plate 6. *The Wedding at Cana*, by Bosch. Courtesy of Museum Boymans-van Beuningen, Rotterdam.

The Garden of Earthly Delights was striking enough in its time to lend itself almost at once to abundant imitation.[66] As we move across the panels from left to right, there are differences in the handling of scale variation, in the disposition of figures, as discussed above, in the relative crowding, in the kinds of groupings, in the ground, and for the Inferno in the overall light. But there are also similarities. And the kinds of creatures differ too, with some overlaps. So on the left panel the creatures are mainly natural, but the pond at the bottom right—in the direction, so to speak, of the rest of the picture—contains a small unicorn-fish next to a spoonbill bird-fish that is sparring with a three-headed water fowl. It contains a dark spoonbill fish swimming and also holding a book it reads. The animals here, as in the central panel, are drinking and foraging, attacking, slinking, and resting.

The center panel offers a higher proportion of fanciful animals in natural scale, but these are mainly drawn from iconographic tradition—mermaid and merman, unicorn and griffin. An innovative exception would be the winged men aloft, one carrying a large fish, the other a large berry. And also there are a couple of strange persons standing on their hands who appear to be half-metamorphosed into berries.

The right panel presents, in full force, creatures, all of demonic character, whose relative freedom from prior iconographic association brings their constituents the more forcefully into significant association through the direct deduction of the viewer—the white mouse-man-otter shield, the bird-demon, the man-egg-tree stump, the pig-nun and the reptile-plant helmet-with-legs that plagues the man it is embracing-assailing. Armadillo-dogs, a donkey-rabbit, and a man-rabbit acting with a hostility not traditional for that animal are busy in a scene that includes a skating bow-spoonbill and a variety of other demons with armor grown into their bodies, a knife-head, a wand-nose, and a butterfly-winged and armor-legged bird, a bird-man, at least two more spoonbills, and others.

These are composite animals. The unnatural color of the plants in the central panel's blue "pillar" invites us to allow for their composite character too, and the roundish objects stacked and pierced upon them resemble sausage casings or internal organs in texture and color. Taken in themselves, the collocations of constituent parts for fanciful creatures are fiercer and more violent still in the Lisbon *Temptation* than in *The Garden of Earthly Delights*. In the latter, however, there obtains a greater complexity of significative combination. Some principle of metamorphosis is felt to be at work in the figures of a painting that generally increases in variety of proportion and in strangeness as the viewer's eye

moves from left to right. For the individual figures inner has become outer: the psyche has taken shape, becoming compressed and distorted and combined into a visible presence, strange and striking, like the green booted figure from the Vienna *Last Judgment* who on a green platform blows a horn that is his own substitute for a nose, joining other composite demons in assailing an Eve-like, golden-haired nude.

Such work goes far beyond the principle of distortion in, say, caricatures, which stay within a natural armature of features to lay stress by exaggeration on the properties of those. Bosch drew some caricatured heads, and as de Tolnay suggests, he may have known the work of Leonardo in that vein.[67] "Leonardo, however," de Tolnay says, "was interested in the abnormalities of nature as deviations from an ideal type, whereas Bosch accepted the ugly as a natural phenomenon." Or did he? We could also assert the contrary, especially in view of the fact that the most marked distortions of facial feature occur in other late paintings of Bosch like the Frankfurt *Ecce Homo* and the Ghent *Christ Carrying the Cross*. In those paintings inner is outer; the ugliness is at once natural and spiritual. In *The Garden of Earthly Delights,* taking this cue, we can say that the natural is fully spiritual, the visible renders the invisible, but the uniqueness of individual instances, even in their similarity, and at the same time their variety too, forbids our taking natural beauty simply as a celebration. It could also, and concurrently, serve as a temptation, and there is nothing in the painting to prevent our taking it as the one poised on the brink of the other. In any case we cannot confine it to the natural observation of some northern Leonardo transferring the examples of human variety from his sketchbook.[68] Even Creation is poised on that brink: there are animal pursuits in the reverse outer panels. And on the Paradise inner panel, as I have said, the "fountain" is a strange vegetable composite concurrent with the strange animal composites of the pond just below Adam and Eve.

When aligned with the composite fictive visualizations, all types in Bosch are ideal. This is so even for the natural types that D. J. Gordon notes,[69] citing Poliziano on the creation of new classical figures in the early Renaissance, figures arrived at by adapting and combining elements found in classical sources. Bosch, in the late Middle Ages, has already gone well beyond this practice by not always using the classical sources for what he adapts and combines, for the individual figures of his painting, and for the relations among them at a point in the painting or from panel to panel. He has found a way of bringing to visual coordination the sort of perception described centuries before by Pseudo-Dionysius: The

higher we rise, the more concise our language becomes, for the Intelligibles present themselves in increasingly condensed fashion.[70]

Bosch is not alchemical, even though he draws on alchemical images. He is not even alchemical in the sense that Jung transposes for alchemy, in which the univocal system of explanation for physical nature is taken for a diagram of psychological forces. Bosch draws the constituents of his pictorial language from too many contrasting domains, and the domains themselves do not correspond well, as alchemy and astrology may be said to do. A blue plant-tower with a red rim that naked creatures crawl over, with a hole in its belly out of which other naked creatures peer while one shows its backside—a tower festooned with kidneylike lustrous objects pierced or set off by similar others, some in crescent shape, topped by tiny perching birds and finally by an elongated bulbous dome—such a plant-tower bodies forth not the results of a system, nor of an exquisite painterly comment on something richly traditional for the spiritual life. This may be said of Piero della Francesca's *Nativity*, say, where we attend directly to the qualities of composition and pictorial representation, subsuming them under the traditional lexicon. Bosch, however, creates his lexicon from "phonemes" of separable iconographic elements, though his statement simultaneously bodies forth distinct representational elements. He offers *langue* and *parole* in a single, visually sealed field; and he offers also the exhilaration arising from so powerful an access to the innate properties of a communication in images not tied to the seriality of words.

Bosch manages the free play that the Freudian dream-material invites, along with the intricacy of connection, the fusions and lapses and changes of plane, that the Freudian dreamwork calls upon through its 'syntactical' rules.[71] And at the same time Bosch's message is more complex than the dream message, which according to Freud is largely decodable through a simple and single expression of desire. We cannot be wrong in finding desire a part of Bosch's world, and de Tolnay labels several unconscious or traditional phallic and vaginal emblems in *The Garden of Earthly Delights*. The Paradise-Creation panels, however, forbid our reading the whole painting for an expression of desire, as does the Inferno panel. And these other panels do impinge on the center panel, by iconographic correspondence and also by harmony of field, or with the Inferno by contrast of field. The plant-tower in the center panel, just taken

separately without its place of rapport with hordes of other images, is itself too complex to be simply phallic or simply vaginal. It is vegetable, but the blue ball at its center makes it seem mineral. It is natural, but its room and its rim and its tower and its unorganic structural additions all make it seem cultural, some dim correspondence to the many dark ruining buildings engulfed by fire in the Inferno panel. It resembles the sort of monument one finds in northern medieval towns, the gigantic central fountain. And it also is a fountain: it spouts water that a single man on the right drinks, in which a group on the left bathes. Since people occupy its hole for intimate activity, it resembles a home. It has the height that in a medieval town only a church can have, and it has a strange, elided version of a Gothic flèche. At the same time, its several crescents assimilate it to a heretical church par excellence, to a mosque. This is traditional: Carpaccio, Bosch's near contemporary, puts several crescent-topped spires in the Jerusalem of his *Saint Stephen*. The marbling cracks on the blue ball recall the cracks on the smaller globe enclosing the lovers in the same panel—and they also recall the obscure lines on the cosmic crystal globe of the reverse.

"The Hearing Forest and the Seeing Field" (figure 37) is the title of an extant drawing of Bosch, one of a landscape containing an owl and another creature or two. The composite bodies of the demons in the Inferno panel speak—but they also register: there is a preternatural alertness in these devils that the wiliest of their victims cannot escape. If they crawl up a burning tower, they are grabbed from behind. The mirror of a backside is a trap as well as a temptation. A few changes of scale from panel to panel and we are prepared for any change of scale, as well as for a logical relationship between change of scale and the function of compositeness for a composite body. A white mouse-otter-shield is possible in a realm where inner and outer have become so apocalyptically transposed that towers take on the attributes of inner organs and churches are indistinguishable from plants. And the portent of a white mouse-otter-shield combines with that of a bird-escort twelve feet high to shed portentousness upon such a tower.

As Adrian Stokes well says of the erotic element in painting generally, "Though the subject-matter of a painting be what the theologians call carnal beauty, in so far as the picture is a work of art, the particular erotic stimulus—no painted flowers seem to have scent, no aesthetic apples cause mouths to water—becomes secondary to a more general awareness of availability that has been heightened rather than dominated by the manifest erotic content."[72] There is a great deal of such heightening of

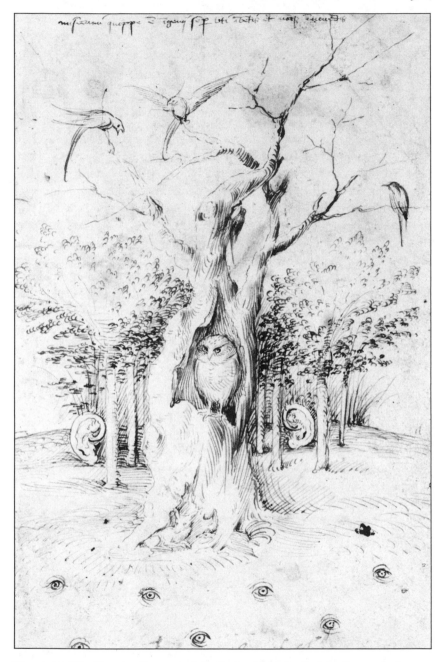

Figure 37. *The Hearing Forest and the Seeing Field,* by Bosch. Courtesy of Scala/Art Resource, Inc., New York, and Staatliche Museen Preussischer Kulturbesitz, Berlin.

carnal beauty as motif and as theme in *The Garden of Earthly Delights*. And the manifest erotic content reaches the proportions of profuse riot—in the center panel almost alone, with the merest intimations in the left panel, the most degraded equivalents for lust in the right panel, and a total absence of Eros in the Cosmic reverse.

The largeness of this canvas, its intricacy of detail, its varieties of scale and lighting, and its willingness to assimilate iconographic details from a variety of sources, impose on the viewer a constant active intimation of some larger whole that it constitutes, a larger whole that has struck a truce between randomness and order. It liberates from the univocal by substituting for the univocal not just one interaction but sets of interactions: between image and image, and also between image and the sense of image, between sense of image and reference of image, between sense of a set of images and the sense of some other single image, between sense of one image-laden area and the sense of another image-laden area. As Lyotard more generally says of what language and painting have in common, "Signification (The *Sinn* of Frege) does not exhaust sense, but neither does a conjugation of signification with designation (The *Bedeutung* of Frege). We cannot rest with the alternative of these two spaces between which discourse slides—that of system and that of subject. There is another space, a figural one. We must think of it as buried, offering itself neither to sight nor to thought. It indicates itself in a sidelong fashion, fleeing before the heat of discourse and perception as from what troubles them."[73]

Bosch provides such a space, trapping system and subject by setting them into interaction with each other in a sort of dead heat that is at once the celebration of a question and an assurance that if so much is brought to view no other answer is needed.

The Changeable Signs

If the viewer pauses to look at the painting, he is manifesting desire, inescapably. In Adrian Stokes' terms, he is invoking elisions between *part-object* and *whole object*."[1] At the same time, though, the painting is public rather than private. It does not engage or respond to the desire even as a conversation might do. The painting refers its communicative property not only to signification but also to the sort of experience the viewer has when he pauses to arrest, and indirectly to express, his desire. If the painting takes as an element of its subject some primary form of the desire implicit in looking at it—if it is a nude or erotic in some other way—its displacement of the desire into contemplation becomes foregrounded in the signs of the painting. It emphasizes the necessity of sublimation to contemplation unless it is "pornographic" in intent, aimed directly at the simplification and distraction of arousal.

Some heightening of all these processes (except the pornographic) comes about in the mythologies of Botticelli—in the *Primavera, The Birth of Venus, Venus and Mars, Pallas and the Centaur.* In each of these works the erotic is explicitly evoked and at the same time emphatically displaced. The displacement operates not through the handling of a single sign, even in *The Birth of Venus,* but rather in the interaction of signs. That interaction remains loose, rather than being locked into the iconographic syntax of one story, allegory, or system. The looseness of connection among the signs in the painting keeps alive the dialectic of apprehending it. Looseness allows the desire to float and at the same time to become generalized across the whole canvas, so to speak, rather than in some one figure or (taken differently) some lexical combination external to the painting. Desire, thus generalized, carries sublimation to its logical conclusion as that which provides assurance, an experiential equivalent

for coherence, in the painting. Desire becomes the somewhat abstracted subject as well as the object of the painting that has thus liberated it.

Some analogue of this process is harnessed by Michelangelo for the quartet of figures in the Medici chapel. Night is overlapped by Dusk and Day by Dawn. All four, schematically crisscrossed at the corners of the chamber, gather the resplendent body, with some hints of the erotic, into postures that are at once strenuous, pained, and rapt—much the way a viewer ideally responds to such works or others. "The Medici Chapel," Adrian Stokes says, "expresses the act of mourning and also the only answer to that condition, the re-instatement, the resurrection of the lost good person within the mourner's psyche."[2] Repetition overlaps Variation to keep the syntax open.

Syntax remains open while signs are fixed in the tarot pack, which developed prominently during the fifteenth century. No zero sum game is enlisted for the player of the tarots. Instead of two players, there is only one, the person whose fortune is being told. In another, somewhat over-schematized analogue to the relation between signs and syntax in Botticelli and Bosch, the player sets down an individual card, which has a fixed figure (The Fool) linked to a fixed suit (Pentacles). The order of the cards, however, is open, and it tends toward the ominous (rather than, as a painting does, toward the delightful) as it emerges. Then, of course, the order, when all the cards are laid down, gets interpreted, and a fixity comes about once more. There is a fixity at the beginning for the individual cards, and a fixity at the end for the interpretation. The middle, though, remains open, rather like the way signs lead to an open syntax in Botticelli or Giorgione.

Bosch, then, not only repeats signs that appear with similar conjunctions in the tarot pack. Still more than Botticelli does, he enchains a multitude of signs sharp enough and complicated enough to suggest fixity while actually withholding it—another analogue to the "middle" of a tarot reading. Now tarot readings tend to overbalance felicity by ominousness in the time-line of laying down the cards. Most readings carry some dire implications. The Eden on the left panel of *The Garden of Earthly Delights*, and the hints of felicity in the middle panel, become overbalanced—as though they were a tarot reading—in the terrible punishments of the right panel.

Desire, then, is not only evoked and sublimated here but is terribly displaced on the right panel while being traced to origins on the left panel, origins that contain a hint of ominousness not wholly to be divorced from the erotic in the strange creatures emerging from the pool near

Adam and Eve. The displacement, too, is of significative structures continually modified across the painting. Physically, the Eve of the left panel resembles women in both the central panel and the right panel. However, in their significative structure, Adam and Eve are typical as well as original on the left panel. In the middle panel the activities of all the acrobatic participants are quasi-allegorical, intimating an access to something like delight, a delight paradoxically coordinated with mysterious blockages to fulfillment. The right panel singles out individuals for punishment in the present for activities only hinted at in the past (gambling, lust, avarice, gluttony).

This change of significative framework from typical to allegorical and then from allegorical to individual permits, rather than discourages, association from one panel to another. If the three were all in one framework, the usual procedure, then each of the three panels would have a distinct, coordinated function. In the skewed signification Bosch has developed, the typicality of Eve in the left can be somewhat assimilated to the allegory of the center, which in turn sharpens through association with the individuation of the right panel, not wholly to be divorced from the typicality in the left. No system will either bring all together or dissociate all from each other.

Thus is enacted in the innovative sign-system of this large picture the process Lyotard notes[3] when he says that the symbol is a speech shuffled or confused (*parole brouillée*). The openness of the field generates a permutation of complexities, and the air of possibility persists over the distinctness of the individual figures in the painting.

Ovid, by failing to fix his mythic entities doctrinally, helps to foreground the physical—the nearly ekphrastic—qualities of his figures.[4] He consequently presents them in ways that are easily assimilable to the sculptural and spatial representation of images. Indeed, the Renaissance took them this way, and would occasionally re-render them. Botticelli goes Ovid one better by failing to fix them in narrative as well as doctrinally. Thus, even without explicit Ovidian reference, he can seem Ovidian in procedure.

The lingering over a gratuitous significant object in these paintings, the many mechanisms that converge to make one act of apprehending them, heightens a sense of space while also lulling it pleasurably by the very reassurances engendered in the process. Certain paintings are especially coded to further such a convergence, and certain icons. Madonna and Child do so by conflating a reposeful religious focusing and a schematic, primary psychic locus. Little or no sorrow is engendered in the viewer

when the painter touches in proleptic hints of the Passion as Botticelli does in the *Madonna of the Eucharist,* the sheaf of wheat or bunch of grapes destined to be called into service for the commemorative Eucharist. In such paintings the Passion itself is assimilated to the painterly repose, and the wheat and grapes pass through the mediation of a splendid youth who serves the Child, a John the Baptist who is later to suffer his own passion.

Eden, just as an icon, offers a space at once comprehensive and imaginary; it is the whole world, but by definition our eyes are forbidden actually to see it. Our eyes, then, are directed to a sort of further spatialization in the comprehensive nostalgia of a lost past as it converges with the hope of a millennial future. No time reverberates through All Time as we are shown an All Space that is now No Space, a lost utopia. Bosch finds a pictorial form for this convergence when he imposes Eden on the left panel of *The Garden of Earthly Delights* while organizing the triptych on a (varied) pattern of Last Judgment. In a poem the temporal sequence must be primary, and Stanley Fish has sensitively traced the consequences of such a condition for the primacy of temporality as it dominates the loss of Eden in Milton's *Paradise Lost* (though Fish underplays, and somewhat misrepresents, the concatenated theology of the poem).[5]

Botticelli in his *Mystic Nativity* simplifies, centralizes, and distorts the spatial proportions of the Nativity to accommodate his superimposition upon it of a sort of Celestial Eden. The world of Giorgione's *Tempesta* is comprehensive enough in its primary constituents to suggest an Eden, the Eden after the Fall that Settis exclusively identifies in that work. Instead of the profusion of animals in *The Garden of Earthly Delights,* it offers only two—a live white stork barely visible on a rooftop, and still less visible, a painted red dragon against a wall. Read in an Edenic context, the integer of the stork may be taken to stand, in the purity of its whiteness, for all animals in Eden, and that of the red dragon to be an icon—in Peirce's sense as well as in others—for the Serpent who long ago served to de-Edenize this garden. And there is the further tiny serpent barely visible in the vegetation at the bottom of the painting. So the Serpent is only memorialized dimly, by paint or faint hint within the painting. The man is clothed, as Man is after the Fall, and in a kind of pride. The woman is nearly nude, as before the Fall, and unerotically, in a kind of humility. The Eden of the Bible has four rivers; here a shrunken stream runs between the figures. The woman nurses a child, an event that happens, too, only after the Fall. The Fall is signaled by lightning from heaven, and a small flash of lightning, which gives its title to the painting, is the strongest indication of this strangely muffled storm.

The most recent cleaning (1982) of the *Primavera* reveals a sky of such astonishing blue that it may be taken for Edenic, or for that classicized Eden that once gave a title to the painting, the Hesperides. It expands to a universalized, comprehensive space the frontal horizontality of the painting, but it does not do so by giving any visual cues of receding depth. The sky is of an unrelieved blue behind the trees, as though it stretched to a universe beyond. Temporality works from right to left in the painting, from the intense moment of Zephyr, through the athletic turning of the Nymph and the dance or dancelike postures of Flora and the Graces, to the languidity of Mercury. Venus stands to one side in an atemporal fixity, while Cupid above combines the intent motion of Zephyr with the set posturing of Mercury. Being induced to read from right to left, a person who looks at this painting is thrown off his usual track and thereby enlisted in a process of temporal construction that by gradual steps runs through an associable variety of tempos. All of these stand short of the Edenic sweep, though they are possessed of a start toward the Edenic comprehensiveness. Spatially, the scene is universalized by the balance between the distant but uniform sky and the close grass and trees—both offering an Edenic profusion. Reading from bottom to top, one observes many precise, small flowers in the grass; in the middle a few rich, medium-sized flowers being strewn by Flora and printed on some of the dresses; and above the heads of all, a number of large fruits, orange against the green of the trees, "like golden lamps in the green night."

The dimensions of Carpaccio's *Young Knight in a Landscape* give that landscape setting a comprehensiveness and an exemplary—and so Edenic—character, reinforced by the iconographic novelty of doing this kind of portrait in an open landscape. In the chaos of predators among the many animals in the picture, only their profusion would touch on association with Eden, were it not for its many flowers. But here predation suppresses Eden, even if Eden retains some of its usual cues.

The new direction I am here asserting may seem a powerful one, but the period of roughly thirty years during which it came into being coincides almost exactly with the career of Columbus. And it is not only the voyages of Columbus that consolidate an age of exploration. His writings, too, in an admittedly loose analogy to the procedures in the paintings I have been discussing, leave almost wholly behind the reference points of traditional marvels that highlight the accounts of Marco Polo and other medieval narratives of distant exploration.

In the fifteenth century the host itself was being centered for visual contemplation in the newly invented monstrance, and the tradition of Mariolatry was complicating into the *Vierge ouvrante*, a statue of the Virgin that opened up to another, interior image of the Crucifixion, or even of the Trinity. In a countermovement the author of the *Imitatio Christi* recommends that his reader "pull the heart away from the love of visible things and transfer yourself to things invisible."[6]

Both iconoclasm and idolatry showed multiple, rich development on the eve of the Council of Trent. Many of the anecdotes in Huizinga's *The Waning of the Middle Ages* variously testify to the penchant for images in the public life of the time.[7] The elaborate ceremonials that accompanied many aspects of the Burgundian Court involved a staging of visual images, even for the administration of justice (41–42). "Charles the Bold . . . would deliver judgment in the presence of all the noblemen of his household, seated on a 'hautdos' covered with gold-cloth, and assisted by two 'maîtres des requêtes.' " Processions, amusements, and public events organized images to create and express the "haute magnificence de coeur pour estre vu et regardé en singulières choses." In both the Burgundian Court and the English Court that imitated it, a ceremonial magnificence was carried out, down to the very details of regulating the meals and the kitchens "of heroic dimensions" that produced them. The temporary triumphal arch that Dürer devised for the Emperor Maximilian (1515) carries with it the sort of improvisatory exuberance in the production of images, if not in their innovation, that we associate with Renaissance masques, or with Bosch's *Garden of Earthly Delights* and Botticelli's *Mystic Nativity*. Dürer's woodcut displays its image-elaboration in its mammoth size, and also in its nearly encyclopedic gamut in the variety of its still conservative icons, from emblems and coats of arms to items drawn from the *Hieroglyphics* of Horapollo, which Dürer had recently illustrated.

The various developments of an open field for the painting in Botticelli, Giorgione, Carpaccio, and Bosch, parallel, and in a sense anticipate, the liberation of drama on the Elizabethan-Jacobean stage both from the dependence on a prior known story in the Miracles and Mysteries, and from the allegories of the morality play. Not only is the relationship reversed between the figure and what it signifies, and consequently between stage and reality, as Anne Righter has deduced.[8] The freedom from prior and external coordinations, even more spectacularly than in painting, allows for bravuras and exfoliations of significational complexity, most markedly in Shakespeare but to some degree in others. Indeed, Spenser has already become, within the single allegorical frame-

work that he creates, multiplex in possibility. He has been compared, once extensively, to Botticelli.[9] The relations between signifier and signified in his figures—Sir Guyon, Arthur, Britomart, etc.—are at once more specific than anything in Plato and more coherent with his other abstractions, even if this or that idea is loosely derived from Plato (and the overall scheme from Aristotle). Malory (d. 1471) had already aspectualized these legends, putting them on a sort of par in separate incidents instead of stringing them in a continuous narrative line.

In later movements, the grail chivalry-type is taken as a sort of abstract model, a given for variations, by Ariosto and Tasso, as well as more abstractly by Spenser; and then it is satirized and turned back on itself by Cervantes. Analogues of these procedures can be found in painting, when the old iconography becomes even further standardized in sixteenth century painting, or else subjected to the visual counter-thrusts associated with Mannerism.

The powerful redefinition of images in Botticelli, Giorgione, Carpaccio, and Bosch was not picked up, in any case, by their successors in the sixteenth century, except partially by Brueghel. And still he does return to story. None of Breughel's paintings transposes images with the boldness of *The Garden of Earthly Delights* or *The Hay Wain*.[10] Perhaps the Council of Trent did succeed in cutting back the luxuriation of imaging. The post-Tridentine church did enforce its strong strictures on image and policed studio practice. It was not until the efflorescence of modern painting that the picture's significations were once more liberated from a predominant mimesis or a separable story—at a time when the work of Botticelli, Giorgione, Carpaccio, and Bosch has also come in for revived attention, though the implications of their boldness, I have been arguing, have not yet been effectively weighed.

A step further—across many centuries—and painting will realize the pure play of forms thought to be implicit in it. As Robert Delaunay formulates it: "The work of art is the fruit not of direct or indirect assemblages of aspects of nature, but of an ensemble of forms . . . the synthesis of forces in a presence."[11]

The visible interacts with the invisible in a painting as it forces its synthesis upon us by the resemblance between its "graphemes" and their significance.[12] Saussure has endowed modern linguistics

with the basic point that the series of letters *woman* does not point at— still less does it resemble—the live woman you may be seeing. The word *woman* is an arbitrary phonetic construct, triggering a lexical category in the mind, which in turn is taken to correspond to the woman. But Flora in Botticelli's *Primavera* does resemble a woman, even if she is not quite in scale, and even if we must be acculturated towards painting just to see this two-dimensional organization of colors as corresponding to the live body we may see.

Some residual resemblance obtains even when free floating color is un-attached to objects. The color red is more direct on the canvas than the letters *red* are. Modern painters may push color attached to mimetic ob-jects outside the mimetic range, by painting a body solid red or letting the same red cover wall, table and floor equally. In doing so they are enlisting the contradiction between resemblance and evocative signification that is already implied as a possibility in the constructive apprehension of any painting. Still the body, the table, the wall, and the floor are taken in by the eye as recognizably that.

When the disposition of colors and shapes within the painting becomes itself subject to high formalization—to perspective and to proportion— then a kind of abstraction has been adduced to govern the painting. Per-spective, as Panofsky said, is a symbolic form,[13] and its evolutions, through the discourse and the activities in the fifteenth century of Piero della Francesca, Uccello, Brunelleschi, Alberti, and Leonardo, extend in another direction the abstractions that the painters I am discussing have at times imposed upon the images themselves. Proportion engages Botticelli more than perspective does; and the same, with adjustments, can be as-serted of Giorgione, Carpaccio, and Bosch.

Proportion, however, is a development, as well as perspective. At no point over the ten thousand years of Lascaux were the animals proportion-ately arranged on its walls. Through a presentation of proportion across its surface, painting on Buddhist or Pompeian walls, as well as in the fif-teenth century, induces a sense that a syntax is already there and will be forthcoming. The elaboration of perspective and its sleights relies on such a reassurance as a kind of anchor for the activity it generates in the viewer. Even the deliberate disestablishment of proportion in baroque art, and the disposition of material on different planes in order to subject the viewer's will to the act of perception,[14] still implies an equilibrium of proportion-ateness against which the viewer is striving. Usually the iconography is fairly direct in such works. We recognize Bernini's Saint Theresa or Michelangelo's Moses, referring the tension between sexuality and devo-

tion or majesty and anger to the relation between these elements in the signifier rather than to a complexity among the icons in the work. The baroque space, a paradox of visualization, arrests us to seek a paradox somewhere, but not in the simple figure.[15] Botticelli and Giorgione pay more attention to proportion than they do to complexities of perspective. Their complexities reside in the relations among the figures. Carpaccio often emphasizes his proportions by large blockings in which smaller figures move. In *The Departure of the English Ambassadors* the figures are miscellaneously occupied through the palace, across whose interior an almost soft green light, shading to yellow, predominates, even over the sky visible through the receding arch beyond and above the angled staircase around and above it. The biggest single area in the painting, taking up about a quarter of its space, is the large, central geometric figure patterned on the green background of the wall, a figure elaborate enough to induce a viewer to trace its near-labyrinth of black-circle-pointed red rectangle, looping at top and bottom to black-circle-enclosing circles, bordering an octagon, inside which eight red-bordered squares, half of them green, are arranged symmetrically around a smaller octagon, linked by four lines at crossed right angles to the edges of another square at dead center.

Carpaccio, again, geometrizes, while not using live bodies as elements in his proportional division of the canvas. Bosch frames his swarming bodies by still larger proportional divisions. In all of these cases the contradiction implied as a possibility in an invented association of iconographic elements is at once fulfilled and superseded by spatial organizations. The whole process, to use Keats's word of the Grecian Urn, "teases" us. He said that it "teases us out of thought," though the deductions of his poem partially belie the assertion. The teasing of the viewer puts him out of thought in the sense that he lingers in the pleasure of the object but into thought in the sense that he must assimilate, and construct, its significative (as well as its visual) properties for access to it. Access does not entail the ability to replicate it. One can take in the *Tempesta* without explaining it. Taking it in, the viewer cannot be oblivious to its single figures or to the mystery of signification in the connection between them. In this sense the painting aspires to the condition of music, as Walter Pater said all art does.[16] As it happens, he said this of Giorgione. The viewer stands between being teased into thought and being enraptured out of it. The release from the univocal in Botticelli, Giorgione, Carpaccio, and Bosch intensifies, and in turn reassures, this intermediate state.

Still life, already to be found splendidly in the foreground detail of

Leonardo's *Last Supper,* provides still a different coding. The icons are univocal but submerged. Apples may seem just visual objects, but they are deeply coded, as Meyer Schapiro has shown us.[17] So too are dead hares, pewter pots, raspberries, squash, half-filled crystal goblets, sides of meat, oysters, cut lemons, shrimp, and all the many objects that have come to be included in still lives. Once the painting occupies itself entirely with such submerged icons, it can carry the act of submerging further. A death's-head is sometimes conventionally set in early still lives, a reminder that for the viewer—an analogue to the owner or the partaker— the luxury of the objects will eventually disappear, and their inert surface. The *Nature Morte* suggests death. *Memento mori* shadows and interprets the objects among which it is also ambiguously one, the souvenir skull *Et in Arcadia ego.* Indeed, in the light of this persistent convention, can a submerged *memento mori* be absent from the undifferentiated dark brown backgrounds that Chardin regularly uses for his still lives, against whose mysterious suspension he sets his luscious and gleaming objects?

The repose, however, is not constant in a painting. Through his various means a painter may produce various levels of intensity, from the profoundly disturbing turbulence of Grünewald, through the perturbed bristling of Altdorfer, the *terribiltà* of early Michelangelo, and the placid sternness of Dürer, to the limpidity of Giovanni Bellini, to cite only late fifteenth-century examples. Without undertaking the elaborate discriminations that would be needed in order to correlate this scale of intensities to mechanisms of visual signification, we may notice that Botticelli, Giorgione, Carpaccio, and Bosch are all located at the lower end of the scale, between Dürer and Bellini. Classifying them as to intensity in descending order—Bosch, Carpaccio, Botticelli, Giorgione—would involve finer calibrations. And for all of them, in their various ways, the relative reposefulness of order in the overall painting serves as a counterweight toward the active recombination of significances among its figures.

The process here is an intricate one at all three points of the exchange between viewer and painting—in the terms utilized by Lotman and others: the sender, the receiver, and the message. To begin with, such a semiotic-oriented scheme entails a bracketing of the extensive repertoire of epistemological conditions that have been elaborated in the tradition running from Kant through Edmund Husserl, Wilhelm Dilthey, Martin Heidegger, Gadamer, and Jauss. All the considerations they raise bear upon the "receiver's" reception of the "message," and they cannot, without disproportion, be subsumed under matchings to a code. These epistemological considerations bear as well upon the "sender's" relation to

his message. And in fact what the message itself funds and transmits will involve no less a degree of intricacy. Terms like "learning the sender's system" have the effect of ironing into a simple set of alternatives the endless subtleties of an artistic "message." All questions are ultimately referred to simple matchings at points of contact, or coding, along a simplified line: sender-receiver-message.

So, to take an example, how could an information-theoretical concept like "redundancy" carry us very far toward the interpretation of Botticelli, even though we might remark that in fact there is a redundancy of pleasing and resembling female forms in the *Primavera?* There is an even higher redundancy of angelic forms in the *Mystic Nativity.*

In the terms of another set, Botticelli is both *rule-bound* and *rule-inventive,* though to call him so is only to characterize him by a truism that applies to much art, at least since the Middle Ages. If we were to use just the second term, *rule-inventive,* to characterize the iconological inventiveness of the *Primavera,* the term would itself be redundant with respect to his procedure there: *rule,* again, would mislead the interpreter to conceive that what he deduces would be formulable in an itemizable code, even though in fact Botticelli does begin with cues to traceable formal conventions for representing women and angels.

The spatiality of a painting and the fact that it is wordless have the effect of arresting the viewer before it, and also of sealing him into his privacy. He is not part of an ongoing stream of discourse, the way he would be as the observer of a play or even as the reader of a poem or novel. His constructions keep referring back to the silent object before him. At the same time the social frames within which he operates exhibit as great a complexity as any other social act, and these frames are called more intensely into play, rather than less, when the painting is an innovative one. To take the categories of Irving Goffman's *Frame Analysis,*[18] the *Primavera* enlists *make-believe* more explicitly than a painting referring to a known story would. For Botticelli so to innovate when painting it makes it an implied *contest* with other painters, especially in a Florence where civic competitions were constantly held for artistic commissions, such as for the bronze doors of the Baptistery. And contests, or something like them, hover over certain paintings—*Pallas and the Centaur,* the devils and the angels of *The Mystic Nativity, The Calumny of Apelles,* even perhaps *Venus and Mars. Ceremony* is attenuated for the viewer of large secular paintings, the Mythologies. But as by compensation, many of them take subjects that have a ceremonial air—the *Primavera,* the Villa Lemmi frescoes, *The Birth of Venus, The Mystic Nativity* (which imports

the ceremonial into a subject usually treated as prior to ceremony). And Botticelli's innovation strikingly embodies Goffman's *technical redoings* and *regroundings,* in a social as well as in a formal sense. These are all what Goffman calls "keying," and his other major device, "fabrication," also locates the act of painting, and especially the act of innovation in painting.[19]

A likeness obtains, but also a difference, between a painting and the whole-objects or part-objects of psychological theory, the "good breast" to which Adrian Stokes likens a successful work. The painting, unlike the breast or other projected objects, does not function just as an object. It "talks back," and all the more so when it is not a Madonna and Child or the statue of an athlete, but rather the sort of complex, original concatenation of images offered by such as Botticelli, Giorgione, Carpaccio, and Bosch. Lacan theorizes the "mirror stage," in which the child realizes himself as perceived by the other, through the process of seeing himself-as-other in a mirror. The model serves for his interchanges of projection and introjection, and it governs the "symbolic chain" of exchanges in language. Now the painting at once breaks and affirms the model of the "mirror stage." It breaks it because it stands as an object before the viewer; the painter himself is absent. And it also breaks it because it allows the viewer to communicate with his own privacy via the painting, and at the same time *not* see himself as other. It affirms the mirror stage, however, because the painter is present in the thought he has coded into the painting, as the originator of that which acts upon the viewer. And he is caught in a version of the mirror stage—even prior to the dialectic of sense and reference that it enables—because the painting *does* also present an Other that he can see as a version of himself. A psychology as well as a celebration underlies the Mythologies of Botticelli. This dialectic is even further extensible, when, for the gold of the *Primavera* or *The Birth of Venus* one enlists what Merleau-Ponty calls a color, "a knot in the fabric of the simultaneous and the successive."[20]

The sign in a painting with mimetic features—say the Venus of *The Birth of Venus*—is also a knot in a fabric. Such a sign is intense not because it is plurisignificant—Venus is only Venus—but because it is pluridimensional. In Peirce's terms, it is an *icon* because it resembles our image of Venus, a beautiful woman; it is an *index* because it points at features that we associate with love; and it is a *symbol* because the figure of a woman stands for a matrix of feelings. This mythology does involve a story, but the story has framed and caught attributes that

may not be iconic: the wind does not resemble live bodies. These figures have the effect of forcing the signs to assert the active possibility of their dimensionality (not their signification only).

In their lack of prior relationship, these beings are singled out, and the primacy of their individual stance holds before the possible relationships we may assert for them. In this sense they continue the working out of the nominalism that finds its analogue in the earlier literature of the fourteenth century, where the concatenations of event in Chaucer and Boccaccio have become arbitrary and individuated.[21] In these innovative painters of a later century also, the individual reality is thrust forward visually as a sort of *ultima realitas entis*. Not only this principle of Duns Scotus stands as an analogue to this act of visual representation; his combinatory principle, the *grammatica speculativa*, finds an analogue in the regrounded, and ultimately abstract, principle of combination effectively enlisted for the images presented in the *Primavera*, the *Tempesta*, the *Young Knight in a Landscape*, and *The Garden of Earthly Delights*. Scotus' *grammatica*, according to Peirce, "has for its task to ascertain what must be true of the representamen used by every scientific intelligence in order that they may embody any meaning."[22] If we apply this statement not to scientific but to pictorial intelligence, these innovative paintings at once test, ascertain, and celebrate conditions of truth under which a condottiere may be set opposite a half-clothed mother across a stream outside a town, in the *Tempesta* of Giorgione. It is the act of combination, and not the richly coded constituent integers, that provides the meaning, which is not that of allegory or story but of an apprehension that seems evanescent in its mysteriousness while at the same time possessing the rigor that evidences the judgment allowing the inclusion of this or that entity in the painting. Giorgione's pentimentos testify to his gradual evolution of such a rigor, one that in the *Tempesta*, and in the *Concert Champêtre*, involves traceable exclusions as well as deducible discoveries.

Here the sense (*Sinn*) and the significance (*Bedeutung*) of the painting broach a possible convergence. Venus means what she indicates just in the painting, without reference to the significances that only hover over her. They are elided, or bracketed, sublimated. The "gypsy" bends to nurse her child as the storm brews in the *Tempesta*, hardly aware of the "condottiere," and her look blends desolation with self-sufficiency. The figural space encloses its power of figuration, and the eye is engaged in an ideal "surréflexion,"[23] a super-reflection that it does not unpack, because the mysteries have been brought to the surface of the painting and organized harmoniously upon it.

Notes

Introduction

1. Jacques Derrida produces this hermeneutic formulation in writing on Maurice Blanchot: "If we appear to oppose one series to the other, it is because from within the classical system we wish to make apparent the non-critical privilege naively granted to the other series by a certain structuralism. Our discourse irreducibly belongs to the system of metaphysical oppositions. The break with this structure of belonging can be announced only through a *certain* organization, a certain *strategic* arrangement which, within the field of metaphysical opposition, uses the strengths of the field to turn its own stratagems against it, producing a force of dislocation that spreads itself throughout the entire system, fissuring it in every direction and thoroughly *delimiting* it." (*Writing and Difference,* trans. Alan Bass [1967; reprint, Chicago: University of Chicago Press, 1978] p. 20). Derrida in *La Vérité dans la Peinture* (Paris: Flammarion, 1978) writes about art in such a way that he lays himself open to his own strictures. On his principles a sort of discourse that was constantly self-referential in its deconstructive metacriticism would in fact only be possible in (re-)demonstrating deconstructive principles. Such discourse would possess a more radical circularity than the more usual hermeneutic discourses do. In *Writing and Difference,* Derrida does concede a great deal to Blanchot and his method: "Such is the case that has been made of Hölderlin and Artaud. Our intention is above all not to refute or to criticize the principle of these readings. They are legitimate, fruitful, true" (p. 174). This is indeed enough to ground them well and keep them in business. The limitation he brings to bear upon their discourse is a limitation for all discourse, including any hermeneutic act. What might be called instrumental deconstruction, the demonstration of possible contradictions or semantic slippages in the terms or procedures of a given writer, would always be preliminary, in fact, as a kind of (de)structural analysis. To get beyond such sophisticated but preliminary work, one would always have to have recourse to something like the procedures of Blanchot.

2. The example is Saussure's own, from *Cours de linguistique générale* (1915; reprint, Paris: Payot, 1960), p. 97. The plate in Saussure's text, we might remark, is itself a culturebound example of graphic art. It is an example of early twentieth-century scientific illustration. As such, the artistic assumptions underlying its somewhat mimetic but nearly two-dimensional features are not wholly distinct from the simplistic or elementary theory they accompany. Saussure does go on to establish principles fundamental to the act of matching word and image that any writer on the significance of the visual arts must undertake: "The signifier, being of an auditory nature, unfolds in time alone and has characteristics it borrows from time: a) *it represents an extent* and b) *this extent is measurable in one dimension;* it is a line." He then builds on this point (which was also Lessing's, after all), as follows: "This principle is self-evident. . . . The whole mechanism of language depends on it. In distinction from visual signifiers (maritime signals, etc.) which can offer simultaneous complications in several dimensions, acoustic signifiers have at their disposal only the time-line" (p. 103). Yet again, the critic of signification in art is obliged to balance and to extend both these principles simultaneously.

3. My discussion owes much, for a particular application to art of such questions, to Jean-François Lyotard, *Discours, Figure* (Paris: Klinksieck, 1972) and Norman Bryson, *Word and Image* (Cambridge: Cambridge University Press, 1981).

4. Max Black, *Models and Metaphors* (Ithaca: Cornell University Press, 1962) and Nelson Goodman, *The Languages of Art* (Indianapolis: Hackett, 1976). One may honor such discourse as that of Black and Goodman and still bracket its questions about the correspondences between representation and its object or models and originals.

5. Assuming that the frescoes in the upper chapel at Assisi were painted by Giotto.

6. Bryson (*Word and Image,* pp. 17 ff.) criticizes still another pair, "Meaning" and "Being" as employed by Pierre Francastel.

7. Erwin Panofsky, *Studies in Iconology* (1939; reprint, New York: Harper, 1962).

8. From the large literature on the many aspects of this question, particularly forceful are Rudolf Arnheim, *Art and Perception* (Berkeley: University of California Press, 1974); Josef Albers, *Interaction of Color,* rev. ed. (New Haven: Yale University Press, 1971); E. H. Gombrich, *Art and Illusion* (Princeton: Princeton University Press, 1961); and Enid Verity, *Colour Observed* (London: Macmillan, 1980). Of course, much of post-Husserlian phenomenology, and especially the later works of Merleau-Ponty, bear directly on these questions.

 Svetlana Alpers in *The Art of Describing* (Chicago: Chicago University Press, 1983) forcefully links the Dutch, as opposed to the Italian, modes of assumptions about ocular perception with modes of representation. These

modes of representation lead, in turn, not only to differences of perspective but concurrently to differences of predominant signification in the whole Dutch tradition.

9. I have discussed other implications of this question in *Myth and Language* (Bloomington: Indiana University Press, 1980).

10. For a still later period, Ronald Paulson, *Emblem and Expression* (New York: Thames & Hudson, 1975) characterizes well the increasingly mimetic emphases from eighteenth- to nineteenth-century British painting as a shift from a dominance of emblem to a dominance of expression.

11. Norman Bryson, *Word and Image,* pp. 11–25 and passim. Bryson demonstrates variously how dynamically *discourse* and *figure* operate upon each other: "The discursive can be disguised as the figural," p. 14, and "Perspective ensures that the image will always retain features which cannot be recuperated semantically." Also this: "Once accepted as in the figural the connotation produces this astonishing result: it persuades us that the denotation was real . . . because I believe in the soldier's insolence and disdain, I believe in the soldier." Many questions remain here, of course, around the assertion "I believe" and its phenomenological substructure, for which once again the deductions of the later Merleau-Ponty would be apposite.

Even Bryson succumbs to the temptation of clean separation between one term and another—he is brought very close, in fact, to Francastel's "Meaning" and "Being" when he says that "Life emerges as what remains once the discursive has been extracted or discounted from the image" (p. 16). This last logical operation is a highly theoretical one it would be hard actually to perform.

But he sensitively disengages interactive roles for *discourse* and *figure* when he addresses an actual painting like Masaccio's *Rendering of the Tribute Money:* "Here again, it is useful if the image can be seen to perform some discursive work, as in the visual sentence 'apostle—donation—soldier': because that sentence is so patent and so distinct, it establishes an area of innocence outside itself, and it is in this innocent area that a more subtle work of signification can be performed" (p. 16). In moving on (pp. 21–23) to the terms *paradigm* and *syntagm* in Jakobson's sense, he shows how Masaccio expands the paradigmatic icons connected in his examples from the stained glass of Canterbury into an increased role for the syntagmatic axis. This process, carried further, would result, however, in a redefinition of the paradigm and a relaxation of both paradigm and syntagm. "Realism works hard to reduce the activity of the paradigm to a minimum" (p. 22). Actually, of course, the same function could be assigned to the most abstract art; these terms admit of a much more extended recombination.

12. Meyer Schapiro, *Words and Pictures* (Elmsford, N.Y.: Mouton, 1973), p. 9. Schapiro goes on to point out how some reduce and others enlarge the text.

13. Panofsky, *Iconology,* pp. 33–68.

14. Ibid., p. 159.

15. These two trees are prominent in their centrality, and also in the isolation of their location between people and building. Equally far from them are grove, garden, and forest. They bear the sort of mimetic weight to which Leonardo's special attention in the *Trattato di Pittura* attests, where most of a whole section, ninety-three items, is given over to points on how to represent trees. The figural signification of trees is particularly rich too, of course, in many cultures, as all the evidence in Frazer's *Golden Bough* shows. The Yggdrasil of Norse mythology, indeed, in its connection with wisdom, carries the association beyond Frazer's vegetation cycles. In a Jungian reading of associations to them, trees are found to bear both masculine and feminine attributes. Within the specifically Christian setting of this period, any tree may be taken to hint at the typology that connects the Tree of the Knowledge of Good and Evil to the Cross. Trees bulk large in the paintings I shall be discussing in this book: the strange dominant tree in Carpaccio's *Portrait of a Knight,* the monstrous tree-man in Bosch's *Garden of Earthly Delights,* the forbidding vegetation on the left side of Giorgione's *Three Philosophers.*

16. Panofsky, *Iconology,* pp. 171–230.

17. As de Tolnay, *Michelangelo* (Princeton: Princeton University Press, 1975), p. 24, says of the Sistine Chapel Ceiling, "In artistic terms it is a unique and inspired solution to the organization on a curved surface of innumerable different motifs, from which the artist nonetheless succeeds in creating a unity. . . . It is a sublime sight, this *fortissimo* of movement which develops in a crescendo of waves towards the back of the Chapel, gripping the spectator who, even before he has grasped its meaning, feels the sensuous thrill of annihilation in a higher world. In its constantly recurring movement, its mass, weight, and the resulting polyphony, this work can no longer be classified as belonging to the style of the High Renaissance, and yet neither does it belong to the Baroque with its continuous motion and melting forms."

18. Trattato di Pittura Cod Vaticano Urbinate 1270, ed. G. Milanese, 1890, p. 30. Cited by Ronald Lightbown, *Botticelli* (London: Ener, 1978), pp. 2, 81.

19. Aby Warburg, "Sandro Botticelli's 'Geburt der Venus' und 'Frühling,'" in *Gesammelte Schriften* (1893; reprint, Leipzig: Teubner, 1932), vol. 1, pp. 1–67. The Homeric Hymn to Aphrodite, which had just been translated in Florence before the painting was done, presents a much greater congruence of detail with the "Birth of Venus," as Warburg works it out, than other texts do to the *Primavera*. Even in the case of the "Birth of Venus," though, there are difficulties arising from Botticelli's very conception. Warburg in his discussion mentions none of the attendant difficulties, nor does he offer any material that would constitute an implicit resolution of any of them.

20. Ernst Gombrich, "Botticelli's Mythologies," in *Symbolic Images* (Oxford: Phaidon, 1973), pp. 31–81, offers the most elaborate repertoire of iconographic combinations for these paintings. I try to qualify his conclusions in my second chapter.

21. Bryson, *Word and Image*, p. 238.

The Presence of Botticelli

1. I am here following Ernst Gombrich's balanced and comprehensive account, "Botticelli's Mythologies," in *Symbolic Images,* pp. 31–81 (though it is at once too arbitrary and too conservative). He sometimes suggests Botticelli's innovating revisions, but then hangs back and ascribes to the painter substantially the same old iconographic practices.

2. As Gombrich says (*Symbolic Images*, p. 202, n. 13), " 'Venere, che le Grazie la fioriscono, dinotando la primavera.' [Venus, whom the Graces deck with flowers, denoting spring.] We have no reason to attach overmuch importance to this description, made some 75 years after the picture was painted. Whenever we are able to check Vasari's descriptions from independent sources we find that he was prone to muddle the subject matter."

3. Ronald Lightbown, *Botticelli* (London: Ener, 1978).

4. Cesare Ripa, *Iconologia,* 1593. Reprinted, from a later edition, as Edward A. Maser, ed., *Baroque and Rococo Pictorial Imagery* (New York: Dover, 1971).

5. A propos of the *Primavera,* Lee Baxendall, *Giotto and the Orators* (Oxford: The Clarendon Press, 1971), p. 87, cites a famous *ekphrasis* of Spring by Libanius. The detail, however, does not go as far as the nameable flowers in the carpet of the lawn in that painting. Nor, as is always the case with Botticelli, can the *ekphrasis* be made to cover the whole painting. Ernst Gombrich, ("Botticelli's Mythologies," *Symbolic Images*, p. 53) claims that the 'Birth of Venus' is based on a Renaissance *ekphrasis,* closely modelled on classical examples." This half-truth can obscure the combinatory originality of Botticelli in working with a number of visual, as well as verbal, sources.

6. Baxendall, *Giotto,* p. 131.

7. Charles Dempsey points out that the *Primavera,* read right to left, reverses our normal order of reading. *Mercurius Ver:* the Sources of Botticelli's Primavera," *Journal* of the Warburg Institute, 21 (1968):251–74). We might take this reversal for a visual beginning to Botticelli's break with the normal canons of visual signification.

8. Gombrich, "Botticelli's Mythologies," p. 7.

9. Ibid., p. 53.

10. As Gombrich (ibid., p. 59) says, "If we approach the Graces of the 'Primavera' with these texts (Ficino's astrological interpretations of mythology and others) in mind, our difficulty is obviously, not that we do not know any meaning, but that we know too many." There is the further difficulty, the crucial one, of bringing these many mediated, and subordinated "meanings" into dialectical relationship with the visible painting. André Chastel in *Marsile Ficin et l'Art* (Geneva: Droz, 1954) argues that Ficino's modification of "le

paradoxe Platonicien" in according spiritual value to painting would have lightened the climate of discourse for such as Botticelli.

11. Gombrich, "Botticelli's Mythologies," p. 60. Gombrich puts the painting in the wrong place, as anyone would have until new evidence located it not in a public room at Castello but in a chamber off the bedroom of Lorenzo di Pierfrancesco's home in Florence. Lightbown, *Botticelli*, p. 79. See Webster Smith, "On the Original Location of the *Primavera*," *Art Bulletin*, 57, no. 1 (March 1975):31–40.

12. Gombrich, "Botticelli's Mythologies," 13–14.

13. Aby Warburg, "Sandro Botticelli," as cited and amplified in Edgar Wind, *Pagan Mysteries in the Renaissance* (New York: Norton, 1958), pp. 113–115. Wind generally expands the classical sources, as those for Mercury (123–125), to a point where the painting is left behind.

14. These sources were advanced by Charles Dempsey in a lecture at Brown University, "Changing Concepts of the Pastoral in the Paintings of Botticelli, Titian and Poussin," March 8, 1980. Botticelli has so heavily transmuted the broad stream of pastoral conventions that to specify a catena of such sources is already to overdetermine that element in the *Primavera*.

15. Gombrich ("Botticelli's Mythologies," pp. 45–52) makes a special case for Apuleius in particular. But the long tradition of commonplaces for the *locus amoenus* in May, coupled with the rich detail of Botticelli's painting, would remove any special significance from correspondence, greater or less, between one or another transmitter of the tradition, visual or verbal.

16. Gombrich ("Icones Symbolicae," in *Symbolic Images*, pp. 123–96) wants to take fifteenth century philosophical traditions even further, including the quattrocento versions of Aristotle!

17. Wind, *Pagan Mysteries*, pp. 113–17; for "The Birth of Venus," pp. 130–37.

18. Leon Battista Alberti, *On Painting*, trans. John R. Spencer (New Haven: Yale University Press, 1966), p. 91. "I should like to see those three sisters to whom Hesiod gave the names of Aglaia, Euphrosyne and Thalia, who were painted laughing and taking each other by the hand, with their clothes girdled and very clean. This symbolize liberality, since one of these sisters gives, the other receives, the third returns the benefit." At another point (bk. 2) Alberti recommends a variety of colors for representing such female figures, a recommendation that Botticelli follows most pronouncedly in the robes of the dancing angels of the *Mystic Nativity:* "When you paint Diana leading her troop, the robes of one nymph should be green, of another white, of another rose, of another yellow, and thus different colors to each one, so that the clear colors are always near other different darker colors. There is a certain friendship of colors so that one joined with another gives dignity and grace." This last sentence is most evocative for the effect of color areas in Botticelli's painting.

19. H. P. Horne, *Botticelli* (1908; reprint, Princeton University Press, 1979) most elaborately discusses these questions of historical source.

20. Wind, *Pagan Mysteries,* pp. 129–30.

21. Heinrich Wölfflin, *Principles of Art History* (1915; reprint, New York: Dover, 1950), passim. Ref. to Botticelli, pp. 101, 128.

22. Wind, *Pagan Mysteries,* pp. 122–23. It is hard, if not impossible, to find any visual clues in this painting for interaction between Mercury and the wisp of cloud or mist hanging before the trees. If a cloud, it is strangely low, tiny, thin, and out of place, about seven feet from the ground. Nor is there much that allows us to see him as a Psychopompos or Hermes Trismegistus.

23. Panofsky makes the point (*Studies in Iconology,* p. 130) that Ficino sought to coordinate not only Plato but also the " 'Platonici,' viz., Plotinus and such later writers as Proclus, etc."

24. Lightbown, *Botticelli,* p. 78.

25. Wind, *Pagan Mysteries,* pp. 138–39.

26. L. D. and Helen S. Ettlinger, *Botticelli* (New York: Oxford, 1977), p. 119.

27. Lightbown (*Botticelli,* p. 74) cites Claudian's type of "eternal spring" as transmitted by Poliziano. He also calls attention (p. 73) to the similarity between the orange and spruce trees of this painting and those described by Boccaccio in his version of a *locus amoenus* suitable for love.

28. Ettlinger, *Botticelli,* p. 120.

29. Wind, *Pagan Mysteries,* p. 114.

30. Gombrich, "Botticelli's Mythologies," pp. 56–59.

31. Ibid., p. 42.

32. Lightbown lists them (*Botticelli,* p. 73): "coltsfoot, forget-me-nots, small grape-hyacinths, cornflowers, irises, periwinkles, grape-plantains, borage, pinks, anemonies, daisies." Identifications are confirmed by Wit Stearn, Natural History Museum, London (see Lightbown, *Botticelli,* p. 53).

33. Kenneth Clark, *The Nude,* (New York: Anchor, 1956). "Her whole body follows the curve of a Gothic ivory. . . . Venus' foot makes no pretense of supporting her body. . . . She is not standing but floating. . . . Her shoulders, for example, instead of forming a sort of architrave to her torso, as in the antique nude, run down into her arms in the same unbroken stream of movement as her floating hair. . . . By this innate rhythmic sense he has transformed the solid ovoid of the antique Venus Pudica into the endless melody of Gothic line, the melody of twelfth century drapery, of Celtic interlacings, even, but made more poignant by a delicate perception of the human predicament" (pp. 154–55)—though the human predicament is submerged in the equipoise of this body between chaste self-absorption and a modestly proportionate display of erotic capacity.

J. Albert Dobrick ("Botticelli's Sources: A Florentine Quattrocento Tradition and Ancient Sculpture," *Apollo* Vol 11. (August 1979):114–27) relates the dancing and nearly dancing females in Botticelli (including Judith) to the type of maenad and maenadlike figures in ancient sculpture.

34. Lightbown (*Botticelli* p. 86) takes the blond figure as a Nymph already con-

quered by the Zephyr. This figure, with its whiter body and slightly more prominent bust, could indeed be female. But the female characteristics are swept up in the activity, at once soft and stormy, of the dominant, browner figure. The blond figure can neither be fully and explicitly sexualized, nor can it be desexualized: the storminess contains an ambivalence that only a reference to the realm of the dreamy Venus at the center could resolve.

35. As Lightbown points out (ibid., pp. 79 ff.), there may have been incidental references in this painting to the harbor of Naples in relation to its rivalry with Florence. So the laurel of the *Primavera* may hint at *Lorenzo* dei Medici, and the citrus fruit, *medica mala,* may contain a gracious compliment to the Medici.

36. The dark shadow of Savonarola does not fall across these paintings, and perhaps not across any of Botticelli's work, in spite of his possible involvement, through his brother, in the puritan savagery of that movement. We have no conclusive evidence that he destroyed paintings, nor can the severity of later works like the second Saint Augustine, the *Calumny of Apelles,* the *Rape of Lucrece,* or even *The Mystic Crucifixion,* be confidently derived from the Savonarolan spirit.

37. Lightbown, *Botticelli,* p. 83. There is no reason to call Pallas "Camilla" as Lightbown does. Botticelli has several other drawings of Pallas. Alberto Busignagni in *Botticelli* (Florence: Sansoni, 1965) p. 28, refers to the "metafisica melanconia" of *Pallas and the Centaur.* Piero Bargellini is more specific in *Il Sogno Nostalgico di Sandro Botticelli* (Florence: Arnaud, 1946), on p. 122: "His Pallas does no violence to the Centaur. Languid as a tired lady, on one side she leans on the heavy halberd, and on the other, rather than taming the obstinate head of the Centaur, she clutches his hair with a motion similar to that of the Graces in the *Primavera.* And the affable Centaur, more than a symbol of force, seems the incarnation of gentleness. He looks at the goddess with nostalgic eyes, as to lament being unworthy of her and to beg for grace from the full face of that plump, long-haired lady."

38. Ettlinger, *Botticelli,* p. 141.

39. A more structured busyness provides complexity for the straightforward allegory in *The Calumny of Apelles,* in which the main figures are strung horizontally through the inner palace. In the niches of its pillars are visible thirteen allegorical statues, at least one more than the figures of the live action. At the bases of the pillars, around the arches and in their entablatures, are a profusion of allegorical scenes, structured and equalized by being shown as in sculptured relief, scenes biblical and classical. Parts or all of at least forty-eight of these tiny scenes are shown in the painting, and more must be conjectured on the principle that every such space of arch and pillar is uniformly so covered. The sharp change in scale from live bodies to the bodies in ornamental sculpture differentiates such usual allegories from those of Mantegna and Titian.

40. Lightbown, *Botticelli,* p. 146.

41. I follow (with modifications) the translation of Ettlinger, *Botticelli,* p. 98.

42. Lightbown, *Botticelli,* p.137.

43. In a lesser, simpler fashion Botticelli had already employed an unusual inscription in the Bardi altarpiece, indicating the Virgin not by a scriptural quotation but by Dante's lines, *Vergine madre figlia del tuo figlio (Paradiso* 33.1). He did this, it is presumed, partly to refer indirectly to the battle of Campaldino, which the altarpiece commemorates and in which Dante fought. But surely only partly for this reason; the great poet whose work he would be illustrating offers an analogue for the assumption of converging religious significances into the secular work of art, and the analogue is both embodied and hinted at in the quotation.

44. More crowded than any painting by Botticelli's hand alone is the *Adoration of the Magi* on which he collaborated with Filippo Lippi. On the other hand, drawings for an early *Adoration* exhibit the energetic crowding present only in the groups of late scenes like the Zenobius series and the *Calumny of Apelles.* The figures in his early Uffizi *Adoration* show large bodies close together, but a great deal of open space around the Holy Family and in the upper half of the painting generally. This contrasts with the Mythologies, as Robert Hatfield positively puts it: "Depth is not wholly sacrificed here to planar dispersion, as it often is in other of Botticelli's most ambitious works." *Botticelli's Uffizi "Adoration,"* (Princeton: Princeton University Press, 1976), p. 7. Vasari speaks of his *Assumption* as having an "infinito numero di figure."

45. Vasari remarks on the difference between Botticelli's *Saint Augustine* and Ghirlandaio's *Saint Jerome.* The *Saint Augustine* shows the "profound cogitation and highly acute subtlety that is habitual for a person whose senses are abstracted continually in the investigation of the most lofty, highly difficult matters." ("quella profonda cogitazione et acutissima sottigliezza, che suola essere nelle persone sensate et astratte continuamente nella investigazione di cose altissime e molto difficili.") The very sense of place described in the Latin quotation above Saint Augustine's head is absent from the person in the painting. "Augustine so gave himself over to sacred matters that he did not perceive that his location had changed up to that point." ("Sic Augustinus sacris se tradidit ut non mutatum sibi adhuc senserit esse locum.") The statement, indeed, could be applied to Botticelli himself, who seems to render the difficult graceful and easy.

46. What Walter Friedlaender says in *Mannerism and Anti-Mannerism in Italian Painting* (1957; reprint, New York: Schocken, 1965), p. 4, may put Botticelli's use of space in perspective: "It might just be remarked that in the painting of the quattrocento the dissociation between constructed space in depth and picture surface with figures is for the most part not yet overcome. The volume of the bodies, inwardly organized and enlivened by a central

idea, is in most cases not yet set in a circular movement as it is in the drawings of Leonardo or in the Madonnas of the immature Raphael (in contrast to Perugino). In the quattrocento the linkage of this volume with the space is for the most part incomplete and in many phases, especially during the second half of the century, often contradictory: for the human figure, there is spiritualization and surface ornamentation; for the space, realism and perspective construction in depth. The resolution of this duality—the subordination of masses and space within one central idea—is the achievement of the High Renaissance, reflected most purely in the works of the mature period of Raphael." This is too negative. Again, Botticelli's personal handling of space falls into relief as a contrast to the Michelangelo that Friedlaender describes (p. 15): "The strongest psychological impulses meet insuperable pressure and resistance—they are denied space in which to expand."

47. Henry James, *Italian Hours* (1909; reprint, New York: Grove Press, 1959), p. 277.

The Integers of Giorgione

1. The first and third of these paintings are connected in Guiseppe Fiocco, *Giorgione* (Bern: Hallweg, 1942), p. 19.
2. Ludwig Baldass, *Giorgione* (New York: Thames and Hudson, 1965), p. 159, cites Morassi on "Col Tempo," who documents it as stock phrase.
3. Giorgio Vasari, *Le Vite* (1568; reprint, Novara: Istituto Geografico, 1967), vol. 3, pp. 411–22.
4. Ibid.
5. Ibid. According to Vasari, "ne se giudica quel che si sia" (it can't be judged what it is).
6. Terisio Pignatti, *Giorgione* (Florence: Alfieri, 1969), p. 69, interprets it as "una allegoria matrimoniale, dove il lauro e il seno scoperto stanno a indicare la virtù e i piaceri delle nozze" (an allegory of matrimony in which the laurel and the discovered breast serve to indicate the quality and pleasures of marriage). Thus valiant and desperate are the efforts to bring elements of Giorgione's paintings into univocal signification.
7. Edgar Wind, *Giorgione's "Tempesta"* (Oxford: The Claredon Press, 1969). Salvatore Settis, in *La "Tempesta" interpretata: Giorgione, i committenti, il soggetto* (Turin: Einaudi, 1978) resumes the prior interpretations and adds one of his own. He tabulates no fewer than twenty-eight of them (pp. 74–75). His own, which would make a twenty-ninth, involves comparable difficulties in its iconographic specificity of identifying the figures as Adam and Eve with Cain after the Fall. In the medieval relief from Bergamo of this scene, which he declares to correspond "almost to the letter" to the *Tempesta*, the Adam is actually nude and holds an implement of agricultural rather than one of exclusively military use, as in all his other parallels. Moreover, the imposing fig-

ure of God stands prominently centered between Adam and Eve, a motif that Settis declares to be picked up in the tiny bolt of lightning at the top of the *Tempesta*. The town, too, is absent, and the Bergamo relief has only a crude temporary shelter in the trees. Settis also repeats Wind's descriptive error in seeing the free-standing columns as "broken." Even Horapollo is brought in (pp. 92–96), the iconographer's last resort. But Settis well says that Creighton Gilbert's opposition between subject and nonsubject is too radical (p. 12). His scheme, if purified and "algebrized," has a certain amount to offer. So treated, and modified, it would approach the scheme of Günther Tschmelitsch's *Harmonia est Discordia Concors: Ein Deutungsversuch zur Tempesta des Giorgione* (Wien: Braumüller, 1966). Tschmerlitsch sees in the painting a set of systemized contrasts between city and country, serenity and tempest, clothed soldier and nude mother, Mars and Venus, etc. Yet again, this quasi-structuralist reading would have the effect of overschematizing the painting and taking away its air of mystery. Its great achievement is managing to be both paradoxically presentational and nearly narrative at one and the same time.

8. Adrian Stokes, *Critical Writings*, vol. 2 (New York: Thames and Hudson, 1978), pp. 127–34.

9. John Erwin, in a manuscript about figuration and presupposition in the Renaissance. Mr. Erwin has generously shown me his manuscript in advance of publication.

10. Arnoldo Ferriguto, *Attraverso i "misteri" di Giorgione* (Castelfranco, 1933). Ludwig Baldass, *Giorgione*, p. 33. Settis (*La "Tempesta,"* p. 164) explains the pentimento by acutely suggesting that she is not a second woman but the same one in an alternate location. Creighton Gilbert in "On Subject and Non-Subject in Italian Renaissance Pictures" (*Art Bulletin* 34, 1952, pp. 202–16) well says of the *Tempesta*, "If there is a definite story, it must have been changed completely from one story to another in mid-career." Gilbert speaks further of Giorgione's "aesthetic of emptiness." But he oversteps his own caveats when he takes the pentimento black who was the original central figure of "The Three Philosophers" for authenticating their identification as Magi. Appositely of my own general theme here, Gilbert cites several instances of rejection or qualification of iconological interest on the part of Renaissance painters themselves, and he quotes Ficino—surprisingly—as stressing the emotional, and not the significative-allegorical, element in painting: "The emotion of the artist . . . excites us to an identical emotion."

11. Stokes, *Critical Writings*, p. 127.

12. Baldass, *Giorgione*, p. 151.

13. Ferriguto, *Attraverso i "misteri,"* p. 109.

14. George M. Richter, *Giorgio da Castelfranco* (Chicago: Chicago University Press, 1937), p. 82.

15. Baldass, *Giorgione*, p. 30. In the thematic perfusions of the landscape, Richter's remarks (*Giorgio da Castelfranco*, p. 89) are apposite, contrasting

Titian's *Noli me Tangere* with Giorgione's work. He says, "In none of these early pictures did Titian renounce the artifice of scenical wings and corner figures, and in none of them did he ever succeed in uniting the human figure with the landscape motifs and that rhythmic and indissoluble manner which we find in Giorgio's works." Much in Giorgione, and nothing else in Titian, offers the figural intricacy of the *Concert Champêtre,* even though Titian's *Virgin, Child, Saint Agnes and John the Baptist* at Dijon does have a flock of sheep in the background. Still, Saint John holds a lamb that Saint Agnes pats, and the lamb, along with the sheep, is thereby easily assimilable to the Lamb—just as the palm that Saint Agnes holds in her other hand is also obviously proleptic. Here, as elsewhere in Titian, we are far from the mysteries of the *Concert Champêtre.*

16. Pignatti, *Giorgione,* p. 56. Pignatti goes on to assert that, like Carpaccio, Giorgione had found a way out of the 'microcolore' of the Flemish, achieving "il nuovo modulo monumentale delle figure nello spazio musicalmente sfumato del 'paesetto.'"

17. Frederike Klauner, "Zur Symbolik von Giorgiones Drei Philosophen," *Jahrbuch der Kunsthistorischen Sammlung in Wien,* 51 (1956):45–168, rightly insists on the significance that must reside in assigning the left half of the painting entirely to landscape. But then this writer—after noticing the fusion of iconographic types by Giorgione—goes on to allegorize the fig and the ivy. "The fusion of the two tree-representations—Mary as [tree of] Jesse and Mary as fig tree—leads finally to still other variations of representation." According to Klauner, the fact that Pico della Mirandola called the Magi philosophers clinches our labeling these philosophers as Magi!

18. Baldass, *Giorgione,* p. 32. Baldass notes, however, that none of the three men bears the signs of royalty that would designate the Three Kings. Settis in *La "Tempesta"* (pp. 124–40) supports the "Magi" thesis at length but does not deal with this, or with such difficulties as the absence of gifts, manger, and Holy Family in the painting.

19. This is suggested in Baldass, *Giorgione,* pp. 30–31.

20. Ferriguto, *Attraverso i "misteri,"* p. 19.

21. The significative complications and elisions of this picture resemble others of Giorgione's and none of Titian's, to whichever artist we assign all or part of the painting. See also Richter's remarks, note 15.

22. Edgar Wind, *Pagan Mysteries in the Renaissance* (1958; reprint, New York: Norton 1968), 143n., with citations, and with the tired adduction of Neoplatonism as a universal key to any mysteries in art from the mid-fifteenth century onward. The women are invisible to the men, and so from another order, according to Philipp Fehl, "The Hidden Order: A Study of the Concert Champêtre in the Louvre," *Journal of Aesthetics and Art Criticism,* 16 (1957):135–59. Fehl does not here reckon with the fact that the figures in Giorgione's paintings often seem curiously invisible to one another. Calling

these women "nymphs of the wood" raises the problem of their individuality, their isolation, and their differentiation—all attributes not conventional for nymphs. If the men, by Fehl's argument, typify city and country, the women must symmetrically have contrasting rather than identical functions. And the shepherd over the rise is in any case "left over." It proves nothing to align the male pair to far simpler significations in paintings of Titian.

23. These identifications are discussed by Robert Klein, "Die Bibliothek von Mirandola und das Giorgione zugeschriebene 'Concert Champêtre' " *Zeitschrift für Kunstgeschichte* (1967): 199–206. Adducing possible analogies to the figure of Poesia on the tarot cards designed by Mantegna and to the paintings, known only from descriptions, in the library of Pico della Mirandola, Klein identifies the woman with the pitcher not as a nymph but as an allegory of Peitho-Poesia. Taking the other three figures (but not the shepherd), he aligns them under kinds of music, producing still another potential division of the canvas. As Klein admits, "The plant symbolism is at best general. Laurel and myrtle remain hard to recognize or are wholly absent." Nevertheless, Klein goes on to bring Ripa into the picture.

24. Bernard Berenson, *Italian Painting in the Renaissance* (London: Phaidon, 1952), passim. Ludwig Baldass, "Zu Giorgiones 'Drei Philosophen,' " *Jahrbuch der Kunsthistorischen Sammlung in Wien*, 50 (1953), Sonderheft 142, 121–30, analyzes the unification of various colors in the Three Philosophers. "The completed picture is striking for its almost complete lack of action clearly he faced the theme differently from the artists of the quattrocento and his contemporaries in Venice."

Carpaccio's Animals

1. Millard Meiss, "Ovum Struthionis: Symbol and Allusion in Piero della Francesca's Montefeltro Altarpiece," in *The Painter's Choice* (New York: Harper, 1976), pp. 105–41. Meiss discusses the wonder, rarity, proportion, and whiteness associated with the purity of the Virgin, in the tradition behind setting such eggs in churches. He points out that an ostrich egg hangs from the ceiling in Carpaccio's *Vision of the Prior of Sant'Antonio di Castello, Venice*. This one, though, is much less conspicuous and centrally coded than the others he cites; it blends into the spacious architecture of Carpaccio's interior. As for Carpaccio's connections to what might not at first be perceived as a tradition, Meiss interestingly links the *Dream of Saint Ursula* to a general Venetian propensity for the motif, in "Sleep in Venice: Ancient Myths and Renaissance Proclivities," ibid., pp. 212–40.

2. Michel Foucault, *Les Mots et les choses* (Paris: Gallimard, 1966).

3. Michel Serres, *Esthétiques sur Carpaccio* (Paris: Hermann, 1975), makes a point of the "geometric" aspect of Carpaccio.

4. *Two Venetian Ladies* is an exception. Its bodies do fill out the segments of the canvas, at least in the picture we have.

5. Serres, *Esthétiques sur Carpaccio,* p. 63.

6. I am here using and adapting Francis Klingender's compendious *Animals in Art and Thought* (London: Routledge and Kegan Paul, 1971).

7. The legends about Apelles are recorded in Pliny, *Natural History,* vol. 35, pp. 88 ff; those about Polygnotus, pp. 58 ff.

8. There is, interestingly, a dog—just a domestic one, though out of place—in the *Martyrdom of Saint Ursula* from the series on Memling's own Saint Ursula reliquary at Bruges.

 In Ghirlandaio's San Giusto predella, a white shaggy dog of the same species shown in *The Dream of Saint Ursula* stands beside the angel as he watches Tobias clean the fish in the "Tobias and the Angel" panel.

9. Klingender, *Animals,* gives several examples. Bestiaries will often list several traits under one animal. By contrast, Richard de Fournival's *Bestiaire d'Amour* (ed. C. Hippani [Paris: Aubry, 1860]) does the opposite, ticking off one by one the resemblances of man or woman to this or that habit of an animal. He adduces the cock, the ass, the wolf, the cricket, the swan, etc. The woman is like a wivern, she treats the man like an ape caught by being shod, etc. His items are all pressed into the rhetorical service of a courtship speech, and the woman replies by adducing other aspects of the same animals. Fournival, interestingly, states at the beginning (p. 2), that there are two gates of memory, poetry and painting. A bestiary close to Carpaccio's tradition is presented in Max Goldstaub and Richard Wendriner, *Ein tosco-venezianischer Bestiarius* (Halle: Niemeyer, 1892). The date of this Tusco-Venetian bestiary is 1468, a bare generation before Carpaccio. Even so, as its editors say, it "preserves a great deal of the spirit of the old (early medieval) *Physiologus,*" though it comprises a "transformation (*Umgestaltung*) of the character" of that work. In the work itself there are elements that recall motifs in Carpaccio. The serpent is a dragon of a certain size that flees when it sees a nude man (p. 20). Among the animals it includes are various birds in a particularly high proportion (as in *Young Knight in a Landscape*), unicorn, ape, ass, dog, panther, crane, peacock, pig, wolf, phoenix, three dragons, and a tortoise.

10. Klingender, *Animals,* p. 86.

11. Michelangelo Muraro, *Carpaccio* (Florence: Edizioni d'Arte El Fiorino, pp. cxl-cxlv). Muraro points to the family motto *Malo mori quam foedari* ("better death than dishonor") in the cartouche above the ermine. The ermine is also one of several predators in the painting.

12. Jan Lauts, *Carpaccio* (London: Phaidon, 1962), p. 39, points out that Dürer was in Venice in 1505–1506 and could have met Carpaccio. Since Dürer also mentions seeing the works of Bosch, he provides a possible link between the two, beyond their kinship, I am asserting, of breaking prior iconological molds. Lauts mentions that the *Young Knight in a Landscape* has in the past

been attributed to Dürer. Dürer's naturalistic focusing on animals as subjects for demonstrating his mimetic skill, independently of direct iconographic correlations, serves as a kind of opposite and counterpart to Carpaccio's manipulation of them in the whole universe of a canvas.

13. The animals are too isolated, too varied, and even too inert, merely to evidence the sort of pantheistic life and freshness that Muraro asserts in *Carpaccio*, p. 140.

14. Roberto Longhi, *Da Cimabue a Morandi* (Florence: Mondadori, 1973), pp. 639–40.

15. As Lauts says of this painting (*Carpaccio*, p. 13), "The subject represented is unusual and full of mystic and symbolic allusions."

16. As again Lauts says (ibid., p. 28), "[The term] genre painter . . . covers only one aspect of his complex character."

17. Giuseppe Fiocco, indeed, claims this as the first independent landscape painting in the Renaissance. ("La Caccia in Valle di Vittore Carpaccio," Bolletino del Museo Civico di Padova, 1955, pp. 3–12). However, the landscape is fairly rudimentary, a characteristic that would make it not so different from an earlier painting, Paolo Uccello's *Hunt by Night,* and perhaps others.

18. Michel Serres (*Esthétiques sur Carpaccio*) provides a focus for interpreting the whole interaction of spaces in Carpaccio's painting by decoding their formations as well as their colors into geometric figures. His statement about the Paris *Saint Stephen* is typical: "Panels of the church giving on the church, space, image of space, tables of instruction for the school . . . in the presented morphologies, isomorphisms abound" (p. 96).

19. Titian adopts this organization, the animal directly below the man, in his triple-headed *Allegory of Youth, Maturity, and Old Age.*

20. Michel Serres, *Esthétiques sur Carpaccio,* p. 104.

21. Ibid., p. 103, "L'ange apporte un message de mort et non pas de semence, où le ouï est latent sous la clôture du sommeil" (The angel carries an image of death, not of fructification, in which what is heard is latent under the closure of sleep).

22. Ibid., p. 103.

23. H. W. Janson, *Apes and Ape Lore in the Middle Ages and the Renaissance* (London: The Warburg Institute, 1952). Carpaccio does not figure in Janson's exhaustive index. We could run through Janson's stereotypes and partially match Carpaccio's solitary monkey to each. Since disaster is slowly under way, the monkey could touch on the *Figura Diaboli,* and on the "sinner." His elaborate dress in a sense fetters him, though he is the opposite of "the fettered ape." Yet he does not even have an identifiable master nearby. Only by a kind of antithesis could he stand for a never achieved sexuality (though monkeys near a maiden in some of Janson's examples do suggest the future sexuality that the ambassadors think may be in view for this bride). The luxury of his dress suggests both "Vanitas" and "Similitudo Hominis." We might

even go far enough to take this monkey for a figure of the painting itself, for his very freedom from it, and touch on the type of *Ars Simia Naturae,* art as an ape of nature. The multiplicity of these possibilities, the vagueness of any of them, both enriches and displaces the figure.

24. Serres (*Esthétiques sur Carpaccio,* pp. 36 ff.) hypostatizes them by calling them Adam and Eve.

25. Many have noted what Pietro Zampetti calls the "caccia agli elementi orientali" in Carpaccio's work. *Vittore Carpaccio* (Venice: Alfieri, 1966), p. 29. The reliance on an Oriental locale amounts to an iconographic displacement as well as to the theatricality discussed by Michelangelo Muraro (*Vittore Carpaccio e il teatro in pittura,* in "Studi nel teatro Veneto fra Rinascimento ed età barocca" (Florence: Olschki, 1971).

26. Serres, *Esthétiques sur Carpaccio,* p. 42.

27. Ibid., p. 116.

28. Ibid., p. 118.

29. John Ruskin, *Saint Mark's Rest,* in *Works,* ed. E. T. Cook and Alexander Wedderburn, vol. 24 (London: George Allen, 1906). He says the *Venetian Ladies* (the *Cortegiane*) is "the best picture in the world. I know no other which unites every nameable quality of the painter's art in so intense a degree—breadth with minuteness, brilliancy with quietness, decision with tenderness, colour with light and shade . . . whatever De Hooghe could do in shade, Van Eyck in detail—Giorgione in mass—Titian in colour—Bewick and Landseer in animal life, is here at once, and I know no other picture in the world which can be compared with it . . . the subject in the present instance is a simple study of animal life in all its phases" (p. 364). How simple the animal life is, of course, I am questioning, and the comparison to Landseer suggests that Ruskin is most impressed by the mimetic skill rather than the redolent signification of Carpaccio, even though he earlier in this book speaks of a project—which he never achieved— "to examine Carpaccio's canonized birds and beasts" (p. 229). He stresses just a "comic" effect of the monkey ("ape" as he calls it) in *The Return of the English Ambassadors,* and somewhat exaggerates its "penetration into the mind of Venice of the Northern spirit of the Jesting Grotesque" (p. 445), since one well-behaved nicely dressed monkey does not a grotesque make. At the same time, Ruskin quickly picks up the possibility of significance in animals, the tiny lizard who holds in his mouth the scroll of Carpaccio's signature in *The Death of Saint Jerome,* the frogs round the dead man and the lizards round the dead woman in *Saint George Fighting the Dragon.*

30. Serres, *Esthétiques sur Carpaccio,* p. 71.

31. Lauts, *Carpaccio,* p. 25.

32. Of another painting Giuseppe Fiocco in *Carpaccio* (Rome: Casa Editrici Valori Plastici, 1930), p. 24, speaks of "the soft enchantment of the airy landscape in which the sacred scene becomes an episode," a phrase that could be adapted to many of Carpaccio's works.

33. As Muraro says (in *Carpaccio*, p. 142), "The two birds that fight in the sky are too big."

34. Serres, *Esthétiques sur Carpaccio*, p. 66.

Bosch: The Limits and Glories of Visual Signification

1. Erwin Panofsky, *Early Netherlandish Painting*, vol.1 (1953; reprint, New York: Harper and Row, 1971), pp. 357–58.

2. Dirk Bax, in *Hieronymus Bosch: His Picture-Writing Deciphered* (Rotterdam: Balkema, 1979), p. 83, cites the tradition of depicting amorous couples together with large fruit on medieval *Minnekästen* (sweethearts' chests). He also refers to a tradition that an empty fruit equals lust (p. 8).

3. Charles de Tolnay, *Hieronymus Bosch* (New York: Reynal, 1966), p. 32. De Tolnay stresses, and sometimes overinterprets, the antiparadisal elements in this Paradise. To be sure, a lion does devour a deer and a wild boar chase another creature. These are emblems for the violence of the fallen life, as adapted by Carpaccio and others from a tradition that goes back before the second millennium. A barely visible crescent, a Moslem emblem and therefore heretical, does top the Fountain of Life. But crescents do not sit at the very top of mosques, and the half-moon figure, in the absence of other such icons in this panel, need not be simply heretical. Moreover to read the newly created figure of Eve as already a seductress, her sexuality already a lure as God introduces her to Adam, revises and in fact negates any version of the account in *Genesis*. It would render null the *Temptation* and *Expulsion* that Bosch paints, along with the *Creation of Eve*, in *The Hay Wain*.

4. Jakob Rosenberg stresses the heretical side of the owl in Bosch, citing the *Dialogus Creaturarum*, (Gouda, 1480), in James Snyder, ed., *Bosch in Perspective* (Englewood Cliffs: Prentice-Hall, 1973): 118–25 "It is cruel, loaded with feathers, full of sloth and feeble to fly. . . . It lurks in churches, drinks the oil of lamps and defiles them with its excrement . . . other birds . . . hate her and be enemies unto her." He illustrates this last trait from a woodcut of Dürer and quotes H. W. Janson's *Apes and Ape Lore* (London: The Warburg Institute, 1952) on the owl's parallel to the ape in these associations. Bax (*Hieronymus Bosch*, pp. 16, 208) sees the dry branch the owl sits on as a diabolical version of a fertile May branch.

5. The iconography of birds goes back at least as far as Aristophanes. Within medieval tradition Bax (*Hieronymus Bosch*) lists several associations in addition to those around the owl. The spoonbill (p. 3) represents unchastity, drunkenness, and gossip. The egg (p. 191) is associated with carnival feasting, though most notably in *The Garden of Earthly Delights* we have a composite man-giant-demon whose body resembles a broken egg. As a figure he is associated with the game "pluck the goose" (pp. 238–39). Bird names are applied to people (pp. 78–86). A bird near the anus signifies a pauper (p. 225).

152

6. E. H. Gombrich, "Icones Symbolicae" in *Symbolic Images: Studies in the Art of the Renaissance II*, (1972; reprint, New York, Phaidon, 1978), p. 124.
7. Ibid., p. 159.
8. Ibid., p. 160.
9. Fray José de Sigüença, *Tercera parte de la Historia de la Orden de S. Geronimo*, (Madrid, 1605), pp. 837–41, as cited and translated in de Tolnay, *Hieronymus Bosch*, pp. 401–404.
10. De Tolnay, *Hieronymus Bosch*, p. 369.
11. Erwin Panofsky, *Studies in Iconology*, (1939; reprint, New York; Harper, 1962), pp. 3–28 and passim. The dog near Bosch's "Prodigal," the man's bandaged leg and emaciated look, all bring him also into the iconographic set of Saint Roch, whom perhaps he echoes, though it would go too far to try to label the painting a representation of Saint Roch. Emile Mâle, *Religious Art* (New York: Noonday, 1958), p. 131.
12. Lotte Brand Philip, "*The Peddler* by Hieronymus Bosch: a Study in Detection," in *Nederlands Kunsthistorisch Jaarboek*, vol. 9, (1958), pp. 1–12.
13. Raymond Klibansky, Erwin Panofsky, Fritz Saxl, *Saturn and Melancholy* (London: Nelson, 1964); Edgar Wind, *Pagan Mysteries in the Renaissance* (New York: Norton, 1958).
14. De Tolnay, *Hieronymus Bosch*, p. 370.
15. An elaborate examination of iconographic originality in Bosch's earlier paintings is carried through by Daniela Hammer-Tugendhat, *Hieronymus Bosch* (Munich: Fink, 1981). She sets herself to investigate "the causes that condition the hermeneutic difference" (p. 7), through questioning "iconographic innovation, narrative means, and principles of form such as construction of space, relation of figures to one another, color, lights, etc." (p. 8). She then discovers contradictions in *The Seven Deadly Sins* (pp. 12–26), relating the work to various sources (p. 27). She goes on to provide an analysis of Bosch's originality by demonstrating how he combines his sources, declaring at one point that a painting (*The Wedding at Cana*) is "not readable" (*nicht ablesbar*, p. 40). She stresses, passim, his particular relation to Van Eyck and remarks of his iconographic originality that "Dieser Widerspruch zwischen Aktion und Aufmerksamkeit wirkt verfremdend"—p. 22. (This contradiction between action and attentiveness operates as estranging.) Further, "Die eminent realistische gesellschaftsbezogene, distanzierende und verfremdende Darstellungsweise spricht dagegen, in Bosch nur den mittelalterlichen, frommreligiösen Moralischen zu sehen"—p. 25. (A mode of representation that is eminently realistic in its relationship to society, distancing, and estranging, speaks against our seeing in Bosch only the moral in terms of a medieval religious piety.)
16. Otto Benesch, "Hieronymus Bosch and the Thinking of the Late Middle Ages," in *Kunsthistorisk Tidskrift*, Stockholm, vol. 26 (1957): 21–42.
17. Wilhelm Fränger has expounded the Adamite thesis at great length in several

publications. In *Hieronymus Bosch: Das Tausendjährige Reich* (Amsterdam, 1969), p. 19, he thus describes the central panel of *The Garden of Earthly Delights*: "In blumenhafter Unschuld spielen die Geschöpfe in dem Gartenfrieden, mit Tier und Pflanze einträchtig vereinig, und die Geschlechtlichkeit, die sie bewegt, erscheint als reine Lust und Wonne wahrgenommen." (In flowery innocence the creatures play in the peace of the Garden, harmoniously united with the animals and plants, and the sexuality that unites them appears to be perceived as pure pleasure and bliss.) He claims that in this painting "no single lustful person" is tortured, but that other sins are, and he offers five arguments for separating it from the depiction of sin in *The Hay Wain*. He sees the crystal sphere of the reverse outer panels as an alchemical retort, the ibis as Isis offering hermetic knowledge of life and death as against the life and fire of the salamander (p. 70). Birds are interpreted as deathbirds and lifebirds (pp. 73–74), and some of them are in triumphal marital procession around the waters of life (pp. 149–52). The twelve maidens in the central panel are the twelve months (p. 155). He quotes Carl Justi on the Atlantis and Indies symbolism of the vegetation, giving India and the Holy Land as the source of the fauna (p. 75). In *Hieronymus Bosch,* (Dresden: Verlag der Kunst, 1975), he takes the satire of nuns in *The Hay Wain* for a straight anticlericalism—a view that critics of Chaucer, for example, have long abandoned. He claims that the references to a black mass in the Lisbon *Temptation of Saint Anthony* would have prohibited that painting from being used on an altar.

Fränger is refuted at length in many places, most notably, by others' accounts, in Dirk Bax, *Beschrijving en poging tot verklaring van het Tuin der Onkuisheiddrieluik van Jeroen Bosch, gevolgd door kritiek op Fränger* (Amsterdam, 1956), 1–208, in *Verhandeling der Kon. Nederlandse Academie Van Wetenschappen, Afd, Letterkunde*, vol. 63, no. 2, 1961. Bax and others point out that the purchase of the painting by Henry III of Nassau in 1517, a year after Bosch's death, taken together with Bosch's holding religious office, would indicate in the actual absence of other evidence an orthodox rather than a heretical context for his activity.

18. A. Pigler, "Astrology and Jérôme Bosch," in Snyder, ed., *Bosch in Perspective,* 81–88. He claims that the emaciated figure with a dog in *The Hay Wain* derives from fifteenth century *Planetenkinderbilder* that omit the planet deities and tend to concentrate on what is taking place on earth, like the painting. J. Combe, *Jérôme Bosch* (Paris, 1957), sees as alchemical the Fountain of Youth, the glass ball, the egg, and the pearls in *The Garden of Earthly Delights*. He points out that mercury can be represented alchemically as "a bird with black feet, white body, and a red heart." Van Lennep in *La Gazette des Beaux Arts,* vol. 1 (1968): 90, interprets one of the plants in *The Garden of Earthly Delights* as the *Pterocarpus drago* tree, exuding a red sap called "dragon's blood" to become the "red stone" in alchemy.

19. De Tolnay, *Hieronymus Bosch*, pp. 31, 363.

20. Xavière Gauthier, *Surréalisme et sexualité* (Paris: Gallimard, 1971). The surrealist celebration of sexuality as a key to perception and the surrealist admiration for Bosch probably underlie the adoption of *The Garden of Earthly Delights* by Norman O. Brown and others as a sort of nonpareil icon for a notion of polymorphous perversity.

21. De Tolnay, *Hieronymus Bosch*, p. 352.

22. Barbara A. Babcock, ed., *The Reversible World: Symbolic Inversion in Art and Society*, (Ithaca: Cornell University Press, 1978). David Kunzle, "World Upside Down: the Iconography of a European Broadsheet," Ibid., pp. 39–95. These adunata and drôleries of animals can be traced to the fourteenth century, though in the Low Countries there are almost no examples on his evidence until late into the sixteenth century, well after Bosch's death.

23. *Het Boek van Tondalus Visionen* (twelfth century Latin, translated) (Antwerp, 1472; Bois-le-Duc, 1484); Combe, *Jérôme Bosch*, pp. 43, 66, n. 56, qualifies ascription to Tondalus of Bosch's imagery by adducing other fifteenth century iconography. And in the right panel, where they are centered, Tondalus' images will account for only a fraction of the representations. Moreover, Tondalus' *Visio* recounts a journey to successive torments, while there is a pell-mell simultaneity to Bosch's painting as a whole, and to the right panel in particular, as well as an order quite foreign to Tondalus. (I have consulted the Latin text, not the Dutch.)

24. Charles D. Cuttler, *Northern Painting from Pucelle to Brueghel* (New York: Holt, Rinehart, 1968), p. 209.

25. De Tolnay, *Hieronymus Bosch*, p. 369.

26. Ibid., p. 365.

27. A. P. Mirimonde, "La Symbolisme musicale chez Jérôme Bosch," in *La Gazette des Beaux Arts*, vol. 77 (January 1971), pp. 19–50.

28. Bax, *Hieronymus Bosch*.

29. De Tolnay, Ibid., pp. 356–58.

30. Mirimonde, "La Symbolisme musicale," p. 29. Swans (de Tolnay, p. 340) were eaten at the Brotherhood of Our Lady in 's Hertogenbosch, a group to which Bosch belonged. They were called "The Brethren of the Swan" and a swan was on their coat of arms. In the Lisbon *Temptation* the swan seems to be a heathen sacrificial animal, and there is a Flemish proverb, "The swan has white feathers but its flesh is black." (De zwaan is wit van pluimen maar haar vleesch is zwart.) In *The Prodigal Son* the swan on a house banner indicates prostitution. The swan also stands for song.

31. De Tolnay, *Hieronymus Bosch*, p. 360.

32. Mirimonde, "La Symbolisme musicale."

33. Combe, *Jérôme Bosch*, p. 71.

34. To avoid the iconographical fusions implied by this paradisal element, de Tolnay, *Hieronymus Bosch*, p. 361, is reduced to reading an anxiety not only

on the faces of Adam and Eve—which is a possibility—but also on those of the rapt, placid figures of the center panel.

35. De Tolnay, ibid., pp. 24, 357; he opts for "The World is a hay-wain; each man plucks from it what he can." (De werelt is een hooiberg; elk plukt ervan wat hij kan krijgen.) There are other possibilities, in addition to Isaiah's "All flesh is grass."

36. De Tolnay, ibid., p. 105. E. H. Gombrich actually interprets *The Garden of Earthly Delights* itself as representing the World Before the Flood in "*The Garden of Earthly Delights:* A Progress Report," *Journal of the Warburg and Courtauld Institutes,* 32 (1969): 162–70. Of the reverse outer panel: "The bright curved streaks under the thunder-cloud on the left wing of the triptych cannot be all reflection on one enclosing surface . . . a rainbow . . . in grisaille." But even if we allow that a rainbow is shown here, to make it the Rainbow of the Covenant renders an odd time sequence for a world before the flood, since the Covenant refers to the world afterwards. Gombrich goes on to connect details of the central panel to commentaries that identify lust as the sin before the flood, Augustine's identification of the blacks there as the "daughters of Cain," along with catalog entries about a painting of Bosch's in 1595 and again in 1621. Even if the describers nearly a hundred years later were indicating this painting by "a history of naked people sicut erat in diebus Noe" or "the unchaste life before the Flood," their remoteness in time and in one case space (Prague for the second) would not mean they had correctly interpreted the painting. Gombrich has a few other, quite questionable details of supposed substantiation: the "pillars" in the painting would be those of brick and stone mentioned by Josephus, and the four parts of the Fountain are stretched to signify the four rivers of Paradise. His one iconographic "parallel," an engraving of *The World Before the Flood* by Sideler, would strike no one, I believe, as resembling *The Garden of Earthly Delights* in any way. It shows a gathering of a few large, clothed people in perfect perspective. This, of course, becomes a parallel to Bosch's painting in the first place only if we allow it to refer univocally to *The World Before the Flood.* Extending this notion, Bo Lindberg in "Fire Next Time," *Journal of the Warburg and Courtauld Institutes,* 35, (1972), 187–99, tries to show, somewhat contradictorily, that the Flood prefigures an end by fire, and reads that too into the painting, with reference to Rudolf von Ems' *Weltchronik* and to Judith 16. He attributes the seeming isolation of the God the Father on the reverse outer panels as implied by the tradition that Christ the Word makes the World before the Flood. All of these univocal interpretations raise far more problems than they solve.

37. Emile Mâle, *Religious Art* (1949; reprint, New York: Noonday, 1958), pp. 62ff.

38. Ibid., p. 72.

39. Combe, *Jérôme Bosch,* p. 14. He compares the work to Dirk Bouts' *Last Supper* at Louvain.

40. Robert L. Delevoy, *Bosch* (Cleveland: Skira/World, 1960), p. 11: "The Brotherhood of Our Lady . . . had a theatrical company which specialized in staging dramatic performances of various kinds, Mystery plays, devil dances, ballets of ghosts and skeletons, farces and *diableries,* all of which called for a formidable array of stage properties: iron helmets, false noses (in leather), painted costumes, masks of cloth and hide, embroidered mangles, banners of silk or cloth-of-gold, tallow candles and oil torches." All of these details are suggestive for Bosch's painting, and especially for a certain theatricality in *The Wedding at Cana.* There are medieval *"drolleries"* in Bosch, discussed by F. Lyna, "De Jean Pucelle à Bosch," *Scriptorium,* 17 (1963), 310–13, as cited by Hammer-Tugendhat, *Hieronymus Bosch,* p. 137, n. 20.

41. The mussel is carnival food, writes Peter S. Beagle in *The Garden of Earthly Delights* (New York: Viking, 1982), p. 93, citing R. H. Marynessen, *Bosch* (Brussels, 1972).

42. De Tolnay, *Hieronymus Bosch,* p. 337.

43. See n. 30.

44. Ludwig von Baldass "Hieronymus Bosch," in Snyder, ed., *Bosch in Perspective,* pp. 62–80.

45. W. S. Gibson, "Hieronymus Bosch and the Mirror of Man: the Authorship and Iconography of the Table of the Seven Deadly Sins," *Oud Holland,* 87, n. 4 (1973): 205–26. Edia Levy, "Miroir de l'orgueil: Contribution à l'étude iconographique des sept péchés capitaux dans la peinture flamande à la fin du XV siecle, *Revue des archéologues et historiens d'art de Louvain,* 9 (1976): 119–36. Levy shows that the primacy of pride among all the sins is connected with the mirror since Chrétien de Troyes and the Roman de la Rose (vv. 1578–80).

46. De Seguença, *Historia.* It should be noted that the religious use to which these severe Counter-Reformation Catholics very quickly put Bosch would tend to belie the notion that the works were too heretical for being hung in a religious context.

47. De Tolnay, *Hieronymus Bosch,* pp. 343.

48. Lotte Brand Philip, "The Peddler."

49. Cited in De Tolnay, *Hieronymus Bosch,* pp. 357.

50. John Manchip White in *The Birth and Rebirth of Pictorial Space* provides series of analyses to demonstrate how many stages were involved over several centuries in this gradual process of redefining perspective.

51. Millard Meiss, *The Painter's Choice,* (New York: Harper, 1976), pp. 19–62, with references.

52. Erwin Panofsky, *Early Netherlandish Painting,* pp. 3, 181.

53. De Tolnay, *Hieronymus Bosch,* p. 354.

54. Rosemarie Schuder in *Hieronymus Bosch* (Berlin: Union, 1975) relates Bosch complexly to the actual social circumstances of his time. Hammer-Tugendhat (ibid., pp. 76–83) describes his landscapes as the typical ones of an actual

northern Netherlands, while lacking artistic predecessors. ("Eine derartige des ganze Bildfeldfüllende Flachlandschaft steht ohne direkten Vorgänger oder Paralele in der niederländischen Kunst des 15. Jahrhunderts. Sie ist aber die typische Landschaftsform der nördischen Niederlands" (This sort of flat landscape that fills an entire image-field has no immediate predecessors or parallels in Dutch art of the fifteenth century. It is, however, the typical form of landscape in north Holland.)

55. Otto Benesch, *Hieronymus Bosch*, p. 24. Hammer-Tugendhat (Ibid., p. 59) says of the Vienna *Carrying of the Cross* that in it "Es gibt keine farbigen Höhepunkte." (There are no high points of color.)

56. Erwin Panofsky, *Early Netherlandish Painting*, p. 97.

57. Again, in *The Seven Deadly Sins, luxuria* has a dish of berries that are red, the same color as the tent of the lustful. This is simple. It contrasts with the small red in the wound of the Christ who shows it, as to a Doubting Thomas, in the inside of the pupil of the Eye of God. This Eye of God manipulates perspective by throwing it back at the spectator, an effect powerfully transposing the pictorial act itself, as Van Eyck does so differently in the mirror of the *Arnolfini Marriage*. That painting has greens and golds of firm signification. Here the eye of God has a blue pupil with the wounded Christ as the center, surrounded by an expansive circle of gold, rayed like a gold coin and lettered in a little darker gold with the warning in ecclesiastical language: *Cave, cave dominus videt* (Beware, beware; the Lord sees). We see what the Lord sees and also see the Lord, bewaring and judging in a single act as precious, we may say, as that thick, central, dominant gold, and as clear as the blue background that has all the freshness of the blue skies in the Books of Hours from the previous century. This blue, though, lacks their natural reference, since Christ is suspended in no landscape. He is only risen a little further than his waist, out of the horizontal greyish-blue tomb. Is the gold the iris of the eye? The rays of the gold do recall the crinklings of an iris. If so, then not just the center of this table-tondo but the entire tondo has to be taken for the eye. Yet the "white" of what this eye would be is schematized into seven segments, seven scenes of sin, each neatly coordinated into the color codings that later undergo such transmutation at Bosch's hands.

The motif of the Harp-Crucifix, found also in the Bruges *Last Judgment*, suggests witchcraft; it is drawn from the *Malleus Maleficarum* (Schuder, *Hieronymus Bosch*, p. 105). (Is this the open book?)

58. I am grateful to the Galleria Cramer for allowing me to inspect this painting.

59. Combe, *Jérôme Bosch*, p. 47.

60. On the *Orbis Terrarum* and the crystalline sphere as inclusive, see Hans Holländer, *Hieronymus Bosch* (Köln; Dumont-Schauberg, 1975), p. 156.

61. E. H. Gombrich, as quoted above, n. 36.

62. De Tolnay, *Hieronymus Bosch*, pp. 397–98. There would seem to have been other encyclopedic paintings of Bosch, now lost: a *Creationis Hexameron*

Mundi for a high altar, and perhaps *la tela delli sogni* (the Canvas of Dreams), formerly in Venice (W. S. Gibson, *Hieronymus Bosch*). A painting formerly in Bonn and burned in 1590 of *Christ Entering Jerusalem* had his birth on one wing and his Resurrection on the other. It would have comprised the summary of a life that, more mutedly, the Vienna *Christ Carrying the Cross* suggests, if taken together with the Christ Child on its reverse, as noted above. This would be even more the case if, with Gibson, we refer the calm on the face of Bosch's Christ not to the particular circumstances of the painting but to His general posture. He "looks calmly and benevolently . . . a model of the Christian virtues," according to the patterns of the widespread fifteenth century invocation to an *Imitatio Christi.*

63. Nicolas Calas, "Hieronymus Bosch and the Parable of the Two Brothers," *Colóquio: Artes* 37 (1978), 24–33.

64. Kay C. Rossiter, "Bosch and Brant: Images of Folly," *Yale University Art Bulletin,* 34 (June 1973): 18–23. "Bosch's imagery is more sinister and tantalizing than the purely moral statement of Brant's verse." According to Anna Boczkowska, for example, in "Lunar Symbolism of the Ship of Fools by Hieronymus Bosch," *Oud Holland,* 56, no. 2–3 (1971): 47–69, the moon in Bosch's *Ship of Fools* concentrates a number of associations: the moon is a water planet, and as a wanderer serves generally for a patron of the traveler. In folklore there is a blue moon boat and a *carrus navalis* carried in procession. The moon is shown with a tree on Babylonian seals, and this motif still appears in the medieval boat-and-tree emblem, together with tree-of-life symbolism in the fifteenth century. The moon governs digestion, and the passengers on Bosch's boat are eating. (Elena Calas, "The Wicked Walk in a Circle in Bosch's Garden," *Colóquio: Artes* 36 [1978]: 32–40.)

65. Its own echoes, when they are not specifically Christian, like Adam and Eve or the Last Judgment, tend further toward the encyclopedic, as Elena Calas finds echoes there of Pol de Limbour's Man in the Zodiac Circle and other Zodiacal features.

66. Gerd Unverfehrt, *Hieronymus Bosch: der Rezeption seiner Kunst im frühen 16. Jahrhundert* (Berlin: Mann, 1980). He lists copies of *The Garden of Earthly Delights* in the period 1530–50, including a Gobelin tapestry owned by Cardinal Granville, Archbishop of Mechelin, along with abundant other examples of imitation.

67. De Tolnay, *Hieronymus Bosch,* p. 389.

68. Bosch worked rapidly, according to J. P. Filedt Kok, "Underdrawing and Drawing in the World of Hieronymus Bosch," *Simiolus,* 6/3–4 (1972): 133–62. Infrared shows this, and it is substantiated by a statement of Carl Van Mader (1604) about current practice. The infrared indicates that a white ground of chalk was mixed with glue and then the underdrawing made with a brush on a black water paint.

69. D. J. Gordon, *The Renaissance Imagination,* (Berkeley: The University of California Press, 1975), p. 110.

70. As quoted in Gombrich, *Symbolic Images,* vol. 2, p. 168.
71. Jean-François Lyotard, *Discours, Figure,* (Paris: Klincksieck, 1971), p. 241.
72. Adrian Stokes, "Painting and the Inner World," in *The Collected Writings,* vol. 3 (New York: Thames and Hudson, 1978), p. 212.
73. Lyotard, *Discours Figure,* p. 135.

The Changeable Signs

1. Adrian Stokes, "Reflections on the Nude," in *Works,* vol. 3, 303–309.
2. Ibid., p. 54.
3. Jean-François Lyotard, *Discours Figure,* p. 13.
4. See Albert Cook, *Myth and Language,* Ch. 6, "Ovid."
5. Stanley Fish, *Surprised by Sin* (London: MacMillan, 1967).
6. *Imitatio Christi,* vol. 1, p. 1: "Stude ergo cor tuum ab amore visibilium abstrahere et ad invisibilia te transferre." The "ergo" here is based on the superiority of what is abiding to what is fleeting—a superiority that, from another point of view, the painting that arrests our attention begins to bring our contemplation toward. ("Vanitas est diligere quod cum omni celeritate transit et illuc non festinare ubi sempiternum gaudium manet": It is vanity to love what passes with extreme speed, and so not to hasten where eternal joy abides.)
7. Johan Huizinga, *The Waning of the Middle Ages* (1924; reprint, New York: Doubleday, 1954).
8. Anne Righter, *Shakespeare and the Idea of the Play* (Harmondsworth, Middlesex: Penguin, 1967). See also Albert Cook, *Shakespeare's Enactment* (Chicago: The Swallow Press, 1976), pp. 102–33.
9. Wylie Sypher, *Four Stages of Renaissance Style* (New York: Doubleday, 1956), pp. 87–107.
10. Edward Snow, in a book in progress on Brueghel, argues that his images also have been inadequately, and too quickly, deciphered.
11. Robert Delaunay, *Du Cubisme à l'art abstrait,* ed. Pierre Francastel (Paris: S.E.U.P.E.M., 1957), p. 59.
12. Notions like resemblance, model, and the like are puzzled out in Nelson Goodman, *The Languages of Art* (Indianapolis: Hackett, 1976). While confusion on such matters is undesirable, one may fulfill both sufficient and necessary conditions for discourse about art without clearing up such confusion. And the process of doing so carries with it the threat of arresting the aesthetic discourse at a stage prior to enlightening comment on actual artistic procedures.
13. Erwin Panofsky, "Die Perspective als Symbolische Form," *Vorträge der Bibliotheque Warburg* (1924, 1925), pp. 260–300, as cited by Lyotard, p. 172. John Manchip White, *The Birth and Rebirth of Pictorial Space.* Howard Brown (lecture at Brown University, March 20, 1980) points out how treatises on musical composition in the fifteenth century speak of mathematical proportions and the universe. In what amounts to an analogue to the freeing

of images in painting from prior strictures, the fifteenth century composers, in Brown's account, at first imitated other composers and innovated only by adding one or more lines to a chanson or by counterpointing an old melody. They worked away from this by retaining only the structural form of an older practice. And then in a "re-composition" or "free-reworking" they moved toward a still fuller freedom.

14. Alois Riegl, *Die Entstehung der Barockkunst in Rom* (Vienna: A. Schroll, 1923).

15. Rosalie Colie, *Paradoxa Epidemica: The Renaissance Tradition of Paradox* (Princeton: Princeton University Press, 1966).

16. Walter Pater, "The School of Giorgione," in *Studies in the Renaissance* (London, 1882). Pater speaks of "the sensual element in art" and an "*Anderstreben* toward music." All art constantly aspires towards the condition of music."

17. Meyer Schapiro, "Cézanne's Apples," in *Studies in Modern Art* (New York: Viking, 1978): 1–38.

18. Erving Goffmann, *Frame Analysis* (Cambridge: Harvard University Press, 1974), p. 46.

19. What Stanley Cavell says of modern art may be applied here with modifications. *The Claim of Reason* (Oxford: The Clarendon Press, 1979), 95. "When in earlier writing of mine I broach the topic of the modern, I am broaching the topic of art as one in which the connection between expression and desire is purified. In the modern neither the producer nor the consumer has anything to go on (history, convention, genre, form, medium, physiognomy, composition) that secures the value or the significance of an object apart from one's wanting the thing to be as it is. The consequent exercise of criticism is not to determine whether the thing is good that way but why you want it that way—or rather, the problem is to show that these questions are always together. A strictness or scrupulousness of artistic desire thus comes to seem a moral and an intellectual imperative . . . ('Economy'). My version of Thoreau's answer is in effect that he takes it upon his writing to tell all and to say nothing—If we formulate the idea that valuing underwrites asserting as the idea that interest informs telling or talking generally, then we may say that the degree to which you talk of things, and talk in ways, that hold no interest for you, or listen to what you cannot imagine the talker's caring about, in the way he carries the care, is the degree to which you consign yourself to non-sensicality, stupify yourself."

As he goes on to say (p. 125), "If it is the task of the modernist artist to show that we do not know a priori what will count for us as an instance of his art, then this task, or fate, would be incomprehensible, or unexercisable, apart from the existence of objects which, prior to any new effort, we do count as such instances as a matter of course; and apart from there being conditions which our criteria take to define such objects. Only someone outside

this enterprise could think of it as an exploration of mere conventions." One might rather think of it as (the necessity for) establishing new conventions.

20. Maurice Merleau-Ponty, *Le Visible et l'invisible* (Paris: Gallimard, 1964), p. 174.

21. I owe this association of philosophy to literary representation to Holly Wallace-Boucher's unpublished study on philosophy and allegory in Chaucer and Boccaccio.

22. Charles Sanders Peirce, "Logic as Semiotic: the Theory of Signs," in Justus Buchler, ed., *Philosophical Writings of Peirce* (1897; reprint, New York: Dover, 1955), p. 99.

23. Lyotard, *Discours Figure,* passim, citing the term from Merleau-Ponty.

INDEX